Other books by Jeff Vande Zande

Fiction

Emergency Stopping and Other Stories (Bottom Dog Press, 2004)
Into the Desperate Country (March Street Press, 2006)

Poetry

Transient (March Street Press, 2002)
Last Name First, First Name Last (Partisan Press, 2003)
Tornado Warning (March Street Press, 2004)
The Bridge (March Street Press, 2005)
Poems New, Used and Rebuilds (March Street Press, 2007).

Bottom Dog Press
Supporting Writing in the Midwest

Landscape with Fragmented Figures

A Novel

By
Jeff Vande Zande

Working Lives Series
Bottom Dog Press
Huron, Ohio

© 2009 Bottom Dog Press
& Jeff Vande Zande
ISBN 978-1-933964-23-2
Bottom Dog Press, Inc.
PO Box 425
Huron, Ohio 44839
http://smithdocs.net

Credits
Cover image "Hot and Cold"
by Randal Crawford
Layout and Design by Larry Smith
Author photo by Stan Cain

Acknowledgments
Thanks to Matt Bell and Josh Maday for being first readers of
the novel and especially Larry Smith of Bottom Dog Press
for expert editing advice.

And at the museums, have you ever been? All abstract. That's all there is now. My uncle said it was different once. A long time back sometimes pictures said things or even showed people.

— Ray Bradbury, *Fahrenheit 451*

This book is dedicated to my son, Maxwell, and my daughter, Emerson...two incredible additions to my personal landscape.

Chapter I

Ray listened to the low grumbling of thunder over the distant lake. He shivered. Above the headboard, the rain was like infant fingers tapping against the window. Leftover flashes of lightning lit the room. He closed his eyes and saw the storm over the blue-blackness of the bay. There would be no people. Everyone would have come in hours ago, tying off in harbors or pulling boats up onto trailers. The bay would be water and sky and water falling from the sky with great moments of light and the colossal sounds of the storm. If he tried to paint the scene, he'd botch it. Who could really improve upon Turner's *Snowstorm: Steamboat Off a Harbour's Mouth*? Surely not Raymond Casper. To capture and paint the true atmosperic effects of a storm, Turner had himself lashed to the bridge of a steamboat for four hours as it made its way from Harwich in rough weather. Ray wondered, Am I that driven by art? Doesn't an artist need to be?

Diane's cigarette glowed outside the room on the small balcony that overlooked the street. The tiny orange light moved leisurely from a low point, up to where it flared at her mouth, and then down again. In the darkness, Ray could just make out the shadow of her arm connected to the cigarette. Then lightning flashed, exposing the arm and the side of her face, even her foot up on the railing. He wondered what she was thinking. If it was about him, it would not be good.

"Why don't you come in now?" he called to her from the bed. "I don't know that you should be out there."

A moment passed. Soon the cigarette's ember arced up into the darkness and fell below his vision. Street lights played on the

wetness that covered everything—everything reflective. The front legs of her chair came down and knocked against the floor.

She moved like a shadow into the room. "It cooled off. You said it wouldn't cool off."

Lightning flashed behind her. He saw her momentarily. The white of her panties, her small breasts. Had anyone ever painted it before—a nude lit briefly by lightning? He tried to envision what she had looked like in that instant of stark relief. His memory couldn't hold it. He remembered only the expression on her face. Resolute. Determined. He swallowed deliberately.

Her thin silhouette moved around the room. She found her jeans and pulled them on. If he could get her to lie with him again, he could make things better. Hadn't things been good between them just a half hour before? In bed she was his.

She bent and came up with a shadow between her hands. As she pulled at it, it became a t-shirt she stretched over her head.

"I'm sorry," he said. "Don't leave."

"Ray."

"I'm serious. I don't want you to leave."

She sighed. "Why are you even apologizing? I don't think you even...you must know why I have to leave. I've been feeling it for so long."

He propped himself against the headboard. "I haven't felt anything."

Her hands flew from her hips. "That's part of the problem."

"I am sorry for what I said."

Diane had gone around the tri-cities and bought used drop cloths from house painters. She took photographs of the painters themselves—men with speckled mustaches and ruddy skin. In Ray's basement, she'd stretched the drop cloths over large frames she'd made. The drop cloths and photographs were now hanging in a gallery in Ann Arbor. She titled the show "Spontaneous Splatter: the Art of the Working Class." The show had won a favorable review from a small independent newspaper; the reviewer was especially taken with the photographs. She'd captured each man, something about his essence. Just that evening at dinner, Ray couldn't hold back. He'd asked her why she was wasting her time on such nonsense. He called it "Art as gimmick."

She stood at the foot of the bed, a darkness hovering over him. "Do you really think that what you said bothered me? Do you think that's why I'm leaving you?"

He wasn't sure why she was leaving. She'd left him before and come back. He sat for a moment, wondering if he should just let her go. He sighed. "It wasn't a kind thing to say. You probably think I'm jealous."

She laughed. "Do you even remember your first words to me?"

He didn't and told her as much.

"You said I painted like someone who was aspiring to work for Hallmark. You said, 'Your painting is edgeless—an attempt to recreate, but not to truly see the soul of what is in front of you.' You said my art wasn't 'after anything.' It had no truth."

He rubbed his hand over his face. "That was years ago... years before we even dated." She had been a student of his, but they hadn't become lovers until much later. She'd left her husband, though not for Ray. They'd run into each other at a local sculptor's exhibition, and afterwards ended up in Ray's bed. They'd been together for four years. "It doesn't even make sense, what I said in class. I guess what you're saying is that I'm still an asshole."

"No," she shouted. "I loved what you said. It was true. I needed to hear it. It changed me as an artist." Her shadowy arms flashed out from her sides.

Lightning flickered into the room again, revealing her sad face.

"But, tonight," she continued, "when you said I was wasting my time...it didn't matter. I wouldn't have paid attention even if you had been excited about my show. Nothing you say about my art matters."

"Man," he said, feeling his blood go sluggish.

She said she wasn't trying to hurt him. "I just want to be honest." She walked over to the Jeliff near the door and sat. They'd bought the chair together at the antique mall. "I just can't respect your opinion anymore," she said.

He cleared his throat. "I'm glad you're not trying to hurt me."

"Ray."

He shifted on the headboard until an ache in his lower back went away. "I'm not sure how you expect me to take what you're saying."

"I've felt this way for the last six months." She breathed in deeply and exhaled. "It's really going to be over this time."

A car hissed by through a puddle. He imagined the water arcing up and away from the tires. "You've left before," he said.

She said, "I'll be coming by with a truck in the morning while you're in class."

"You don't love me?"

She stood. "I didn't say that."

"Then, why?"

She crossed her arms. "What are you after, Ray?"

It was a question he often put to his students—or at least he had at one time. It was a question he had put to Diane. What are you after? What's your vision? What do you have to say to the world with your art? Once they were questions he thought he could answer for his own art. His early work was compared to Hopper. Then he went abstract. The pieces that got him gallery showings were compared to Pollock and Kandinsky. The gallery shows, the favorable reviews, finishing his Masters Degree in Fine Arts...all of it had helped to land him a teaching position at Dow University in Saginaw.

He closed his eyes and confessed to what he'd been feeling for some time. "I guess I haven't been after anything in awhile—for years maybe." He felt her sit at the end of the bed.

"Why?"

He rubbed his eyebrows. "I don't know. Maybe I wasn't ever after anything. I was always neo-something or just like so and so." He looked at her face distorted in the shadowy light. "I don't know, Di."

"Don't you want to paint anymore?" she asked softly.

"I still paint."

She collapsed dramatically onto the bed. "I don't want to talk about *Riverscape*, Ray."

In March, he'd gone down to the river with two easels, a big canvas, and oils. He painted the skyline on the opposite bank. He painted a freighter in the river and the bridge opened up for it to

pass through. He painted tiny people on the other side watching. Anyone from Bay City would look at the painting and say, "That's Bay City!" Przybylski, a colleague, told Ray that it reminded him of a Bellows piece without all the gritty influence of The Eight. One thing Ray knew he didn't want was a compliment from Przybylski. Art was no gimmick for Przybylski. It was a cash cow.

Ray sold *Riverscape* to a downtown hotel for a thousand dollars. They had it in their lobby. The university's president had stopped by Ray's office to tell him that he'd seen the painting. "I like how they have your name and right under it that you're a professor here." Ray had smiled weakly in return.

"It was one painting." He scooted lower and rested his head on the cool pillow.

"I don't understand why you painted it. What were you after? The money?"

"No," he said. "Hell, no."

She explained, "In class, as we painted, you used to pace between our easels. You told us not to give the viewers what they already see, but to give them what is there, but that they can't see. Or, they refuse to see. You used to quote Aristotle: 'The aim of art is to represent not the outward appearance of things, but their inward significance.' I still remember it."

Ray said that maybe those were just words. "They sound good in the classroom, or maybe they make me sound good. But, I don't—"

"You used to tease us that if our paintings didn't have an edge, then they'd end up hanging in hotel rooms."

He grinned. "Mine's in a lobby."

"I've been to that lobby and studied that painting, and I don't see any of you in it. The old you would have refused to sell such a thing."

"I don't know about that."

She was still there, talking to him. It was something. He shifted his foot and touched her hip through the comforter. She didn't move away.

"I know about it," she said. "Everything about that painting ...I just hate it."

"Not everybody would agree with you, Di." But, in his heart, he agreed. She was saying what he'd refused to say ever since completing *Riverscape*. It wasn't art. He'd been happy to be painting again, but the accolades that came with completing the piece had surprised him—and consumed him. He'd enjoyed the money, the praise, the write-up in the newspapers. He'd taken pride in what he'd done, and he'd been a fool. Still, why be so hard on himself? I'm painting again, he thought, and that is at least something. Isn't it?

"Some people liked it," he said.

She propped herself up on her elbows. "Like who? President Bonner? That guy thinks a freshly poured sidewalk is art."

Ray laughed, stretching his arm across the comforter. He couldn't reach her with his groping fingers.

"You could have at least done something subtle. I mean, your sky is blue. Why not overcast? Or, what about having the ship floating high in the water, suggesting it's empty—that it's really not bringing anything into the city. Or, what if the bridge weren't up? Some subtle tension. Nobody would notice it easily, but at least you'd know that there was no way the boat could make it through. You'd chronicle the impending crash. Your painting has nothing."

He longed for her to come back to bed, felt his blood shifting to have her just as he'd had her before the storm. Legs wrapped around his back, her fingers finding handholds in the headboard. He wanted to be done with the talking. He wanted her to come down from her pulpit and live with him among the pillows and sheets.

Diane rose from the bed—rose away from his foot—and stood. She sniffed. Her voice cracked. "Ray, I'm trying to tell you why I'm never coming back."

He bolted up to sitting. More lightning lit the room. "Over what? Over a painting?"

"You'll bring me down, too."

"Down? What are you...Are you saying you don't love me?"

She walked to the door. "I do love you. But, I need to be with an artist. I need that around me. I want to be an artist first and a woman second."

Sorrow washed over him. Then it flashed to anger. "An artist first? So you can keep hanging that crap you have down in Ann Arbor?"

"Ray, you can't hurt me. It only hurts me that you're trying to hurt me." She walked to the bedroom door, moved through the doorway, and closed the door behind her.

He sat up to follow her. She moved too quickly. He could hear her for a moment on the steps, and then the front door opened and closed. He lay in the dark for a time, and her words replayed themselves in his mind. Everything she'd said was true. His progress, his recent activity in the studio—he'd only been going through the motions of painting. The new painting he was working on came into his head, a landscape of a tractor working a field of sugar beets. His motivation? A CEO from the local sugar refinery had seen *Riverscape* and hinted that they might be willing to pay for something similar for their conference room. Ray was working from a photograph he'd taken, recreating in oils what the photograph had already done. He wasn't saying anything new. He wasn't after anything.

In time, his own tears came. He'd lost—Diane, his art. He didn't hear the dying storm anymore, only the small thunder of his own sadness.

Chapter II

The end of the spring semester and the beginning of what would be eight weeks free of teaching brought Raymond Casper none of the good feelings he'd come to anticipate. The light at his windows and its warmth in his rooms left him restless and wanting out of his house. The sun reminded him too much of Diane. That was always her desire when she painted—"Better light. I need more natural light." She always complained about his basement studio. "Natural light isn't a big part of what I do," Ray would argue.

Diane had been gone for two weeks. She e-mailed once to say that she'd found an apartment in Ann Arbor. Her show was still going well. The emptiness around him, rather than giving him the feeling of more space, made him feel constricted. He went for walks, leaving his Fourth Street home and quickly going to Center, which took him downtown.

Bay City, like so many Michigan cities, was trying to create a new identity. It had been a lumber town, a ship building town, a crane town and, most recently, a sugar and automotive town. Its future was as a tourist town. At least that's what the city council seemed to hope. A new look to the riverfront of the downtown, a new hotel and conference center, a new emphasis on the arts— Bay City hoped to be a resort destination. Ray felt that it had a long way to go.

He walked, flanked by the Center Street mansions. Built by the lumber barons so long ago, the homes were gigantic with nine, ten, eleven bedrooms. Each had almost as many fireplaces. Vast kitchens spilled into vast dining rooms which connected to sprawling living rooms, family rooms, sitting rooms, solariums,

and libraries. The high ceilings spoke of a time when heating efficiency was shrugged off for elegance. Who lived in such places at present, Ray didn't know. Doctors and lawyers, he guessed. Even with a full professor's salary, he could never hope to live in such a place.

His walking brought him closer to the downtown. The nature of the mansions changed. Some, for whatever reason, had been razed. He'd seen pictures of their magnificence in Bay City history books. Houses built on the remaining lots were sometimes more modern—an Alden B. Dow structure tossed in among the looming Victorians. Though most of the mansions remained, many had declined. Multiple mailboxes screwed next to front doors suggested how the architectural masterpieces were divided into six, seven, or even eight apartments during the seventies and eighties. The idea of such butchering did little to help Ray's mood. He felt like the mansions—busted up and misused. A breeze carried the Saginaw River's stale smell to him. Ahead, the hotel that hosted *Riverscape* loomed on the skyline. He looked down.

The sidewalk was littered with the spent bottle rockets and the flowering black stains of other fireworks. Tattered red, white, and blue decorations stirred listlessly from telephone poles, the remains of the weekend's Fourth of July celebrations. Ray had stayed inside, not bothering with festivities. Bay City celebrated with three nights of fireworks, ending the third night with a half-hour grand finale. It was something he and Diane had gone to every year. They'd spread a blanket in the park down by the river. Once, a little tipsy, she said, "The sky is a giant canvas, the fireworks just a kind of temporary paint. Fugitive colors." He smiled sadly. Everything in town held a memory of her.

Ahead of him, around the stone entrance of a Pentecostal church, a group of older boys were skateboarding. He stopped to watch them. Their long bangs hung over their eyes, and their rolled sleeves exposed skulls and fire, tattooed along their forearms. Propelling themselves from the medieval church doors, they jumped—or tried to jump—up onto the handrail that ran along the stone steps. They didn't wear pads, and most of them ended up spilling headlong onto the sidewalk below. Ray winced, waiting for the screams of broken bones. He recalled being goaded into

football with his older brother and father in the front yard. In one unfortunate tackle, his father had landed on him, breaking cleanly the radius and ulna of his left arm. The bones still ached in cold weather, reminding him of his regrettable upbringing.

The boys in front of him seemed impervious to breaks, almost invincible. They rose from their spectacular falls, rubbing sore spots and shouting: "Dude! Jesus Christ, dude. Holy shit. Did you see that? That shit hurts!" The others only laughed.

Studying them, Ray noticed that they were older than he'd first guessed. They weren't in high school. He wondered if he didn't recognize a couple of them from the university. In time, they began to shoot glances at him, and he moveed on leaving them alone with their youth.

Several blocks later, he opened the door of the Seagull Bar. The smell of beer and cigarettes filled his nose. When the door swung shut, he was left in a sudden darkness. He waited for his eyes to adjust, wishing it were that simple to adjust to the rest of the darkness in his life. He looked around, blinked, and then spotted Carl Sheldon in a booth near the back.

"You're late," Carl said, scratching his beard. "Again." He smiled. He taught in the English Department at Dow. He and Ray had started as new faculty members together in 1986.

They shook hands. "Sorry," Ray said. "I still can't time the walk." He slid into the booth.

A pitcher of beer sat sweating in the middle of the table. Carl smiled sympathetically. "How you holding up?"

Ray sucked his lower lip in and bit. The physical pain overshadowed the emotional. He nodded his head. "I guess pretty well." Carl didn't need to know how Diane's absence had hollowed him.

The bartender checked on them. He looked at the two men and shook his bald head. "Drinking in the middle of the day," he said, smiling. "Mom shoulda raised me to be a college professor." He walked away.

"There's no tips in it," Carl called to his back. He reached the pitcher over the table and filled Ray's mug. "Wet your whistle, sailor."

Ray held the cold glass with both hands, studying the beer. He liked the lighting of a bar, but then bar scenes were an overdone theme. Manet had the patent.

"I don't think they're going to approve our new tenure-track position. This will be the second year in a row that we have adjuncts teaching our Children's Lit classes." Carl took a long pull of his beer.

Ray nodded, his head barely moving. He smiled.

Carl smiled back. "You probably don't want to do this...no shop talk, right?"

"I don't...it really doesn't...I just don't know what kind of company I'll be today. My head's everywhere."

"Don't worry about it. You're never good company."

Ray sniffed a laugh. Probably too early for me to be around anyone, he thought.

Light flashed into the bar. Two silhouettes stood in it, disappeared when the door closed, and then faded in again gray, but almost dissolved in the interior's darkness. They walked to the bartender and asked for cigarettes.

"Professor Sheldon?" one of them shouted.

Carl lifted his hand. "Hi, there."

The boys paid for their cigarettes and then partly walked, partly bounced over to the booth.

"Dude," the one who had recognized Carl said to his friend, "I gotta introduce you to the only professor at Dow that I can stand. This is professor Sheldon—the Sheldonator."

Carl extended his hand to the other boy. "Just Carl is fine."

The boy nodded, taking Carl's hand awkwardly, as though handshaking were a new custom. Ray recognized both of them as skateboarders from the church. Neither gave him more than a glance.

Carl smiled. "So, how are you, Billy? Did you get through Comp Two?"

Billy's face soured. "No." He shook his head. "It was nothing like your class. The papers sucked. Do you teach Comp Two?"

"No. I told you guys at the end of the last class that I teach Comp Ones and Shakespeare. No Comp Twos."

Billy snorted something back through his nose and swallowed. "That blows, man. Your class rocked. You gotta start teaching Comp Two." Both he and his accomplice snapped their heads, flipping their bangs out of their eyes.

"Not going to happen." Carl took a tentative sip of his beer. "I'm not a Comp Two man." He looked at Ray and winked.

Ray thought of his own students. It had been a long time since he'd had a conversation with one of them on the street. When they did see him, they seemed to avert their eyes. He couldn't really blame them. His teaching had changed. He knew it.

He was bitter, distant in the classroom. Starting each class, he told his painters he'd be in his office if they had questions. He told himself that it helped them build their initiative. It was a lie. What it built was their resentfulness, which many of them unleashed in their student evaluations: "Prof. Casper doesn't act like he wants to be here." "I learned more from the other students." "Casper is a good name for him—the guy is a god-damn ghost." "He always seems mad...well, when he's actually in class." "Casper needs Prozac."

Ray scratched his head.

"So what are you doing, having some beers?" Billy asked.

His friend looked impatiently toward the door. "Let's go."

"Chill, man." Billy smacked his cigarettes against his palm. He cleared his throat. "So, I was just wondering if you were going to be around your office this summer. I need to talk about things. College and stuff."

"Actually, I'm not going to be around," Carl said.

"Oh." Billy's face fell.

Carl shrugged. "Sorry."

Ray could feel the beer tingling in him. Still, his impulse felt like more than just alcohol-induced compassion. There'd been something in the way Billy had asked, as though he really had something big on his mind. He needed someone. Ray introduced himself. "I'm around this summer," he offered. "Come talk to me if you need to talk to someone. I'll be in and out of my office."

Billy looked at him. He shrugged tentatively. "Okay. Thanks," he said.

"Come on, Billy," the other boy said, punching him softly in the arm.

"Well, I guess we're gonna cruise," Billy said, shooting Ray another glance. "I'm going to look for you in the class schedule, Professor S. Comp Two, man. Comp Two." The boys dis-appeared back into the light outside the bar.

Ray looked at Carl and smiled. "Comp Two, man."

Carl flicked a fingernail against his half-full mug. A low tone resonated from it, but died quickly. "America's future," he said.

Ray laughed. "Dow isn't Harvard, Carl. They've got other places that take care of America's future."

"Yeah," he said. "Then what's our job—holding out false hope?"

Ray shrugged.

Carl tilted his beer, drained it, and set the empty mug on the table. "You know what he wrote his first paper about?"

Ray shrugged.

"It's a paper I have them write about their careers. Old Billy there said he's going to be an engineer. Why? 'Cause that's where the bucks are.'"

"Dude," Ray offered.

Carl wrinkled his nose. "I had a chance to talk with Billy during a conference. He told me about the other classes he was taking. Among them, he had Olson for Math 099." Carl shook his head. "Do you know what the chances are for a kid to start in Math 099 and go on to become an engineer?"

Ray took a drink of his beer. "Probably not good."

"Not good at all." Carl pushed his tongue against the inside of his cheek. "And, my smart kids—the ones who could actually become engineers...well, they don't want to be engineers. They want to be writers." He laughed. "Writers, for chrissake. In this country! Who the hell actually reads, anyway?" He took a drink. "Hey, Phil," he called to the bartender. "You read any good short stories lately?"

The bartender smiled and shook his head as though he'd been told a corny joke.

Carl described a new woman the English Department had hired the year before—a novelist. "She's good, Ray. She's really

good. I read her novel and her collection of short stories. Really good stuff. You know where she'd be without this teaching position? She'd be in a god-damn bread line."

Ray yawned. He hadn't been sleeping well. "Well, maybe Math isn't Billy's calling. Maybe he could be a journalist. The next Bernstein. How were his papers?"

"Terrible." Carl filled his glass.

They worked their way down to the bottom of the pitcher, starting small conversations, only to witness them sputter and die. They talked of their ex-wives. Carl's ex was getting married a third time. He was invited to this one. Ray's Marcy was remarried and living in St. Paul. He hadn't heard from her in years.

Ray told Carl what Diane had said about *Riverscape*.

Carl shrugged. "I liked it. I mean, what are you supposed to do?" He ran his hands over his face. "Drop cloths? I'm sorry, but is that a joke? No wonder people hate modern art." He looked at Ray apologetically.

"Don't worry about it. I'm not her white knight anymore."

Carl spoke loudly, thumping his mug against the table. "I got an idea. I saw on the news that some kids in Saginaw are really getting into huffing spray paint. Maybe you could get a few of them to sneeze on a canvas for you. That would be art of the down-and-out. That would be modern."

Ray laughed and felt better than he had all day. "Some people would call it art, I guess."

They drank from their beers for a moment.

"So, what are your plans for the summer, then?" Carl asked. He looked at the pitcher and pointed at it before Ray could answer. "Should we get another, sailor?"

Ray felt something humming at the surface of his body, breaking up the tension that had left him stiff since waking. His cheeks tingled. "Yeah, let's get another."

Carl signaled the bartender.

"I don't know about the summer," Ray said. He guessed that he wouldn't be able to paint. He couldn't think like an artist anymore.

The bartender brought the pitcher over.

Ray filled his glass and raised it in the air. "It was the summer of my discontent..."

"Winter."

"I know, I know. You just had to correct me."

"And it's 'our' not 'my'."

"Shut up."

Carl filled his own glass. "Seriously, though, what are your plans?"

Ray shook his head. "I don't know how to make plans anymore. I guess I'll get up, walk around, eat, go to sleep—wait for the end of summer."

The door opened again. A small, slower silhouette shuffled to the bar.

Ray watched the shadow become an old man climbing up onto a stool. Without a word, the bartender turned, took something from the shelf, and poured a shot.

"You really have no plans?"

He looked at Carl. "Hey, come on, Diane just left me. I'm not going to cut my ear off or anything, but give me a little mourning period."

"No, I'm just...it's just that in about a week I'm bringing a group of students over to London for a two-credit Shakespeare Experience course. We're going to see the Globe, a few plays, check out places Shakespeare frequented—all that overseas stuff. You could come along."

Ray furrowed his brow. "Take your class?"

Carl laughed. "No, just get in on the travel package. We have a pretty good deal. I mean, the school wants more people to go. They don't get reimbursed for the empty seats. Once we're there, it wouldn't take much for you to hop the channel and go to France. You could check out the Louvre...I mean, it's the kind of thing you artists like to do, right?"

Ray smiled. He took a long pull on his beer, feeling sleepy and happily numb. France. He hadn't been there since he was a young art student and had gone for a month as a part of a summer course. He'd painted outdoors like Monet. He visited the back stages of theaters where it was reputed that Degas had found his dancers. He went to the Gulf of Marseilles to try to find the

exact spot where Cezanne had stood while painting *L'Estaque.* An older woman, a Belgian named Jolien Poiret, had taken Ray on as a lover. Thick brown hair, a generous body...he'd teased her that she could have modeled for Renoir. Jolien had only laughed, taking no offense as an American woman might. She was unhindered and easy. No hang-ups.

Late at night, he painted nudes of her. He remembered discovering her fleshy contours and discovering himself as a lover. He never felt more like an artist than when he was walking the narrow streets of Paris. It certainly beat the narrow halls of Dow U. or the unmufflered streets of Bay City. France had made him feel that art—even his art—mattered. He wanted to feel that way again.

"You're not kidding, are you?"

Carl shook his head.

"I could, couldn't I?"

Carl shrugged and said he didn't see why not.

Ray felt something pumping through him he hadn't felt in a long time. It was like when a painting was really coming along and he could feel it, almost touch it. He finished his beer. "I'll do it. I'm going to go. Jesus, Carl, I mean...this could be just what I need."

Carl nodded. "Why do you think I offer the class? I do it for me as much as for the students."

Ray scooted from the booth and stood. "You don't...you don't mind if I leave, do you? I mean, I just want to get started, especially with my passport and everything."

Carl waved his hand. "Go ahead. You don't think I want to sit around in some dark bar with you all day, do you?" He told Ray who he'd have to call at the university for the travel arrangements.

Jogging for the door, Ray ran into the old man and nearly knocked him over. He helped him steady himself.

"Come on, Ray," Carl shouted, laughing. "Take it easy."

The old man looked at him, frowning playfully. "Where's the fire?"

Ray looked into his eyes. "In my belly," he said, smiling.

The old man returned his smile. "Good for you."

Ray apologized again, waved to Carl, and then left. Outside, he squinted until he could take the new light. The young men were still skateboarding when he passed. Billy cocked his head toward him, and Ray waved ridiculously in his direction. Billy returned the wave. Another boy sat in the grass rubbing his forearm.

Ray was home in ten minutes. He found his passport in a shoebox. Before going to the post office, he decided to call the university. He emerged from the dark closet, feeling as though he'd grown wings.

The red light flashed on his answering machine. Was it Diane? He didn't even care. The hell with her and her drop cloths, he thought. He wanted to tell her about going to Europe. Like her, he was doing things, too. He pressed the button.

His brother's voice entered the room like a ghost, seeming to stop Ray's breathing. "Ray Ray, it's Sammy." His words sounded like they were catching on something. "Give me a call as soon as you can." He sniffed in a long, wavering breath. "It's Dad, Ray Ray. Dad's dead."

Chapter III

Stoop shouldered, Sammy stood before their father's open grave. His baggy, bloodshot eyes made him look tired, and his belly nearly untucked his white shirt from his pants. His sports coat belonged on a Salvation Army rack. Ray remembered it as the same coat Sammy had worn to their mother's funeral ten years ago. Breast cancer.

Sammy had told the priest that he wanted to say a few words. Only a handful of people had come, but Sammy immediately beaded with sweat when he stood up and faced them. He dragged his mammoth palm across his forehead, looked at it, and smiled absently. Stammering at first, he started a sentiment about his father being a great man, and then stopped and stared out at the small gathering. Ray guessed that Sammy hadn't given any thought to what he might say. Such a train wreck, Ray thought.

Hands deep in his pockets, Sammy leaned from foot to foot. "I don't...I wanted to say something...something nice. Somebody should say something nice, but not me. I'm not very..." He searched the faces and soon locked his moist eyes on Ray.

No, Ray thought. An uncomfortable warmth tingled just under his skin.

"Ray Ray, you should do this." Sammy pointed, smiling. "You're the professor. You should say something about Dad."

Ray felt everyone suddenly studying him. He took a deep breath, nodded once and rose. Sammy stepped forward, hugged Ray, and then collapsed into the seat Ray had just emptied. Ray's shoulder was wet with his brother's tears. He stopped near the casket and set his hand on it. Bronze. His father had gotten a deal on a pre-pay package. "One of us is going to go out of this world in style," he'd said, after burying his wife in a cheap steel casket.

Ray didn't know what to say about his father, at least not anything good. He and the man had been so different. And, he hadn't seen his father in years. He walked over to the spot where his brother had stood and looked into the fresh hole. Gathered in their folding chairs, the attendants had the detached look of people in Hopper paintings. He looked at Sammy and into his teary eyes. Sammy snorted in a breath of air and nodded encouragement at Ray.

Ray had driven down to Ohio the day before. He'd given himself time to take the Lodge Freeway so he could stop by the Detroit Institute of Arts for a few hours, mainly to see the Diego Rivera murals. It was a route he knew well. In the past, he'd made a point of taking his students down for field trips. Just past Oak Park, Detroit's skyline began to make an appearance on the horizon. He looked around, hoping that the city had started some kind of recovery since his last visit. It was always so depressing. Burned-out houses, smashed windows, graffiti—an entire city slowly rusting away. The tallest buildings loomed with abandonment.

When the exit for the arts institute had finally come up, he drove past it. The city and its lingering death had sucked his enthusiasm away. He didn't want to see Rivera's murals. They were archaic given what the city had become. *Detroit Industry.* Where? Or maybe he was just jealous of Rivera. The man had known the messages he wanted his art to express. He'd never faltered. Ray wasn't up to being face to face with what that meant.

Instead, he drove, and his thoughts turned to Diane. He missed her and ached with the missing. Why couldn't she have just stayed? He had to fight the impulse to call her and tell her about his father. It would be plotting for a sympathy visit. No, he wasn't that pathetic. Not yet.

His thoughts then stayed with his father. Doubting his eighteen-year-old son's chances as an artist, the old man had helped him get a position in a Cincinnati tire manufacturing company. "Paint at night if that's what ya gotta do, but you're going to earn money," his father said. By the third day, Ray knew that the hot work wasn't for him. He told the foreman, "I'm through here."

That night his father gave him a stinging backhand across the face. "You fucking think jobs grow on trees?" he shouted. It was the only time his father had struck him. It was enough. Ray moved out, found work as a cook, and eventually saved enough to take some college classes. Student loans followed—loans he was only able to finally pay off within the last five years.

Before Ray left for Europe that first time, his father called him. "So, you made something out of yourself, eh? I'm happy for you. You just gotta understand the way I saw it. You were looking like you had your head up your ass. That was a good job you quit. I had to pull strings to get you in there."

Ray told himself he forgave the old man, but seldom returned home in the following years. He kept contact through infrequent phone calls. He remembered a message his father had left on his answering machine. "Okay, you're mad at me. Maybe forever. But, it's your mother that's suffering. You're cutting her out, too."

Ray cleared his throat. The people in their seats, none of whom he recognized, watched him expectantly. Their smiles seemed to try to encourage him.

"My father," he began, "was a hard-working man. He believed in work. He tried to instill the idea of hard work into his sons." He pointed at Sammy. "My brother has worked hard all of his life."

A few of the older men raised their eyebrows. They looked at each other.

Ray guessed what they were thinking. They were probably friends of his father's. If they were, they knew something about hard work. They taxed their hands into arthritis, watched baseball, and didn't give a great deal of thought to art or anything else as far as Ray knew. What did they think of Hank's artist son of whom they'd probably heard stories? Hadn't he once done a painting of his own penis? Wasn't that his idea of a self portrait? And hadn't some professor at the University of Cincinnati given him an A on the painting, calling it the most honest piece he'd seen in a long time? "Guy's probably gay," Ray could imagine his father saying.

"That idea of hard work was passed on to me, too," Ray continued. His forehead went warm and moist. "Except I apply

it to my paintings. I work hard on my art." He motioned toward the casket. "I owe the man something for my work ethic."

Ray felt relieved when the old men in front of him nodded. He tried to remember what else people said at funerals. Then it came to him. They told stories...heart-warming stories of the deceased's kindness or idiosyncrasies. Were there any such stories about his father? Sammy could probably tell them. Why the hell wasn't he up here? Ray glanced at his brother. Sweat still dripped down the side of his bloated face. Pale, he looked like he might have his own heart attack soon. His eyes were far away, blurred.

Something came to Ray. It felt right. "Sammy," he said, "do you remember the moon landing?"

Sammy blinked and his eyes came into focus. A smile lifted his face and he nodded.

"My father," Ray said, "wanted us to see the moon landing. He wanted us to see the astronauts. I think he really thought we might be able to. He spent money that he probably didn't have on a telescope." He told them how their father said that they wouldn't be able to see anything from the city. Too many lights. "He drove us north, past Dayton, and then got off the highway and into miles and miles of farm country. Do you remember, Sammy? The horizon looked so far away." Their father told them that that's how it had looked to the settlers. "'Can you imagine,' our dad said. 'that much land? They must have felt like their futures could hold anything.'" He told his boys that theirs was a generous country—a country with space. "He took us to a field and fed us cold hotdogs without buns, and waited for the sky to go black. I can still see that sky, bigger than anything I'd ever seen. It was so dark, and yet I wasn't afraid at all with my father nearby. We took turns looking through the telescope, trying to see Armstrong and Aldrin walking around. The way our father talked, we really believed we might see them." His father was disappointed that they hadn't seen the astronauts. "We stayed so late, he had to call into work the next day," Ray explained.

He wasn't sure why the memory had stayed so strong with him. Was it the first time—maybe the only time—his father had been so giving, so adventurous? He could have just watched on television or listened to the radio like so many others. Sammy

had fallen asleep on the ride back to Cincinnati. What had his father said? "I wish I were up there, Ray Ray. Man, what those bastards are seeing. You get one life, you should try to live it big."

Ray looked out at his audience. They were waiting. He hadn't said anything since he'd told them about his father calling in to work. Even Sammy looked impatient, as though many other better stories to tell had come to him.

"My father wasn't a perfect man," Ray said, trying to finish. "Are any of us? But he gave to his sons when he could, and now he's gone from the world, and we should remember him." After a pause, he spotted an empty seat in the second row and made for it without looking at anybody.

Nobody spoke. Ray stared at his hands, the half moons in his thumbnails. A heat started at the back of his neck. Then there was a sound. A click. He looked up. His brother had lit a cigarette.

The priest stepped forward. He thanked Ray for speaking and sharing such a touching story.

Sammy sobbed openly when the casket sank into the ground. He and Ray were asked to step forward and throw a shovelful of dirt. Afterwards, Sammy nearly collapsed onto Ray and shook with his sadness. Ray could feel that if he let go, his brother would fall.

Chapter IV

An older couple gave a funeral dinner at their small house in Rossford on the south side of Toledo. Following a carload of old men, Ray crossed the Maumee River, reminding him of the Saginaw River cutting through Bay City. At the house, only three or four people had shown up besides Ray and Sammy. The hostess had made food as though she had expected many more. She stood by Ray and watched him eat. She kept telling him that she hoped it tasted good. "I just really want this to be nice for you," she repeated. "You've had quite a loss."

Sammy sat across the room sunken into the couch. The old men sitting around him talked. He hung on their words and nodded. Something dripped out of the end of his ham roll and fell onto his tie. One of the men reached over with knobby fingers and pressed the splotch off with a napkin. Sammy smiled. The men seemed to be fathering him, as the hostess was mothering Ray. "The noodles aren't too hard are they? Are they too chewy?" He assured her that they weren't.

Two hours later, he unlocked the door of his hotel room. He reached in and flipped a switch, and two lamps lit the small space. He could feel his brother behind him, his heavy breaths. The paper bag in Sammy's hand made a sound, and Ray bit his lower lip. Would this be a long night of talking about their father? A long night of his brother drinking himself numb?

Ray set his keys, watch, and wallet on the dresser and then stepped into the bathroom. The taste of beef stroganoff lingered in his mouth. He tried to swallow it away, but finally decided to brush his teeth. Afterwards, he opened the tiny bar of soap and lathered his hands. "Long drive down here," he called out. "I barely had any sleep last night."

He came back into the room. Sammy had pulled a chair over to the partially open window. The smoke from his cigarette crept up through the lamp light and disappeared somewhere in the dimness outside the screen. He'd taken his six-pack from the bag. He held an open bottle between his legs.

"This is non-smoking," Ray said.

Sammy took a drag, leaned his lips close to the screen and exhaled. He pushed on the window, but it didn't move. "You can only open these fucking things about two inches." He'd pulled his shirt out of his pants. He took a gulp of beer. "Dad didn't even look like himself," he said after swallowing.

Sammy. Always predictable, Ray thought. Leave it to him to say the one thing everyone says after a funeral. Ray sat on the bed. He started to kick off his shoes, but then remembered that he would have to drive his brother home. Something landed on the comforter. A beer. "Thanks," he managed.

"Wouldn't open that right away," Sammy said. "When you do though, we'll drink one for Dad."

"One?" Ray asked. He studied his brother sitting half in shadow, half in light.

Sammy lit a cigarette with the cherry of the one he'd been smoking. The small ember flared.

Ray sniffed resolutely. He told himself that he should be there for his brother, mourn his father, but more than anything he wanted to be on the plane to England, the plane that was leaving the next morning.

No, he thought. I'll still be in Toledo helping Sammy settle Dad's affairs. "Who do we see tomorrow, again?" he asked.

Sammy said they needed to go to probate court to file the will. "It wasn't very long. He left me the guns. He left you his paintings."

Ray imagined poorly framed pictures of dogs playing poker. "Is there anything else we have to do?" He swung his legs up onto the bed and rested his back against the headboard. He opened his beer.

"Hold on," Sammy said. He drew out another beer and opened it. "Okay," he said, holding up his bottle. "This is to Dad. Our dad." He blinked.

The brothers brought their bottles to their lips. Ray took a quick sip. He asked again what else they had to do.

Sammy sucked on his cigarette. "We should probably sell the rest of Dad's stuff—clothes, a microwave, I think some furniture."

Ray took another sip. He had imagined meetings with lawyers. "That's it? Do you really need me to stay?"

Mashing his cigarette into the ashtray, Sammy fished out another. "Let's see how tomorrow goes. Maybe I won't need you for much more than tomorrow."

The brothers drank quietly. Sammy opened his third bottle. Ray studied him in the lamp light. It didn't seem possible that they could have come from the same parents.

Sammy cleared his throat. "So, where the fuck you been, Ray Ray?" His voice was louder than it had been.

"What?" Ray looked at him. Sammy looked at his beer bottle. His neck and cheeks were red. "What do you mean?"

He shifted only his eyes so he looked out from under his angry eyebrows. He studied Ray's face for a moment. "I mean, for ten fucking years where you been?"

Ray took a sip of his beer. He sniffed. "Where I've always been, I guess."

Sammy picked up his cigarettes and shook another one to his lips. He looked into the pack and then crushed it in his fist. "And you never once thought about us?" he asked, lighting his cigarette. "You didn't have the time to pick up a phone?"

"I called." Ray tried to adjust to Sammy's sudden mood, but it was like reasoning with a stranger who insists he knows you.

"Bullshit. Maybe you called when Mom was alive, but you haven't called Dad. Or me. You haven't..." He took a drink and banged the bottle down. "Were we that easy to forget, Ray Ray?"

Ray felt the sweat rising to the surface of his forehead. "I didn't forget. I—"

Sammy hunched forward. "What? What did you do? Send Christmas cards? Send us birthday cards—sometimes a month late. Sending 'em to us like an overdue bill."

"Sammy—"

"What was that thing you sent that one time?"

Ray didn't know what Sammy was talking about. What had been a graying dusk was now a full darkness pressed against the window, constricting the room.

Sammy took a drag and talked the smoke out. "I remember. It was a thing in Kalamazoo. You sent us a postcard."

It came to Ray. He'd had a show in Kalamazoo. The gallery manager had sent him fifty postcards to invite friends and family. He didn't know fifty people, but the cards were postage-paid, so he sent them everywhere. One to an old college buddy in Alaska. One to an old professor who had retired to Texas. One to his ex, Marcy, over in St. Paul. And, one to his brother and father in Toledo.

"That show was postponed, I think," Ray offered.

"Do you think?" Sammy scratched his neck. "We found out by driving up there. Two and a half fucking hours."

When the show was postponed, Ray called anyone that he thought was going to go. He didn't call the people that he already guessed wouldn't attend. "You guys came? You guys drove up there?" He couldn't get his mind around the idea of it. "I didn't know."

"How would you know?" Sammy dropped his empty back into its chute. He pulled out a fresh one.

Children ran past the door hollering. An adult called to them to slow down.

"Probably going to the pool," Ray said absently.

Sammy drank his beer and nodded at the same time. He was taking longer drinks. Ray had emptied his bottle. "I'm sorry," he said. "I'm sorry you guys drove all the way to that show. It must have been surreal to get there and find a gallery full of somebody else's work."

Sammy looked at him. His lips were wet. "I don't know shit about surreal, but I know it sucked. Dad was a wreck. He kept acting like it was his fault."

"Why?"

Sammy laughed. "Shit. When it comes to you, as far as Dad was concerned, everything was his fault. You would have called Mom more if he hadn't been such a shitty dad. You would have

come down to visit if he hadn't been such a shitty dad. You would have loved him if he hadn't been such a shitty dad."

Ray swallowed something in his throat. "I loved him."

Sammy's lips made a noise akin to a horse. He tilted his bottle and guzzled the last half. "Don't lie, Ray Ray. We buried the man today. Don't lie today. Love is doing shit, and you haven't done shit in the last ten years." He pulled out the last beer.

Ray wiped the back of his hand across his forehead. How had the conversation arrived here? "You're saying I didn't love him?"

"Maybe you told yourself you did, but you sure as hell didn't show it."

Ray stood up and walked over to the dresser. He looked in the mirror. Everything was coming to him at once, demanding his emotion. "Sammy—"

Sammy pulled a fresh pack of cigarettes from his pocket and tore away the plastic and aluminum foil. "Dad cried," he said.

Turning from the mirror, Ray looked again at his brother. "Dad cried?"

"Over you," Sammy said. He smacked a cigarette up and pulled it out with his teeth. "Not all the time, but when he'd get really drunk, he'd go on about you." He said that their father would say he failed with Ray and that's why Ray didn't love him anymore. "That shit ate him up."

Ray eased himself down onto the bed. "I didn't know. I guess I figured he wanted as much to do with me as I wanted to do with him."

Sammy flicked up a flame. "What else don't you know, Ray Ray?"

Ray looked at his brother's watery eyes. "Sammy?"

"Did you know Dad and I were living together?"

Ray nodded. "He moved in with you about a year after Mom died."

"Yeah." Sammy took a long drag. "I took care of him. Went out to the bar with him. Played cards with him and his buddies."

Ray pushed his wet palms against his thighs. "I should have tried to have been closer. I should—"

"But you probably don't know what happened, do you?" Sammy interrupted. "You probably don't know that the Jeep plant laid me off, that for the last three years Dad's been taking care of me. We've been living off his social security." Sammy lifted his beer. His swallowing pulsed into the room.

Ray scratched his head. "Sammy, how would I—"

"How would you what? Know? You might know by returning a fucking phone call sometime...by hitting play on your god-damn answering machine."

"Sammy."

Sammy stood, finished the rest of his bottle. He wobbled. "You got time for us now, Ray Ray? Because now it really doesn't matter. Dad's dead." Tears streamed down his stubbled cheeks. "Now I got nothing. And you could give a shit less."

"Come on, Sammy. I didn't even...How could I have..."

"Up at your college there...You never once thought about us? About us?"

"I thought about you. I thought about both of you."

Sammy looked at him and exhaled. "Well, I guess you're a fucking saint then." He staggered forward.

"Sammy, don't go," Ray said, getting up. "Where are you going? You shouldn't—"

"I know you think I'm stupid, Ray Ray. But, I'm smart enough to see that you don't want my ass around here. I'm smart enough for that." He took a drag, but his butt was dead. "You just get to bed. You had that long drive yesterday."

"Don't, Sammy. Don't be like that. Just stay. Or at least let me give you a ride somewhere."

"I don't need a fucking ride. I've walked this town. I can walk this town tonight." He opened the door and stepped out. The door slammed shut on its closer.

Ray went over to the bed and sat. He kicked off his shoes and then worked slowly at the rest of his clothes. Once he'd undressed, he turned down the covers and climbed under the cool sheets. His brother's words had been like art—painting a sad picture of a father and a washed-up son scraping by in a lonely apartment. But, Ray had also seen himself in the story, or

how he wasn't in the story. He saw himself as the terrible son, the insensitive sensitive artist.

He pressed his face into a pillow. It was the day of his father's funeral, and Ray Casper finally wept like a man who had really lost something.

Chapter V

In the morning, Ray's phone rang him awake. Sammy wanted a ride to the courthouse. He didn't mention this the night before. "I can pick you up in an hour," Ray said. Sammy yawned and told him that would be fine.

Ray and Sammy drove downtown. People in the probate office considered their father's wealth and advised that they go through a streamlined probate process. They were finished in less than an hour. Afterwards, they went three doors down and filed the will. A few more legal papers needed to be filled out.

"Did Dad really even need a will?"

"The guns," Sammy said.

Ray nodded.

The guns. Their father had owned a collection of guns—one from every war America had fought. Flintlock pistol from the Revolutionary War, a Brown Bess musket from the War of 1812, a Texas ranger's five-shot Colt revolver from the Mexican War, a benchrest sniper rifle from the Civil War, a Model 1896 Krag-Jorgensen Rifle of the Spanish-American War, a Springfield M1904 from World War I, a Tommy Gun from World War II, an M-1 from the Korean War, and an M-16 from the Vietnam War.

Ray couldn't remember how many times he'd been dragged down to the basement to see the guns. His father gushed. His father bragged. Ray never understood what all the fuss was about. He had grown up practicing hiding under his desk at school in case the Soviets decided to push the big button. Next to the nuclear bomb, his father's collection looked like a box of sticks.

"Just get the hell out of here if you can't appreciate the history in this god-damn room," his father would say; he had never fought

in a war. "I'd a blown some gooks on their asses." He'd get drunk. "Too young for Korea, too old for Vietnam," he said, as though he'd really missed out on something good.

"Are you going to sell the guns?" Ray asked, walking out of the courthouse with Sammy. The sun was on everything.

"Hell, no."

Ray guessed as much. They reached the bottom of the stairs. "Is there anything else we have to do?"

Sammy said he needed to call the Social Security Administration. "We just need to notify them of the death."

Ray said that he could probably do that online. "They probably have a form."

Sammy set a cigarette between his lips. It moved when he talked. "I hate computers."

Ray looked at his watch. He looked at his overweight brother lighting a cigarette. His brother—practically a stranger to him. "You want to get some lunch? My treat?"

Sammy exhaled, like a tire losing air. "Where?"

"It's your town. What's a local flavor?"

Sammy started down the sidewalk. "Come on," he said. "There's a Big Boy about three blocks over."

Big Boy, Ray thought, shaking his head, smiling. He followed his brother.

They looked at their menus. The smell of fried foods was heavy in the air. The waitress told them about the specials. They listened, and then they looked at their menus again. Ray delayed ordering, but finally did when the waitress came back the third time. She took the menus away, leaving the two of them hopelessly exposed. Sammy sat across from him, and the only thing left for them was talking, and the only thing left to talk about was the night before. Ray flipped through the pie menu. He studied it, and read each description carefully, as though he were taking a final exam the next day.

"You like pie?" Sammy asked. He lit a cigarette and exhaled into the air above their table.

Ray watched the smoke hovering over them. He wrinkled his nose. "Not really. I guess I'm not a dessert person."

Sammy nodded. "No shit. Give me Cheetos over cake anytime."

A craving for salt. At least they shared something in common. Ray perked up at the sight of the waitress emerging from the kitchen with a tray, but sighed when she stopped at a different table.

"Dad loved sweets," Sammy said, drumming his fingernails against the table. "Always had those Brachs caramels around. Those fucking things can pull out fillings."

Ray looked at the big, still unfamiliar face. "Look, Sammy. Last night. What you said about—"

"I was drunk. Forget it."

"Drunk or not—"

"Ray Ray, really. I don't know shit when I've been drinking. Shit, I don't know shit when I haven't been drinking. Just forget it."

The waitress stopped at their table. She set Ray's salad in front of him. Sammy had ordered a club sandwich with fries and a chocolate shake.

"Is that really all you ordered?" he asked, just before closing his mouth around his first bite.

Ray shrugged.

"At least have a few of my fries," Sammy managed in between chewing.

"I'm fine."

They worked their food. Sammy took a bite of sandwich, pushed in a few fries, and then poured in some shake. He swallowed and then took a final drag on his cigarette. Ray flicked the pieces of bacon to the side of his plate. A moment later, Sammy reached across the table, scooped up the bacon, and put it in his mouth.

Ray stared at where the hand had just been. He cleared his throat. "Not enough bacon on your club?"

"Never enough bacon." Sammy chewed, smiling.

Ray smiled. He couldn't get mad at his brother for his indelicacies. His brother was his brother. "If I dig out more, I'll save them for you."

Sammy nodded. "Thanks."

Ray's mind went to Diane. Where was she now? Would there be a message waiting for him on his machine? He burned with missing her and stopped chewing.

"I don't think I'm going to sell Dad's stuff," Sammy said.

"What are you going to do with it? Keep it?"

Sammy shook his head. "I'll call Dad's friends. They can come over tonight and take what they want. Most of 'em don't have two nickels to rub together. They might as well have first dibs."

Ray smiled. As far as he knew, Sammy didn't have the two proverbial nickels. His brother's generous thoughts brought Ray back to ideas he'd entertained during the long night in the hotel. "What are you going to do now?" he asked.

Sammy stopped the last of his sandwich just before his mouth. "Now?"

"Now...you know. Now that Dad's gone."

Sammy's froze. "I still can't fucking believe it." He sniffed. "It's so weird to hear someone say it."

"So," Ray started again. "What is your plan? Are you going to stay in Toledo?"

Sammy smoked. "Good a place as any."

Ray twitched his hand and the ice in his glass did a few laps around the bottom. "Stay here and do what?"

"Have to do something. I was waiting for something good — guess I'll take anything now." He set his cigarette in the ashtray. Its smoke slithered upwards.

Ray scratched his cheek. "What reason did you...I mean, what's holding you here? I mean, now that...What's holding you here?"

Sammy picked up his cigarette and studied the glowing cherry. "Nothing, I guess. What's holding me here is that I ain't got any place else to be."

Ray cleared his throat. "So then, there wouldn't really be much stopping you from coming back to Michigan and staying with me for awhile." Who was saying this? Was it really him?

Sammy sat for a moment looking across the table. He nibbled his lower lip. "No, there wouldn't be much stopping me, I guess."

"So why don't you, then?" Ray sucked in a deep breath.

"Why would you want me to?"

Ray exhaled. Words came to him. "Because I have a brother. I have a brother that I don't really even know anymore. I think we should know each other again."

Sammy looked at him. Smiling, he mashed out his cigarette. "Don't feel sorry for me, Ray Ray. Everything I said...I was drunk."

"It's not pity." Ray shook his head. "It's not. I want you to come back to Bay City with me. I'm not talking about growing old together. I'm just saying that you can use my house, find work up there. We can get to...you know, be brothers again."

Sammy drank from his milkshake and then licked its residue out of his mustache. He lit another cigarette. "We ain't exactly birds of a feather, Ray Ray."

Ray shrugged. "But we're brothers."

"I don't know for sure," Sammy said, smiling. "I saw the way mom used to look at the mailman. I think that guy liked art, too."

Ray laughed. It might be good to have his brother's easeful ways around the house—something to help him forget Diane's absence. As boys they had laughed all the time together.

Sammy took a long guzzle from his milkshake. He rapped the thick glass against the table. "Okay," he said. "Why the hell not? Let's go to Michigan."

Ray swallowed. "Okay, then."

That evening old men rooted around the shoebox apartment that Ray's father and Sammy had shared. Ray couldn't believe the size, or the smell. He wondered if they'd used ashtrays or just ground out their butts right into the shag carpet. A kitchen and dining area were crowded into an eight by eight space. The living room was only slightly bigger, with a doorway that lead into a bedroom and one that led into a bathroom. "Where do you sleep?" Ray asked.

"On the couch."

The old men came over around five o'clock. They started piles. They took clothing, tools they found in drawers, bedding—whatever they could find. One man who had claimed the microwave stopped collecting other things and instead stayed where he could keep the appliance in sight. He shuffled over and sat next to Ray on the couch. He had thick waves of gray hair.

"Your dad was proud of you," he said.

Ray smiled.

"Big famous painter."

"That's a bit of an exaggeration." The old man smelled of Aqua Velva. Ray wondered if they still made it.

"What's your brother doing?" He picked up an ashtray from the coffee table, examined it, and set it back down.

Ray told him that Sammy was packing some things.

The old man cleared something from his throat. He spit it into a handkerchief. "He told me you're taking him up to Michigan with you. To live with you."

Ray nodded. "For awhile, anyway."

The old man whistled.

"What?"

"Your brother is a real handful."

Ray wanted to ask what he meant, but Sammy stomped out of the bedroom. "I think the guns will fit right in your hatch, Ray Ray."

Ray had a Saab station wagon, back space handy for hauling paintings around.

The old man stood. "Sammy," he said, "help me get this microwave down to my car. It's all I want."

"Sure thing." Sammy opened the door, picked up the microwave, and started down the stairs. The pounding of his descent echoed in the apartment.

The old man turned to Ray after a moment. He pointed. "You tell him you changed your mind."

Something turned in Ray's stomach. "You're talking about the man that just gave you a microwave." He tried a smile. "Even carried it to your car for you."

The old man didn't return the smile. "I'm talking about the man that broke your father's heart. Broke his spirit."

Ray's jaw went slack. "What—"

Sammy huffed back into the room. His shirt was dappled with sweat. He slapped the old man's shoulder. "You're all set, Smitty. I put it on your passenger seat."

"Good," Smitty said. "Thanks, Sammy." He walked, but then stopped in the doorway. "You don't give your brother too much trouble now, okay?"

Sammy reddened. "Oh Christ, Smitty."

Smitty smiled. He looked at Ray. "Okay, then. I'm leaving. Thanks for the microwave." He disappeared down the stairs.

The other old men slowly left with armloads. There wasn't much left once they were gone. Ray sat on the couch, motionless. What had he done? He had asked his brother—an ox of a stranger —to come live in his house. He'd lose his privacy. He'd lose his space.

Sammy came out of the bedroom again. "Ray Ray, come look at this."

Ray forced himself to standing and followed. Sammy crouched on the floor next to a lockbox. "Check this out. Balls and black powder for that flintlock. Dad always wanted to see if it could still shoot." His eyes went fuzzy. "He'll never get a chance, now." He showed Ray how to load the pistol. "There's really nothing to it. I don't know, though, maybe it was a helluva lot tougher on a battlefield."

Something on the bed pulled Ray's attention. Frames. Paintings. "What's—"

Sammy stood up and waved his hand over the bed. "Those are the paintings Dad wanted you to have."

Ray stared. He must have sent them to his father. Maybe to his mother? He'd probably told them to hold onto them for him. Then he'd forgotten them. They were nudes of Jolien Poiret, some of the last of his representational works. "I...I mean...Those are paintings I did," he said to himself as much as to Sammy. He studied them, remembering how that body had felt under his young hands.

He could see, too, what he'd done in oils with the flesh and her face. He had captured her exactly as she had been—not just physically, but in essence. In her expression, he could see and remembered the aging woman, resigning herself to the role of sexual mentor. She was an experiment, a rite of passage. In her eyes, one could see that she wasn't fooling herself into believing that she would ever keep the young lover. And, yet, Ray was at least something for her. Someone wanted to touch her and be touched. It was momentary, but wasn't life momentary? Wasn't it easiest to seek simple pleasure over pain, appetite over apathy?

She was forty-seven when he'd painted her—close to seventy now. If she was even still alive.

Ray took in the paintings. He blinked. He had actually been that good at one time. Is that what his instructors had seen in him? And then what had happened? All that dripping. All that abstraction. All that experimentation—trying to find a way that painting hadn't been done before. It gave him sudden minor successes. And then it undid him.

Sammy came over and put his arm around him. "You painted those?" He shook his head admiringly. "Man."

Sammy could see it too—in his own way an innate art critic. The skill couldn't be denied. Ray studied the brush strokes, his awareness of light and shadow and what they could do to a face, a body. She looked so lonely. He blinked at the moisture gathering in his eyes. He was finally sad that weekend for something that had died.

"Those are really something," Sammy said. "You can really paint tits."

Chapter VI

Two days later, after they'd finished up the details that followed their father's death, Ray and Sammy drove north on I-75 toward Michigan. The gray sky lingered above them and spread out over Lake Erie like something a smoker had exhaled.

Ray glanced at his brother, who sat staring out the passenger side window. He had talked excitedly about the good times they were going to have together, but had grown sullen after they'd crossed the border into Michigan.

"You all right?"

"That's a state game area over there," Sammy said, pointing toward a swampy bay. "Dad used to hunt ducks in there about five years ago."

Ray nodded, trying to ignore the cigarette odor wafting from Sammy's clothes.

"I'll be all right," Sammy said. "I'm just remembering."

"I understand."

The interstate worked its way along the lake. Ray read the signs. Luna Pier. Allens Cove. Toledo Beach. North Shores. Avalon Beach. Bolles Harbor. Diane used to read the signs aloud. It once bothered him, but now he missed it.

Sammy snored lightly, his head bumping against the window. When their tires hummed on the bridge over the Raisin River in Monroe, he woke up. "Sorry," he said. "I was up late last night."

Ray had just turned on the radio. A public station out of Detroit introduced Stravinsky's "The Rite of Spring." A warm tingle ran along his spine. Jolien Poiret had first played it for him, and before it was over they made love while it ebbed and flowed discordantly against their natural rhythm. "Stravinsky was a true artist," Jolien said. "A revolutionary."

What a revolutionary time it had been in art. Facts from Ray's art history training came back to him. 1913. The Armory show opened in New York featuring work by Kandinsky, Rodin, and Duchamp. People were appalled. In Russia, Vladimir Tatlin founded the Russian Constructivist Movement. The fool thief Vincenzo Peruggia tried to sell *The Mona Lisa* to an art dealer in Florence. The world was changing, and people seemed ridiculously afraid. The audience at the premiere of "The Rite of Spring" was so loud in their distaste that the music couldn't be heard. Some said that the whole affair had led to suicides.

"You got dead air," Sammy said.

Ray shushed him. "Just listen."

The bassoon solo grew into its haunting of the car. Ray looked over and saw Sammy almost sleeping again. He turned his attention back to the highway and listened to the masterpiece waking up in his speakers. He was overwhelmingly happy, but could give his happiness no reason other than the sounds intensifying around him.

Sammy stirred. "How the hell is anyone supposed to sleep through this?"

"You're not."

Sammy rolled down the window and lit a cigarette. Losing volume to the air rushing past, Ray turned the music up even louder.

"You like this stuff, huh?"

"Shh."

"Jesus Christ, it makes me all tense."

"Please, Sammy."

"Alright. Alright."

The music crashed into the car, symbolic of spring storms. They drove into Southgate on the outskirts of Detroit. The cacophony of instruments was eerily fitting for the exit signs flashing into view. Wyandotte. Ecorse. River Rouge. Ugly names of the places that Ray heard people refer to disparagingly as Down River.

The music stopped abruptly.

"What a shit hole," Sammy said, looking out his window. "It's like Toledo on steroids."

Ray shushed him as the music, like the backdrop of a dream, came through the speakers again.

"Sorry. Shit. I thought it was over." He lit another cigarette.

They rolled on through the ruin of city. Construction detoured them onto Woodward for a time. The downtown, with its sky-bound buildings, made a half-hearted attempt to imitate a living city, but the street-level sites suggested otherwise. Miles of closed stores. Trash. Poverty. Blank-eyed people staggering about in rhythm to the melancholy ballet. Detroit. The resin of what had been a smoke-belching auto industry. Around Highland Park, Ray turned back toward I-75.

"Depressing, isn't it?" he said.

Sammy shrugged. "This music is depressing. It makes me feel like crying, but I keep waiting for someone to jump me, too."

They drove on. After another cigarette, Sammy dozed again. Ray listened to the ballet until its end, which was around Royal Oak. He turned the radio off. The rubble of Michigan went past the car. Pontiac. Flint. Saginaw. Little brothers of Detroit, abusive like their older sibling, but each with its own special brand of meanness.

Ray woke Sammy up just outside of Bay City. "You didn't get much sleep last night, did you?"

Sammy yawned and shook his head.

They took the first exit toward the city. Off in the distance, the twin stacks of Big Chief, like towers, rose above the trees. "That's where they refine sugar," Ray said, pointing. "You might even be able to find work there."

Sammy nodded.

They crossed a bridge over the Saginaw River.

"What's that place?" Sammy asked.

Ray looked at the long stretch of building—more glass than anything else. "I don't know."

"It's huge."

Ray shrugged.

"They hiring?"

"No. That place has been closed for a long time."

"Then they should tear the fucker down."

Ray didn't look at the hotel where he knew *Riverscape* was hanging. Someone really needed to tear that down, too.

Minutes later, he pulled into his driveway.

"God-damn Rockefeller," Sammy said.

"Hardly."

They carried Sammy's few belongings into the house, up the stairs, and into the guestroom. The hardwood floors creaked under their labor. Ray wasn't excited about seeing so many guns come into his house. He carried the nudes of Jolien down to his studio.

Going back to the guestroom, he found Sammy sleeping face down on top of the covers. There was something grotesque about the way his big body seemed to smother the Victorian bed. Ray had seen his father the same way many times after he'd come home from a ten-hour shift. The man just seemed to die into sleep. Ray closed the door, wondering how long his brother would be his guest, and then reminding himself that the whole thing was his idea.

There were no messages on the answering machine. Nothing interesting in the mail. Ray made a turkey sandwich, which he planned to take down to the studio. Stravinsky was still in his head. His own inspired paintings of Jolien Poiret were leaning in view of his easel. He had to try to paint.

When a half hour had passed and he still stood, brush in hand, in front of an empty canvas, he walked away. The painting of a tractor he'd started after *Riverscape* was on another easel. He'd already titled it. *Landscape with Tractor and Sugar Beets.* Pitiful. He dipped his brush in red paint and slashed up the tractor and its field. Taking a utility blade, he cut the canvas from its frame and folded it into the garbage.

He picked up his sandwich, took bites, and studied the art of the young man he had once been. The mustard was strong in his mouth. The earthy smell of Jolien's body was strong in his memory. He sat on the studio couch. What happened to me? he thought. He lay down.

Ray opened his eyes. Someone was walking on the floor above. His first groggy thoughts went to Diane. Then, he remembered Sammy. His heart settled into its regular rhythm. His brother. In his house. Maybe this was all a mistake. It would be a mistake if

he let him stay too long. The joists groaned under Sammy's heavy footfalls.

The last time Ray had fallen asleep on the couch in the studio, he'd been working. He'd painted himself into a blissful exhaustion. When he was married to her, Marcy used to say he slept more in the studio than he did with her. He'd been working on an abstract piece. An action painting. The ceiling above him was still splattered with paint from the process. He had nailed canvases to the ceiling and flung paint upwards. Its dripping to dry had a nice effect. One of the finished pieces from that experiment hung in the university's faculty display. He'd titled it *Pollock's Kinked Neck.*

Anymore, he walked by it every day, and it meant nothing to him. It was imitation—an illusion of originality. It was a trick. Most of his talent was an illusion, he decided. But, like some academic magician, he'd landed a job with it. He had a beautiful house, decent money, a nice car, summers off.

Stick with what works, they say. He stood and stretched his stiff back, knowing that an artist couldn't afford to think that way.

Something slammed against the floor above him. It sounded as though Sammy had somehow managed to knock the microwave on the floor. Heart racing, Ray ran up the flight of stairs and into the kitchen. Stooped over, ass crack peeking out of his pants, Sammy retrieved a huge box of beer from the floor and set it back on the counter. Ray read the side of the box. Thirty-six pack.

Sammy smiled. "Wouldn't open one of those for awhile."

"You went out?"

Sammy looked at him. "Ain't I allowed to?"

"No. I mean, sure. It's just that..." Ray looked around. "Did you take the car?"

"No. You got a party store right around the corner."

Ray could hear the defensiveness in his brother's voice. "No. Sure. The party store. I'm just saying...you could if you wanted. You know, take the car." He pointed at the wall. "The keys are always on that hook."

Sammy looked at the keys and nodded. Then he ripped his big hands through the cardboard and pulled out a beer. He tapped

his fingernail against the pull tab, sounding a tinny pulse. He looked around the kitchen. "This is a nice place, Ray Ray."

Ray started to deny it, but then stopped. His kitchen was almost as big as the entire apartment Sammy had shared with their father. He thanked him. "I do love it," he said.

Sammy opened his beer gingerly and it hissed, but did not explode. He glanced around the kitchen again.

"You hungry?" Ray asked.

Sammy nodded, scratching his belly. "I could eat. Why don't we order pizza?"

A different idea struck Ray, sent a little jolt of something through him. "No, I'll make you something. I'll make us both something."

Sammy took a long drink. "Make something?"

"Sure. Yeah." Ray knelt down, opened a cupboard, and took out a frying pan. He had chicken breasts in the freezer.

"Don't knock yourself out for me." Sammy took another drink.

Ray looked at him, thought for a moment, and then put the frying pan back.

"Change your mind? Pizza sounding better?"

Ray stood up, holding a baking sheet. "Nope," he said, "just changed the entrée. You like Chick Dijon?"

Sammy shrugged. "Like just about any food." He set his beer can on the table and it rang its emptiness. He pulled out another. "Like I said, don't feel you gotta do this for me."

Ray started thawing the chicken breasts in the microwave. "Actually," he said, "I want to." He drew aluminum foil from a drawer and pulled two feet from the roll. "You know," he said, tearing the sheet along the serrated edge, "I think I could have been a chef. I mean, if I wasn't an artist, I think I could have liked culinary school." He nodded. "Cooking really is an art." He spread the aluminum foil over the baking sheet.

Sammy sipped his beer. "I tried short order cooking. It sucked."

Ray pulled a brush from the utensil drawer. "I guess I don't mean short order. I mean a chef." He opened the olive oil, poured

a puddle on the aluminum foil, and then painted it even. The foil shimmered.

"You mean with the funny pants and the hat?"

Ray looked at his brother. He smiled and nodded.

Sammy didn't say more. He worked on his beer.

Ray poured himself a glass of chardonnay. Stirring Dijon mustard and mayonnaise into a small mixing bowl, it dawned on him why he felt so good. All of this reminded him of cooking for Diane. She often said it was one of the things that she loved about him. "You can really cook, Ray. Lots of guys try, but you really do it." Smiling, he spooned the yellowish mix over the chicken breasts. Dijon Chicken. Simple. But, it was one of her favorites. She couldn't cook anything. He wondered when he would see her again. If.

"You still here?"

Ray looked up. "What? Sorry. Just thinking."

Sammy said he was going to go out onto the porch for a cigarette. Ray was glad that smoking in the house wasn't going to be an issue; his brother had at least that much sense. He opened the oven, and the heat rushed out over his hands.

Diane could be with someone else already, he thought. It'd been a month. Maybe she'd met someone more her age with her same passion. Or, maybe she didn't need anybody. She certainly didn't need him.

Ray searched out the white wine vinegar, the mustard seed, the black pepper. Sammy came back into the kitchen. The smell of smoke followed him in.

Ray turned on the small television on the counter, sipped wine, and watched the local news with his brother. Sammy cracked a new beer. After Ray took the chicken from the oven, they continued to watch television while they ate. He planned to put some of the meal away as leftovers, but Sammy ate four breasts, leaving nothing.

They took drinks outside where Sammy could smoke freely. Ray and Diane had seldom used the porch, preferring the seclusion of the backyard's deck. In the fall, though, on Friday nights, when the high school had football games, they'd sit on the porch swing, drink wine, and listen to the sounds of the game. The distant

announcer's voice echoed around them. "Jankowski for seventeen yards." Although neither really liked sports, Diane enjoyed the jubilant sounds of the crowd—the people who worked and lived around them, who otherwise felt like strangers. They cheered for those young boys as though what they were doing really mattered. "I'd like to paint that sound," Diane once said. Ray liked it when she talked that way.

Sammy lit a cigarette. Ray rocked on the porch swing and studied his brother sitting on the top step. His t-shirt had rode up on the side and exposed the pale skin of his belly. He looked at his beer can, took a drink, and then looked at the can again.

Ray cleared his throat. "So what do you think your plan is?"

Sammy looked out toward the street. He grinned and smoked leaked from between his teeth. "Getting nervous?"

"What?"

Sammy looked back at him and then looked toward the street again. "You already wondering how long it's going to take your bum brother to find a job and get out?"

"Sammy," Ray started. "Am I...I'm not making you feel that way, am I?"

Sammy knocked back his beer, emptied it, and then rolled the can across the porch toward Ray's feet. He laughed. "No, Ray Ray. You're fine."

"Because I was just—"

"I'll start putting in some applications tomorrow."

"You don't have to start tomorrow. I was just asking." Ray picked up the empty beer can and set it by the door, uneasy with the awkward twist in the conversation.

"I know you were. Just forget what I said." Crack. Another beer. "I'm going to go through the want ads tomorrow. See what's out there."

Ray told Sammy about some of the different plants and factories in the area. "I'm sure there are others, too."

"Good," Sammy said.

"I mean, of course, whenever you're ready."

Sammy said he'd be ready the next day. Working on his beer, he stared out at the street. He looked around at the houses and then flicked his butt to the sidewalk. "You got a good life here,

Ray Ray. Dad and I used to talk about what your life must be like. It looks like you got it pretty good."

"Yeah, I guess I've done all right."

Sammy turned. "Do you ever hear anything from Marcy?" He lit another cigarette.

The name meant little to him—his ex-wife from some other life. Maybe he would eventually feel the same about Diane.

"She remarried. Has kids like she always wanted. I don't really know much. We don't really talk." He couldn't really understand why they'd ever married. Their love had started as summer, felt like it would stay there, but marriage had somehow fast forwarded them into a long winter. He was in grad school, an assistant in a drawing course. She was an undergrad and a student in the class. They went out and had a good time. Lots of good times. She wasn't much of an artist, not the capital A artist that Ray imagined himself trying to become. But, she had conventional talent, and she wanted to teach art to elementary school kids. The sex was good. He thought he loved her. Marriage seemed like the next thing. Then the job at Dow came. The next thing, at least for Marcy, was kids. Ray didn't want kids getting in the way of his work. One time, she had said she didn't want kids—happy to teach other peoples' children. Then, seemingly on a whim, she wanted her own. Period. They fought about it until it was clear that neither would win the fight. Making payments, he slowly bought her out of her share of the house.

"I hardly remember her," Sammy said.

The wedding. It was the last time the family had really been together, except when their mother was sick. Sammy was working then and thinner. Drove a GTO. He'd come with a good-looking woman, a bottle blonde. After the dinner, he'd slurred his way through a toast. Ray took the microphone from him when Sammy tried to croon his way through "When a Man Loves a Woman."

"Barely remember her myself," Ray said. He excused himself to go inside and refill his glass.

"This is a nice life you have," Sammy said, raising his can to Ray's return. "Nice god-damn life."

Ray nodded. "It is." He sat on the porch swing. "But then, nothing's perfect."

Sammy stood, wobbled a moment, and then walked over to Ray. He lowered himself onto the swing. Ray glanced at the chains and the hooks in the ceiling. They creaked, but held.

Sammy took a guzzle. "So what's not perfect about it? Too many dandelions?"

Ray said it wasn't anything they had to get into. "It's just that I don't think anybody is perfectly content, no matter what it seems. Richard Cory and all that."

"Who the hell's Richard Cory?"

"It's a poem. Never mind. It's just that I don't know that anybody has a perfect life. We all have things we want to change."

Sammy nodded. "Too fucking true."

Pushing their feet against the porch floor, they rocked. They found a rhythm. Sammy lit up again.

"But, then, what bothers you about your life, Ray Ray? What's your big beef?"

"My beef?" Ray sipped his wine. "It's not something everyone can understand, I guess. Most people aren't after what I'm after, so I can't really explain it."

Sammy swallowed a belch. "Try me. What are you after?"

"It's hard...it's. I can't explain it, really. It's just with my art. An artist needs to be after something. An artist changes the world, changes perception—at least the great ones do."

"I don't understand."

"I didn't think you would."

He set his empty down on the porch. "I said I didn't understand." His brows furrowed. "I didn't say I didn't care. Why don't you try to explain it to me? Go slow, I'll try to follow."

"Don't be like that."

"I'm just saying—"

"Okay. Okay. I hear you. I'll tell you what I think I mean." He finished his wine and set the glass on the porch railing. "I can paint," he said.

Sammy nodded. "You're fucking good."

"Yeah, I've got technique down solid. But, so do a lot of my students. It doesn't make someone an artist."

Sammy scratched his cheek. "You're not a good artist if you can paint shit good?"

Ray shook his head. "No."

"Then what the hell makes someone good?"

"Vision."

Sammy didn't say anything for a moment. "Guess it would be hard to paint if you couldn't see."

"I'm not talking about sight. I'm talking about—"

"Ray Ray, relax. I was kidding. I'm not as stupid as you think."

"Sorry."

Sammy looked up into the ceiling of the porch. "So what do you mean by vision?"

A thought came to Ray. "Hold on," he said. He jogged into his den and slid a book from the shelf. He soon sat with his brother again and flipped through the pages. He stopped when he found Renoir's *Luncheon of the Boating Party.*

"Now look at this. This is art. This has vision."

Sammy studied the painting for a moment. Then he got up, said he'd be right back, and soon returned with a beer in his hand and two others pinched between his arm and his ribs. He set the extra beers under the porch swing. Lighting another cigarette, he looked at the painting. "It looks like a bunch of assholes having lunch." He exhaled. "I mean, it's good. I sure as hell couldn't do it."

"But it's more than just good," Ray said. "Anyone with technique can paint people, maybe even capture the light accurately." He felt stirred, like he once had in the classroom.

Ray started pointing his finger around the picture. "Look," he said, pointing at a man with a mustache whose face was barely in the center of the painting. "He's looking at her, but she's looking at the guy across the table, and he's looking at her, but she's looking at him." His finger skated around. "But this guy, he's looking down at her, and she's looking at him, but he's looking across the table at her. And her, she's more interested in her dog." Ray's heart pounded under his words. "I mean, Renoir captured something with this painting. He captured an aspect of life."

Sammy looked at the painting again. "What aspect?"

Ray smiled. "Isn't that how it is? Everyone is interested in someone else. You love someone, but they love someone else who loves someone else. And maybe you don't even know it, but

someone loves you. Or at least lusts after you. I don't know, he just captures a part of the human condition. His painting shows us something—shows us something so obvious, and yet we're amazed by his expression of it. And then, too, he's just plain good, like you say. Technique and vision." He tapped his finger on the arm of the swing. "An artist has to have both. It would lose something if it were just a bunch of people having lunch."

Sammy looked at the painting for a long time. He seemed woozy. "I don't know. I guess."

"And," Ray said, standing up. "That's been my problem. I haven't had vision in a long time. I had gimmick for awhile, which pretended to be vision, and that got me here. But, I'm really starting to feel that's not enough. That's why I've been depressed. Detached. My art is vapid." He was saying it as much to himself as to Sammy.

Sammy drank his beer. He finished it. He reached down, opened another, and looked out at the street. "No offense, Ray Ray," he said, his voice loud again as it had been in the hotel room, "but, boo fucking hoo."

Chapter VII

Ray picked up his empty wine glass. His hand strangled the stem. He shouldn't have bothered. Did he think he was going to make his brother understand? Sammy? The man was simply a younger version of their father.

Ray swallowed. "That doesn't strike me as fair, Sammy."

"Fair. You want—"

"You wanted me to tell you, and I told you. Now I wish I hadn't. Maybe it doesn't mean anything to you, but—"

"It doesn't mean anything to anyone, Ray Ray."

"It means something to me."

Sammy took a long drink. "Most people I know have real problems. I got real problems. Sounds to me like you're just dreaming shit up to worry about."

Ray wondered if the neighbors, with their windows open, could hear his brother. This was probably a pattern with Sammy. Drink some beer. Become an asshole. "Just keep it down. You asked me what my beef was. I told you." Ray looked out toward the street. "I have other problems, too—real problems."

"Like what?"

Ray looked back at him. "Why do you even want to know?"

"You're my brother." Sammy finished his beer. "Shit man, we're bonding." He set the empty can down, and Ray followed the motion of his hand.

"I'll tell you, but then no more beers for awhile."

Sammy stopped his hand over a fresh one. "What?"

"I don't know how many you've had, but you're getting loud, and I don't even think you're listening to me."

Sammy sat up. "All right. Fine," he said. He shook a cigarette from his pack, put it between his lips, and smiled. "Can I smoke?"

Ray walked over by one of the porch columns near the stairs. He leaned against it. A car drove by, muffler coughing. In the picture window across the street, the tops of two gray heads peaked up over two recliners. The old couple watching television together—as usual. They worked in the yard together. They went for walks together. They would always be together. Diane called them Norman and Ethel.

He hadn't talked about Diane with anyone—hadn't heard himself say what he'd been thinking. Saying it would make it real. He looked at Sammy. His brother blinked at his soupy eyeballs as though he were trying to keep them from popping out of his head.

"I think I lost something good," Ray said. "Someone good."

"Marcy?"

"I already told you I have no contact with her."

"That doesn't mean—"

"It's not Marcy, okay? Are you even going to listen?"

Sammy looked at the porch floor.

Ray told him how he'd met Diane, about the life they'd made together, and how she'd just recently left him. He told him that she'd left before, but this time looked like it was for good. "I don't think I'll meet someone like her again—not at my age."

Sammy started to bend for a beer, caught himself, and then sat back. His face had changed, seemed more in tune with the conversation. "Why did she say she was leaving?"

Ray told him.

Sammy shook his head. "She left over a fucking painting?"

Ray shrugged. "I suppose it was me, too. I wasn't supporting her art. I guess I'd changed—wasn't the man I was at first."

Sammy flicked his cigarette. The butt missed the sidewalk and smoldered in the lawn. Stopping the swing, he reached under it for his beer. He held his finger over the pull tab and looked at Ray. "I listened," he said, smiling sheepishly.

"Yeah, you listened."

Sammy cracked the beer, took a long drink and made a satisfied noise. He turned the can in his hand, studying it. "You know what? She doesn't sound like much of a loss to me."

"Why did I even bother—"

"And you artists...you sure fucking worry about some fucked-up shit." He took another drink. "How do you...I mean, what is that shit, anyway?"

He was loud again, slurring. Ray asked him to please stop swearing. "Keep it down. Let's just not talk anymore for awhile. Let's just sit out here."

"What the hell kind of—"

"Sammy, please. No more."

Ray sat on the top step and watched the streetlights come slowly aglow. The old woman across the street stood up from her chair. She started to leave, but then turned back and said something to her husband. She smiled at him before leaving the room. After a moment, Ray turned away from them toward a new sound behind him on the porch, a sound he never would have anticipated. Sammy was crying.

"Sammy? What's wrong? I don't—"

Sammy threw his beer can spiraling into the street. "You probably don't even fucking know...I mean, Sarah...you don't even know, do ya?"

Ray looked from the beer can back to his brother. His uneasiness tingled under his skin. "Take it easy, Sammy."

Sammy looked at him. "No, you don't." He shook his head. "How would you fucking know about her? How would you have any idea?" He stood up and pointed at the book. "You were too busy staring at pictures of assholes eating lunch."

Ray looked around. He thought he heard somebody close a window. "Sammy, you have to keep it down."

Sammy swayed from side to side. "You want to know my fucking story?" he whispered, seeming to have trouble keeping his soggy eyes focused on Ray.

"Sammy—"

"No, I can tell you my story. I can tell it real calm, too." He found his pack of cigarettes. Dropping the first one, he watched

it roll off the porch. He managed to get the second one between his lips but didn't light it.

He explained that about six years ago he was doing pretty well right before Jeep laid him off. "I had a nice house—enough rooms even that Dad could come live with me." He tried a drag on the unlit cigarette, looked at it crossly, and then threw it into the grass. "I was only in the job for two years. Then the layoffs came. Last hired, first fired."

Ray rolled the empty wine glass in his palms.

Sammy said he found work in other plants around Toledo. "Same fucking story. 'We're letting some people go. You're the newest.' Boom—out the fucking door. After 'bout four years, I lost everything. The house. My Nova. Sarah." He stopped and looked at Ray.

"Was she the woman you brought to my wedding?"

"Are you talking about Crystal? That slut?"

Ray shrugged.

"Sarah was my fiancé." He said that they had dated for about three years. "She stuck it out with me from job to job—kept telling me that she knew that the next one was the one that was going to stick." He took a drink. "Stick it to me is more like it."

"I don't know what kept her with me. I was boozing every night. Not looking for work. I couldn't give her anything she needed. Not anything." He made as though to sit again. The swing rocked out from behind him and he ended up on the floor. His throat made a watery noise.

"Come on, let's get you up and inside."

"I couldn't do nothing for her," Sammy mumbled, his head lolling. "No money. No house." His eyes came into focus and locked onto Ray's. He pointed. "That's why you leave someone. Not over some god-damn painting."

Ray stooped over and tried to pick him up. "Come on."

"That's why I did it."

Ray got his hands into Sammy's swampy armpits. "Come on."

"Did you hear me, Ray Ray? Did ya? I said, 'That's why I did it.'"

Ray guided him through the door and up the groaning stairs. "You've had too much," he said, resting a minute on the second landing. "Why did you drink so much so fast?"

"What you having me here for, Ray Ray? You shouldn't oughta have me here. I'm no good."

"Quiet now," Ray huffed, reaching the top step. "You just had too much. Just help me walk you." He moved him into the guest bedroom and then released his nearly dead weight crashing onto the bed.

"You shouldn't oughta have me here," Sammy repeated while Ray untied his shoes.

He shushed him. "Just get some sleep and you'll feel better."

Shoes off, Sammy turned his face over into the pillow. His words were muffled.

"What?"

He turned his face to Ray again. It was wet and red and crying without sound.

"Just take it easy. Go to sleep."

Sammy sniffed in a big breath. "I said I tried to kill myself a few years ago," he sobbed.

Ray stared.

Crying, Sammy said it was after Sarah left him—after everything. Their dad had left to go duck hunting. "At that state game area on the way up here," he managed. "Dad took different pills—back pills, pills for blood pressure, pills for anxiety—"

Ray couldn't picture his father as anxious.

"He had all kinds of shit in the bathroom. Old pills even that Mom used to take. And, I swallowed all of them along with half a bottle of wine." Tears streamed down his face. "Dad came home early. He fucking came home early."

"Sammy—"

He turned his face into the pillow again. The tremors of his sorrow shook his massive body.

Ray looked out the window and over the rooftops across the street. It was just starting to get dark. The sky looked like the sky in Monet's *Cathedral of Rouen*. He stared at it until his brother stopped sobbing. It wasn't long before Sammy passed out,

breathing heavily. The smell of beer seemed to wick up to the surface of his skin. Ray studied the drunken wretch.

He looked up again, but the sky outside the window was no longer Monet's. It was just dark. He looked down at his brother. Attempted suicide? The idea of it somehow made Sammy seem deeper, more complex. More human.

Ray went downstairs, poured himself a glass of wine, and took it to the porch. In time, he grew calm, less shaky. He rocked on the swing, sipping. The gray heads were in their window again across the street.

Quiet, the neighborhood seemed to remember nothing of what had just happened. Every small light, every glowing window, every shadow was in its right place. Cars passed from time to time as they always did. Even the beer can had somehow disappeared from the street. The transformers hummed tranquilly above him on telephone poles. Behind him, his house was no different, gave no outward appearance of the turmoil of those who were living in it.

He sat for a long time in the peace of the evening, trying to understand everything. Sammy's sadness-broken face kept coming to him through the darkness. And then words. Help him. Help him. Help him.

Chapter VIII

Ray emerged from the basement and looked at the microwave clock. Ten in the morning and still no stirring from upstairs. Sammy had gotten up a few times in the night to use the bathroom, and Ray was startled by the noises in the hallway. His brother's urinating sounded like someone pouring a pitcher of water into the toilet.

Waking at eight, Ray had made strong coffee and then retreated to his studio to see what might happen. Nothing did. Every idea seemed either cliché or some strained attempt to be original, cutting edge. He'd spent most of the morning on the couch, watching how the sun coming through the basement's window wells changed the room from minute to minute. He thought of Monet painting his pond in every kind of light. Maybe what Ray lacked was fascination. Compulsion. Monet and his lilies. Degas and his dancers. Renoir and his curvaceous women. O'Keefe and her opening flowers. Maybe it didn't take vision at all. Maybe the real artists simply fell in love with one small aspect of the world.

He turned on the television in the kitchen and watched the news. He refilled his cup. The news anchor talked about gas prices going over three dollars a gallon.

"Fucking hell in a hand basket," Sammy said, staggering into the kitchen. He massaged his forehead between thumb and finger and squinted at the television.

"That's how you feel?" Ray asked.

"No. All of us. If gas prices keep going up, it's all fucked." He moved his hand down to his throat.

Ray asked if he was all right.

"Just a sore throat. Just a bug I can't shake."

"I'm sure drinking all that beer doesn't help it."

Sammy sat at the counter, propped his elbow, and rested his cheek against his palm. He closed his eyes. "Don't give me a hard time, man. I'm already paying for it. I got a headache for the record books."

Ray turned the volume down.

"Thanks," Sammy said. He opened his eyes, the whites of which were skies of red lightning, seemingly trying to electrocute his irises. He blinked. "Sorry for anything I might have said or done."

Ray told him not to worry about it. "Do you want coffee?"

"If it's all the same, I think I'm going to go back to bed."

Ray poured him a glass of water and set it on the counter. "You'll start feeling better if you hydrate yourself."

Sammy picked up the glass and guzzled it. "That's a drink I can reason with, bartender. Got another?"

Ray refilled the glass. "I think I'll run out to school if you're going to sleep again."

Sammy nodded and yawned. "I'm going to need some more time. I should be up by supper."

Ray raised an eyebrow.

"My treat," Sammy said. "I'll order us pizza."

Ray looked at him. What a mess. "You look like one of Degas' absinthe drinkers."

Sammy squinted. "Hmm?"

"Never mind. Go back to bed. Come down when you're human again."

Sammy filled his water glass a third time and drank. He let the water run from the corners of his mouth and soak into his threadbare t-shirt.

"You have to take it easy tonight, Sammy."

He made a noise and then turned. He stumbled out of the kitchen and up the stairs. Ray wondered if he wasn't still drunk.

Summer time at school. Ray sat down at his desk. The place was almost empty, especially the art wing. Early on in their careers, many of his fellow faculty took their summers off to work in their studios. A few still did, but anymore most were simply used

to the time off. They produced a few things here and there, enough to have a faculty show every three years. They'd produced when there'd been a practical reason to produce. They were the kind of artists that worked best when someone gave them a deadline. While working on their MFAs, they had professors giving them deadlines and the excitement that comes with receiving a grade. Imagining themselves one day having university offices and giving their own deadlines and grades, they worked feverishly. Once they graduated, the idea of a full-time teaching position drove them to produce more—to have a portfolio of slides and computer files to bring to interviews. When they finally landed jobs, their output was driven by tenure. And, a couple years after tenure was behind them, they didn't feel any great need for art. They dabbled.

Of course, Przybylski didn't dabble. He had a regular assembly line cranking out paintings of older women in hats. He called the line "Women of Substance," though Ray wasn't sure what that meant. That's all Przybylski painted. "It's what people want," he had once told Ray, "something pretty to hang up in their homes." Przybylski never entered anything in the faculty show. "Where's the money in that?" he'd joke. Unlike the others, Przybylski didn't need the ego boost that came with the faculty show—the wine sipping afterwards, the self-congratulating, the cheese. Ray envied him at times. He'd made himself a cottage industry by going around to art fairs in the Midwest and selling his "dainty lasses." Rumor had it that he pulled in nearly forty thousand dollars a year from sales alone.

Ray considered himself and Kleminger, the sculptor, the only true artists in the department. "Most of our colleagues," Kleminger once told Ray, "never had a fire in their bellies. And, Przybylski only has a fire in his wallet."

Kleminger worked with old furniture frames. "The guts inside a hide-a-bed," he said. "It's amazing." He'd take them apart and rearrange them into something that looked like dinosaur bones. "And people actually throw this stuff away," he'd say, smiling. He talked about driving around Bay City and Midland in his rusted-out pickup truck on garbage nights looking for furniture. The students loved his stuff. Without him, Ray guessed that sculpting would die at Dow. Kleminger was the program. Most students

didn't want hands-on art. They wanted graphic design. They wanted computers to do the art for them.

Ray liked the idea of being friends with Kleminger. With Diane out of his life, maybe he could call him. Maybe a conversation with some intensity would get him painting again. As he flipped through his address book, someone knocked on his door.

A young man's face, familiar as though Ray had seen it in a painting, peeked in through the doorway. "Professor Casper?"

"Yes?" Ray tried to place the young man. He could have been a past student. There'd been a blur of them.

He stepped into the office. He was tall. He wore black Converse high tops, shorts that went below the knee, and a black t-shirt with white lettering that read: Pardon me, do you have any Grey Poupon? He rubbed his left hand up and down his tattooed right arm. He flipped his head, and his bangs came out of his eye and stuck above his ear. "Do you remember me?" he asked, looking at Ray, then looking at the bookshelves, and then looking at Ray again.

A faint hint of cigarettes had come in with him. "Were you a student of mine? I mean, I'm sorry. I have so many—"

"I'm Billy." He explained that Dr. Sheldon had introduced them at the Seagull Bar about a week ago. "Do you remember?"

Ray nodded. "Now I do."

Billy smiled. His hair looked like he'd just gotten out of bed.

Ray thought of Kleminger and looked at the wall. Two o'clock. Probably late enough for an afternoon cocktail invitation. Surely Jackson Pollock had had a few at the Cedar Tavern before five. Something must have been behind him ripping the men's room door off its hinges. Ray liked the idea of having a few beers with Kleminger. Maybe they'd get drunk. Maybe they'd shout about art.

Ray smiled at Billy. "Just stopping by to say hi?"

Doglike, Billy scratched the top of his head. "I guess I kind of need to talk."

Ray looked at him and hoped that his face might give something away. What were they going to talk about? Art?

"In the bar," Billy started. "I said I wanted to talk with Dr. S., and he said he'd be out of town, and then you said I could talk to

you." He pointed his finger around in the air in front of him. His eye contact was flickering at best.

Ray nodded. "That's right. I did." He rubbed his palms together. "So, what are we talking about?" He tried to remember the questions students usually had.

Billy's gaze pivoted around the room, stopped on the guest chair covered in unopened interdepartmental mail envelopes, and then came back to Ray.

"You can just set that pile on the ground," Ray said, realizing that some of his mail was over six months old.

Billy cleared the chair and sat. He scratched trails of dry skin up and down his tattoos.

Ray smiled at him. "Okay, then."

Billy's hand slipped into one of his deep pockets and came out with a cell phone. He turned it over and over in his palm. Closing his eyes, he pushed the heel of his other hand into his forehead. He clenched his teeth. "I don't even know where to start."

Ray swallowed his apprehension. "Well, what's on your mind?"

Billy looked up into Ray's face. "Everything." He smiled a troubled smile. "Everything's on my mind, man."

Ray forced his own smile. Did he still have the list of numbers that they'd given out at a department meeting a few years back? One of the numbers was a hotline to the counselors. Faculty weren't supposed to meddle in students' psychological problems. "Send them to the counselors," the department head emphasized. "Don't try to play Freud."

"Are you sure it's me you want to talk to?" Ray leaned back in his chair.

Billy nodded. "It's about school. That's all it is, man. It's just school." He flipped open his cell phone, look at its glowing face, and then snapped it shut again. "Maybe other shit, too."

"Well, let's stick to school for now."

Billy bowed his head toward the floor. He squeezed it between his hands. "I just don't know...it's all so jacked."

Staring at the floor, scratching his fingers through his hair, Billy seemed harmless. Just a kid...just the drama of a young kid.

"How do you see me being some kind of help in this?" Ray managed.

Billy picked his head up again. He rubbed his hands over his face. "I guess I just need someone to talk to about what the hell it is I'm supposed to be doing. I thought I was doing it, but it's not working. Nothing's working, man."

The boy's eyes. They were watery like Sammy's. "What's not working?" He'd had students come in frantic about financial aide, ready to quit school, but they never looked as despondent as Billy.

"Anything. School. Work. I just feel lost. Sometimes I think about it all, and I have trouble breathing." He laced his fingers together as though he might begin to pray.

"So, school isn't going well?"

Billy shrugged. "I don't know. I did pretty good with math in high school. Good enough. Good as any of my friends. Not good enough to be an engineer, though."

"There are other professions," Ray said hesitantly.

Billy shrugged.

"Was engineering a dream or something?"

He shook his head and looked at the floor. "Dream? No. I just want to have enough money that I can do shit and take care of a family."

Ray smiled. They were always in such a hurry. "Come on. There's plenty of time for a family. You don't have to—"

"Already have a family."

"What?"

"Got a girl and a little boy."

Ray studied him. Hadn't Billy been among the boys skateboarding recklessly at the church? "Two kids?" he asked.

Billy shook his head, smiling. "No, my girl...my girlfriend and me. We have a little boy."

Ray nodded, skating the tips of his fingers over his desk. "Can I ask how old you are?"

"Twenty going on fifty-five, man." Billy attempted to laugh but what came out sounded lifeless.

Somebody walked by. Footsteps echoed in the empty halls.

"I never even saw school in the plans," Billy said. He couldn't keep any of his limbs still. He checked his cell phone several

times. "My dad had a web design business that was going great. He taught me everything about it, but it went belly up before I even finished my junior year of high school."

"Your dad's business?"

Billy nodded. "He started it after he retired from GM. It was just something for him to do, but for awhile he was pulling in nearly forty thousand a year. Every damn business in Mid-Michigan wanted a website."

"And that's what you planned to do? Work for your dad?"

Billy nodded. "I planned to take over the company. I could do it all. HTML. Dreamweaver." He shrugged. "But now, anyone can."

Ray smiled. "I can't."

Billy scratched his pimpled cheeks. "Who does your website for the art department?"

"I think our secretary."

He snorted an angry laugh. "It's that way with everyone." He shook his head. "For a long time, when I was in middle school, Dad said I'd be able to follow him right into GM. That was all just blowing smoke up my ass, too."

Having noticed it, Ray's eyes kept coming back to the stud pierced through Billy's tongue. "Do you have some kind of job?"

"You can call it that. Seven bucks an hour changing oil at the Quick Change. I'm lucky to get twenty hours a week."

Something rattled above them in the ceiling. The air conditioning breathed to life.

"Does your girlfriend work, too?"

Billy scratched the back of his neck. "No."

"You guys can live off a hundred bucks a week?"

Billy smiled sheepishly. "Kari and William live with Kari's parents. I live with my folks. It works out that way for now. Kari's going to school for nursing."

Ray looked at his watch, not trying to hide it. Billy had already been in his office for half an hour. "Well, the nursing sounds good," he offered. "Maybe you'll be a stay-at-home dad."

"I guess." Billy shrugged. "Stay-at-home loser is more like it."

Ray had heard that kind of defeatism in his art students. They complained that they had no good ideas. Instead of agreeing with them, as he was inclined to do, he had to inspire them otherwise. "I don't think talking like that will get you anywhere," he said.

Billy's arms waved about, hands slapping down on his thighs and rising again. "I know, I know. But it's not like that's all I've been doing is talking. I been trying. Everything just keeps slipping out of my grip, man. What the hell is even out there? I see a nametag that says Billy. That's my future. How am I supposed to give my girl and my little dude what they need?"

Ray wasn't sure what to say. "People do it...somehow they do it. They—"

Billy's hands covered his face. "I don't want to just get by. I want nice things."

"Anyone does. I mean, couldn't things be worse? You have to think about what you ha—"

"I'm just drained, dude. I keep throwing up plans and they get denied. Smack. Right back in my face." He exhaled, and his limbs went still. As instantly as he'd stopped moving, he shot up to standing as though his spine were spring-loaded. "I'm going to have a smoke. Do you mind if I have a smoke? I mean, I'll be back. I don't know. I just need a quick smoke."

"Do what you need to do. I'll be here. Just take it easy. We can still talk." Billy's face was pale. Ray smiled. "Come on. Things aren't so bleak."

"Things feel pretty bleak to me, man. I'm drinking two shots of NyQuil every night just to get to sleep." He pulled a pack of menthol cigarettes from the deep pockets of his shorts and said he wouldn't be too long. "And, really, thanks for listening. I just had to talk to someone."

"Happy to do it." Ray leaned back in his chair and listened to Billy's squeaky soles fading down the hallway. Then a door opened and slammed shut, and he heard nothing else save for the hum of the air conditioning. What would he tell Billy when he returned? He didn't have any solutions. Still, he could at least listen. He could do that much.

Ray turned back to his address book and found Kleminger's home phone number. Claude was standoffish, but could be

interesting enough. He had a quirky, stiff-jointed walk that seemed like a swagger. He took art seriously. That's what I need, Ray thought. He dialed.

The phone rang eight times. When it finally picked up, he guessed it was an answering machine. He didn't want to leave a message.

"Speak."

Not a machine.

"Is this...I'm trying to...Is this Claude?" He sounded suspiciously like a telemarketer.

The voice on the other end cleared forcefully. "Who is it?"

"Claude? It's Ray. Ray Casper from Dow."

A moment passed. Claude chuckled. "Raymond." He breathed another laugh out of his nose. "Why are you calling?"

"How are you? How...how is your summer going?"

"How am I? How is anybody? I guess I'm fine. I'm busy. The work is going well."

Ray swallowed and words wouldn't come for a moment. "Good," he managed. "Good to hear." Would Claude ask about his work?

"To what do I owe this pleasure," Claude asked after a silence. "Are you and Przybylski doing a show together? Am I being invited to attend?" He laughed.

Ray laughed, too. "No. Hell, no. I was just calling to talk to you. It'd been awhile."

"I suppose it has...though does it matter? Everyone seems to want to talk to me this summer. Fall semester will be here soon enough."

Ray switched the phone to his other ear. "Well, I don't know, Claude...We don't have to wait that long, do we? I was thinking we could get a drink."

"Now?"

"Well, not right now. I'm talking with a student right now. But maybe in an hour or so?"

Air conditioning filled the silence. "A student? Are you teaching this summer?"

"The student's a long story. We can talk about it at the Seagull."

Claude cleared his throat again. "Raymond, I don't drink in the middle of the day. Maybe a glass of wine on a Friday. Drinking clouds my mind when I'm working."

Ray nodded. "Sure. Sure. I mean, it doesn't have to be a drink. We could go for coffee."

Claude's breathing sounded negative, dismissive. "I don't think so. Not today. The work is going too well."

Ray remembered calling girls in high school and being turned down for dates. Claude had him feeling the same way. "Yeah, sure. Can't walk away from the work when it's going well."

"The work must come first."

"Sure."

Claude sniffed in a breath. "So, how are you, Raymond?"

Ray guessed that he was just being polite. "Good enough. Look, I don't want—"

"I heard about Diane. I'm sorry. She was a good woman... and sometimes a good artist, too."

Diane's name in Claude's mouth was like a sucker punch. Something welled in Ray's eyes. "Yes. I miss her."

Claude let a moment pass. "Are you depressed, Raymond?"

"Am I depressed?"

"I worry. I hear the students talk about you. Maybe I'm stepping over my limits, but what they say doesn't reflect the Raymond Casper I thought I knew."

Ray shrugged off the chill that settled over him. "Look, students talk. If you don't give them A's, you're just some frustrated failure in their eyes. They just—"

"They pay for the classes. They deserve a teacher."

Ray couldn't speak for a moment. "I teach, Claude," he said. "I've just had some things going on."

"I'm sure," Claude said. He laughed. "Remember though what Matisse said: "Le travail guérit tout.""

Ray tried to recall what he could of French. "Everything is hardship?" he hazarded.

Claude sniggered. "'Work cures everything.' An artist has to work, Raymond. Get painting. You'll feel better."

Ray sank lower in his chair. "I've got nothing. I know you've seen *Riverscape*. I know it's weak. But, the other—the abstract pieces I was doing...they don't mean anything either. They—"

"The more horrifying this world becomes, the more art becomes abstract."

Ray was quiet.

"That's Klee," Claude said.

Ray rubbed his hand over his face. The phone was like a little furnace against his ear. "I guess that worked for Paul Klee. For me—"

"Look, I'll call you," Claude said, "I'll call you if the summer frees me up."

"That sounds good, then," Ray said. They hung up.

He stared at the wall until the noise of the air conditioning stopped. A loud silence settled around him. A question began to repeat in his head: Who the fuck did Claude Kleminger think he was, anyway? Did he think he was Rodin? Michelangelo? Ray had been to an opening of one of Claude's exhibits. Hands gesticulating wildly, he explained that he used the insides of furniture for his pieces because "we seldom really see the complex insides of the things in our lives that we take for granted. It could be furniture, or it could be the people we love." He said his sculptures attempted to bring those things to the surface. Holding their wine glasses, people in the audience nodded as though a light had come to them. Ray remembered thinking it was bullshit. An old professor of his always said that if the art needed an artist's statement then it wasn't art.

And, what did Claude mean by the crack about Ray showing with Przybylski? Was he taking a shot at *Riverscape*? Was he suggesting that it was a sellout? And then the thing about Ray and his relationship to students. Claude Kleminger could shove his artist's quotes up his ass as far as Ray was concerned. He spun in his chair, fuming.

Footsteps echoed down the hallway.

Billy.

He drifted in and flopped into the visitor's chair. He smelled like an ashtray...like Sammy. "Something wrong?" he asked.

Ray looked at him. "No."

Billy nodded. "I wish I could say the same, dude."

Ray leaned back in his chair and pinched the bridge of his nose between his finger and thumb. He exhaled. "I don't know what more there is for us to say. You just need to figure things out. Make a plan." Kleminger kept coming into his head: "Raymond, I don't drink in the middle of the day." Ray squeezed his hands into tight fists.

Billy's eyes went far away. "I just really want—"

Ray drummed his palms on the arms of his chair. "Sometimes it's not a matter of what you want, but what you need. You need to get serious." His father's words were in his mouth.

"I'm trying, but—"

"Then you have to try harder. I don't know what you expect me to say."

Billy sighed. "I don't know either, I guess."

After a moment, Ray stood up and slipped his keys into his pocket. "I think you just have some thinking to do."

"I been thinking until it hurts."

Ray shrugged. "Well, in any case, I need to get going."

Billy nodded slowly, standing. "Alright," he said. "I didn't mean...I just hope I didn't suck up too much of your time." He lifted his arm in a lazy wave and left.

"You'll be fine," Ray called to him. Billy's footsteps faded down the empty hallway.

When Ray arrived at his house, Sammy was sitting at the counter eating pizza.

He stopped chewing and smiled sheepishly. "I got hungry," he said. "You like pepperoni?"

Ray walked to the cupboard, uncorked the wine from the night before, and poured a glass nearly full. "No pizza for me. It will just slow this down." Kleminger had haunted his head the whole drive home. Ray's palms were sore from wringing the steering wheel. He took a long drink, and the wine stung along his throat.

Sammy peeled another slice from the box. "What are you doing?"

"I'm getting drunk."

"Holy shit," Sammy laughed. "No good doing that by yourself."

The brothers drank and talked. Ray opened another bottle of wine. Sammy told off-color stories about different men he had worked with in different factories. "One guy," he said, "would sneak into the locker room and take a shit in the lunch pail of any new guy. A big dump. Just a welcoming present, I guess. That kind of shit happened all the time."

Ray laughed despite himself. He remembered being a kid,when he and Sammy used to make prank phone calls. "Remember?" he asked. His head felt like it was filling with helium. His smile tingled in his cheeks.

Sammy, his grin widened by seven beers, nodded vehemently. He picked up the phone and tossed it next to Ray. "You have to do one...for old time's sake."

"You're kidding."

"No, I ain't. You were always great at them. Just do one. Come on."

Ray felt light. He laughed. "Okay," he said. "I got one." The number was still raw in his mind. He punched it in.

The other end picked up. "Speak."

Ray deepened his voice. "Is this Mr. Richard Head?"

"No. You have the wrong number."

"You sure? You sound like a dickhead to me," Ray said, hanging up.

Sammy's laugh burst from him like vomit. "Jesus Christ, that's good. Where'd you get that?" He surrendered to his laughing again. "That's really fucking good."

Ray imagined the look on Kleminger's face. It had to be priceless. When the phone started ringing in his hand, he jumped.

Sammy laughed. "Someone's pranking us."

Ray picked up.

"Raymond?"

Kleminger. His voice went through Ray like Novocain.

"Raymond, your number came up on our machine," Claude said. "We have one of those machines."

"I..."

"I feel so sad for you, Raymond. What's happened to you? It's pathetic." He hung up before Ray could even begin to answer.

He sat, still holding the phone to his ear. The dial tone hummed hollowly. He felt the blood draining from his face. Anything the wine had given him was gone.

Sammy kept lapsing into laughing fits. "Dickhead," he repeated.

Ray told him to shut up. He went into the kitchen for another bottle of wine.

Chapter IX

Waking the next morning, Ray's first memory had been of the phone call he'd made to Kleminger's. Every time he thought of it, he winced, and even wincing hurt his head. Wine hangover. The worst. His eyelids sagged as though he hadn't slept in days. He let his jaw hang open. He made coffee, but then the smell of it made him sick. He retreated to one of the reclining chairs on the deck. The sun breaking over the trees only added to his misery. Too much light.

The backyard had been Diane's. She liked that she could make it different every year. Her favorites were annuals. Ray couldn't remember the names of most of the plants and flowers, but he remembered digging hundreds of tiny holes for the Impatiens. By July, with her watering and weeding, the backyard was brilliant with color. "It's really like a canvas," she often told him. Everything was a canvas with her. Without her, the backyard was mostly a dull green, freckled with the bastard yellow of dandelions or the fuzzy white of dandelions gone to seed.

When he was nearly asleep, the door to the deck slid open. "Good coffee," Sammy said.

Ray looked into the dim pink of his eyelids. "I'm so glad."

"Hey, don't take your hangover out on me. Not my fault you can't handle your wine."

Ray opened his eyes and glared. Sammy's ashen skin surprised him. He looked sickly. "Sorry," he said. "You're right. I put myself here. I just need some rest." He closed his eyes again.

A few minutes passed, and Ray's thoughts went dreamy. Sleepy.

"Richard Head," Sammy chuckled.

Ray opened his eyes.

Sammy laughed. "That was good."

Kleminger. What did he think of Ray's prank? Would he tell other people in the department?

Ray closed his eyes, hoping to sleep, hoping to wake to find that all of it had just been a bad dream.

Two days later, Ray ate a turkey-stuffed pita and watched the news in the kitchen. The anchor spoke about the near absence of dental care in rural Mongolia. Ray and Sammy had been taking it easy—watching television, eating, sleeping. Ray talked about painting. Sammy talked about finding work. They assured each other that they'd come out of their slumps.

Sammy came in sweat-soaked from the yard. "Lawn's done." His color looked good, flushed pink from the mowing. He mashed his hand at his sweaty hair.

Ray chewed and swallowed. He looked at Sammy and smiled. The thoughts he'd been thinking at night came to him. "I want to do something for you, now" he said.

Sammy scratched his cheek. "You already done too much."

Ray said that what he wanted to do wasn't a big deal. "I'm just talking about clothes. A haircut. Do you even have anything to wear for an interview?"

Sammy swallowed. "Got a nice sweater."

"In July?" Ray pulled his wallet out. "You have to have some things. A nice white shirt. A tie. Some khakis. Decent shoes." Sammy had worn black tennis shoes to the funeral. "Get a nice hair cut, too. Maybe a professional shave."

"I've got a white shirt."

Ray wondered if he meant the shirt he'd worn to the funeral, the one stained urine yellow in the armpits? "Just get some nice clothes. Think of it as a loan if you want." He set eight twenties on the counter. "These are just basic things that you have to do."

Sammy looked at the floor. "I have some money. I don't—"

Ray held up his hands. "I know you have money. That's your money for getting by. I just want you to take this money so you look good for your interviews."

Sammy didn't look up from the floor. "You're doing too much. I don't even—"

"I just want to help."

Sammy shuffled to the counter and picked up the bills. "What if I'm beyond help?"

"Nonsense. Take the car. Take what's left of the afternoon. You can pay me back by taking me out to dinner with your first paycheck."

Taking the money, Sammy came around to Ray and hugged him. "Thanks, Ray Ray." He released Ray and stuffed the money into his pocket. "Suppose I'll hit the shower first."

"Sure. A shower will make you feel reborn."

A half hour later, Sammy came into the kitchen. He'd slicked his wet hair back over his head.

"Feel better?"

"Not really."

Ray told him that he was just nervous. "You're taking a chance. You're starting over. It can be scary, but you'll land on your feet."

"I don't know." Sammy picked the keys off the hook. "Guess I'll go."

"You'll come back feeling like a new man."

Sammy shrugged and opened the door.

Ray watched him back down the driveway. He started for his studio. Then, thinking better of it, he went to the couch and watched *On the Waterfront*. It was after six o'clock when he woke from a nap. He grilled a chicken breast, cut it into strips, and mixed it into a salad with grapes, celery, and a dressing of red wine vinegar, olive oil, Dijon mustard and fresh ground black pepper. Sammy could fend for himself. Ray wondered when he would be home. It was a worrisome wondering.

The light had become summer darkness by the time Sammy pulled Ray's car into the driveway. He fought with the front door. Ray turned from the television to his drunken brother. His hair, though shorter, still sprouted from his head like weeds. He labored to walk as straight as he could to the couch. "Hey," he said. He clutched a shopping bag in his left hand.

Ray turned off the television.

"You still up?" Sammy managed, steadying himself on the back of the couch.

Ray took a breath and exhaled. He let the stupidity of the question resonate for a moment. "Little hard to sleep."

Sammy said nothing.

"They cut your hair one strand at a time?"

"Huh?"

"You've been gone for eight hours." Ray checked his anger. "Did you ever think that I might need the car for anything?"

Sammy switched the bag to his other hand. "You said to take it."

"And, driving it drunk—you think that was a pretty good idea, too?"

"I've drove drunk before."

Ray made a sound like a laugh. "You're really a piece of work, Sammy."

Sammy rubbed his chin into his shoulder. He mumbled, and Ray was sure he'd heard something about him going to hell.

"What?" He sat up.

Sammy looked down into his face, released the couch, and stumbled around to a chair, falling into it.

Ray stared at him until Sammy looked up. "I think I deserve better than that, Sammy."

"Ray Ray..."

"I think I've been pretty decent—decent enough that maybe you shouldn't tell me to go to hell."

The window behind Sammy was black. He looked down at his hands. "Do you even fucking know where you live, Ray Ray?"

Ray lay back on the couch. He exhaled. "I'm going to bed."

"Just tell me if you know where you fucking live." The edges of his voice sharpened.

"Sammy."

Sammy scooted up to the edge of his chair. "I'm serious. I don't even think you know."

"Fine. I'll go to bed, then." He sat up.

"Hold up a minute. I'm making a point." His enormous hands moved on his knees.

Ray leaned back. "What. What's your point?"

Sammy said he'd stopped at a bar across the river.

"For a haircut?"

"Just listen." Sammy waited. "I'm going to tell you where you live. You want to know?"

"Sammy."

"You're in the poorest part of Michigan—damn near the worst place to get a job in all the Midwest. That's where you brought me...to a shithole. Thanks."

It wasn't what Ray had expected to hear. "What?"

"Factories are closing. Ain't nothing new coming in. Factories that are here probably won't be here in five years—"

"Who told you this?"

Sammy said he talked with guys at the bar.

Ray coughed a laugh. "Credible sources."

Sammy shot up. "If by that you mean they don't know what they know, then fuck you. The guys down there know a fuck of a lot more about that kind of shit than you do." He teetered between his feet and stabbed his finger toward Ray.

Ray held up his hands. "Take it easy. I'm just saying that maybe—"

"Don't say nothing. This isn't nothing you know anything about. It's not some god-damn painting." Sammy reached into the bag, pulled something out, and tossed it at Ray's feet.

A shirt and a large pair of dress pants. "What's this?" Ray asked.

Sammy reached into the bag again and withdrew a pair of black dress shoes. He threw them to the floor. "This ain't about clothes or haircuts. Cleaning me up ain't going to do shit. There aren't fucking jobs here."

Ray cleared his throat. He spoke calmly. "And you know that because you looked, right?"

"I don't need to look," he said. "Them guys know. There's nothing here, Ray Ray."

Ray reached down and started to fold the pants. "Nothing? I don't know, when I'm on my way to school in the morning, I'm out there with quite a few other drivers. They must be going somewhere."

"I'm just saying that the factories aren't hiring—"

"There are other jobs. You could—"

"Listen, I'm a factory rat. Period."

Shrugging, Ray kept folding. "It's just—"

"It's what I know, Ray Ray. I've tried other stuff. It either don't pay or I just don't get it. I tried yard maintenance for a hotel. I didn't mind, but after three months, I got my first raise. I went from six an hour to six twenty-five. I'm used to making at least twenty...at least."

"So you've already decided then—"

"Decided?" Sammy yelled. "You act like I got some say in this shit. I'm just saying that it's going to be hard for me to find work. This ain't the land of plenty. You're probably gonna be stuck with me around here for awhile."

The idea left Ray feeling weighted, drowning. "So you're not going to look?"

Sammy sighed. "Shit, I don't know, Ray Ray." He looked up at the ceiling as though maybe expecting to find an answer etched there. "I'm going to get a beer. You need a beer?"

"No."

Sammy disappeared into the kitchen. The shadowy shapes around Ray were absent of light's dimension. He tried to remember why he'd asked his brother to come back to Michigan with him. He wanted to help him, get him back on his feet. Or, was it just guilt?

Sammy came back. He held an open beer and set an unopened beer on the floor in front of his seat. He took a long drink. "Shit," he sighed, lowering the can to his knee.

"I think I'm going to go up to bed." Ray rubbed his eyes. "We can talk about this in the morning. Things will look better in the morning."

Sammy took another long drink. The can knocked hollowly against the oak floor. "What do you want from me?"

"From you?" Ray wasn't sure what to do with the question.

"Yeah. You don't fucking like me. You don't want me here, really. So, what do you want from me?" He crouched low in the chair. His neck disappeared. "Buy me a bus ticket for Toledo and I'm gone."

"What do you mean? What do you mean, 'I don't like you?'"

Sammy laughed. "You can't stand my ass. Don't fucking lie."

He didn't say anything. Trying to deny it would only prove its truth.

"You know why I came here, Ray Ray? You know why I said 'yes' when you asked me?" He was quiet, seemingly waiting for Ray to give a response.

"Sammy."

"I came up here because you're my brother." He pointed. "I thought this would be a chance to get to know you again. I remember when you were my brother. Now, I don't even know you."

Ray searched for words, for something. He smiled. "Well, we can—"

"Don't, Ray Ray. Don't say you want to know me, too. You been looking at me like I'm a cold sore since I got here—since we got in the fucking car back in Toledo."

Ray whispered that it wasn't true.

"It is. It is true. Don't say it ain't." Sammy opened the second can and lifted it to his lips. "So, what do you want? Tell me what you want me to do. What the hell is it you want from me?"

"It's not a matter of—"

"We're nothing alike. We ain't got shit in common. You don't even know." Sammy seemed to be talking to himself.

"I guess I'd like—"

Sammy stood. "I want you to quit looking at me all the god damn time—looking at me like I'm missing an arm or I'm in a fucking wheelchair."

"Now, what are you—"

"Stop feeling sorry for me. Stop acting like you're my god-damn social worker. Just tell me you want me out of here if you want me out of here. It's not like I can't do for myself. You want me out of here, just say the word."

"Sammy." Ray coughed a tickle from his throat. "I want you here."

Moving faster than Ray would have guessed he could, Sammy pitched the rest of his beer into the brick mantle of the fireplace.

"Sammy!"

He pointed his finger in Ray's face. "Shut your mouth. Don't even...You don't even know. Like I haven't been trying. Like I haven't tried a haircut and a new set of god-damn clothes before. Like I haven't been at this for fucking years. You'll just come

along and say 'get a job' and everything will be fine. Everything will be just fine for your stupid ass brother. Then you can stop feeling sorry for him."

Ray looked at the little worm of drool shining on Sammy's chin. Get him to bed, he thought. "Okay, Sammy." He started to stand.

Sammy shoved him back into the couch.

"Hey, what do you—"

"Sit down. I swear if you get up I'll clock you. You fucking made Dad cry. You made him fucking cry," he yelled.

"What?"

Sammy stared at him, but his eyes looked whoozy. "I asked why you wanted me to come to Michigan with you. You said, 'Because I have a brother.'" Two tears raced each other down Sammy's cheeks. "'I have a brother that I don't really even know anymore.'" He fixed his stare on Ray's eyes. "Well, now you know me. And, you can't fucking stand me. I'm fucking it all up." He squeezed his right hand into a fist, and the knuckles drained from red to white.

Ray stared at the knot of flesh and bone at the end of Sammy's arm. Something churned through his guts. His brother loomed over him, swaying. "Take it easy, Sammy."

Seeming to catch himself, he pulled his eyes off of Ray and started toward the stairs. Like lightning, he launched his fist into the wall. "I'm fucking it all up!"

Ray jumped. A silence consumed the room.

Sammy shook his hand and stared at the hole.

Ray took a long breath, his first since Sammy had punched the wall. "I don't—"

"Ray Ray," Sammy said, his voice sounding like it had when he'd called with the news of their father's death. Pieces of plaster fell inside the wall. Sammy raised his left hand to his eyes. He rumbled for a moment and then, like a storm cloud, burst into his sobbing. "I'm sorry," he wailed. "I'm so fucking sorry."

Before Ray could say anything, Sammy lurched toward the stairs and pounded up them.

He crashed into the guestroom and onto the bed like thunder. Then, not another sound. The storm was over. Ray sat for a

moment in the silence, not quite sure what had just happened. His heart slowed slowly. The insides of the couch moaned under him in response to his slightest shifting. He thought of Kleminger. Maybe he was onto something with his furniture sculptures. Sammy's surface certainly didn't reflect the strata of his person. His insides were a mess of rusting steel and rotting wood—a sofa left outside through too many storms.

Ray rose and walked over to the wall. He pushed his foot through the pieces of plaster on the floor. Inside the hole, a few strips of lathe were cracked and splintered. Sammy's hand could be broken. Ray imagined what might have happened if Sammy had gone after him instead. He gave the wall a little jab with his own fist just to see. His knuckles turned pink and throbbed. Sammy was going to be hurting in the morning. Afterwards, in the afternoon, Ray would need to try to talk to him. The idea that things could yet escalate haunted the room, leaving him feeling as though he weren't alone.

Sammy twisted in the bed above him.

Chapter X

Morning. He walked past the door behind which Sammy slept. A sigh whistled softly from Ray's lips. The stairs creaked under his feet. He made no effort to find the quiet spots as he would have had it been Diane sleeping in. He stopped on the landing and listened.

"Sammy," he called. Lying in bed the night before, staring into the darkness prior to falling asleep, he decided to confront his brother. They couldn't have another night like the one they'd just had. If he couldn't control his drinking, or at least his temper, he'd have to go. Brother or no, he couldn't treat Ray that way. "Sammy," he called again into the hollow of the stairwell.

Nothing.

Ray stopped in front of the damaged wall. He studied it, shook his head, and walked into the kitchen. The news on television covered the riots in Paris. What a mess, class wars.

He had another day ahead of him. Another day without painting. Without Diane. He scratched his hand through his greasy hair and looked at the door to the basement. He had nothing to bring down there. Sitting, staring at a blank canvas, would only depress him further. Inspiration would come when it came. He'd wait—even if it meant that a whole summer would pass without picking up a brush. He stood in the kitchen, listening for any stirring from the upstairs.

A moment later, he found a note by the coffee pot. Seeing his brother's ragged handwriting, he experienced a secret hope that it was a going-away note. With luck, he was telling him that things weren't working out and that he'd caught a bus back to Toledo. Guilt followed closely behind such thinking. He's my brother, he reasoned. I asked him to come here.

He walked the note into better light and squinted.

Ray Ray

Sorry, all of last night that was bullshit everything you done for me is great. I shoold not of drank I get real bad. I hate my self when I wake up. I'm really sorry. I hope you will let me stay, I want to stay. I can fix the whole. I will later

I'm going out to look for jobs now. I'm going to try. I will be back later I love you.

Sammy

He read the note a few times. He pushed the back of his hand into his misty eyes. "I can fix the whole," he read again. His brother was an accidental poet. Maybe he could fix the whole.

Sammy came home shortly after one o'clock with a large bag in his hand. He was wearing his new clothes, and his hair was combed down the middle and neat. He looked at Ray and then looked at the floor. "Hey, Ray Ray."

"How's it look out there? Any prospects?"

Sammy said he'd picked up a few applications. "There were some places. More places than I thought. Them guys at the bar might a just been a bunch of drunks."

Ray said they'd just have to wait and see. "I read your note."

Sammy grinned. "Sometimes I can't say what I want to say, so I write it." He scratched his ear. "I am sorry."

"I know." Ray smiled sympathetically. "How's your hand?"

Sammy looked at his raw knuckles. "Hurts," he said, "but it ain't broke." He held up the bag in his other hand. "I got some stuff to patch the hole."

Ray watched him get to work. At first Sammy didn't seem to know what he was doing. Using a hammer and chisel that Ray had in the basement, he chipped the hole bigger. When he seemed satisfied, he pulled metal lath from his bag, cut it, and fit it into the rectangle he'd chipped into the wall. He opened a small can and brushed its contents along the edges. "That will keep the moisture from the new plaster out of the old stuff. Moisture's no good."

Ray nodded.

Sammy mixed his ingredients into a bucket. It eventually looked like dough. He set the mixture onto a metal sheet. "This is the hawk," he explained. He used a trowel and slowly filled the hole. "You don't fill it all the way," he said. He used the other side of the trowel and combed texture into the plaster that he'd just applied. "That gives the finishing plaster something to grip." His voice sounded like their father's—the voice Ray had ignored whenever it was explaining the rituals of some household repair.

Ray patted Sammy's damp back. "You know your stuff," he said.

Sammy smiled proudly. He shrugged. "I picked up a few things here and there. Dad showed me a lot." He prepared the finishing plaster, which involved mixing lime and water, forming a ring, pouring more water into the ring, and then sifting the gauging plaster into the center of the ring. After a moment, Sammy folded the ring into its own center.

"There's an art to it," Ray said.

Sammy blushed. "Shit, Ray Ray—it ain't that big a deal." He dipped a paintbrush into water and alternated between it and the trowel to smooth the plaster's finish. Each of his hands moved in a rhythm that even Sammy seemed more to observe than control. It reminded Ray of the footage he'd seen of Pollock— the filming fiasco that tumbled ol' Jack the Dripper back into drinking, as legend had it.

Sammy brushed on the final coat of water. "That should do it. Just have to paint it after it dries. You got the original?"

Ray shook his head.

Sammy's face dropped.

"But it needs fresh paint, anyway," Ray offered. "The whole room does. We could paint it together."

Sammy looked around, nodding. "That'd be good. Real good."

Sammy spent the evening filling out his applications, while Ray removed things from the walls. It wasn't the kind of painting he'd hoped for, and yet something about the prep work was already lifting his spirits. His summer wouldn't be a total waste. While his hands were busy, his mind was free to wander ideas. Sometimes he felt on the edge of inspiration, but could never quite hold the new visions. Still, he hoped that the coming week would give him

something more than days of watching television had. He herded furniture into the middle of the room, tucked in drop cloths, and listened to Sammy's tuneless whistling coming from the dining room table. Before going to bed, Ray proofread Sammy's applications.

The next morning Sammy left and returned around noon with half a dozen more. "You gotta look for them," he said, "but there are factories around." After lunch, they took the car to a local hardware and picked out primer, paint, brushes, and roller heads. Diane had always complained that the living room was too dark, so Ray chose a color called Coffee with Cream. The clerk offered to shake the cans. Sammy grabbed a few stirring sticks and said that they could mix the paint at the house. "I should be home, really. I could get a call any time."

The living room was the largest room in the house and featured a great deal of woodwork that they needed to cut in around. Around six o'clock they finished priming and stood with their hands on their hips, looking around. "We can start the first coat tomorrow," Ray said. He opened and closed his sore hand. The brothers had filled most of the silence with stories that they could remember from their childhood. These were good stories from their youngest years—stories made sweet by distance and nostalgia. When they were young, they hadn't been so different from each other, and their recollections suggested that they had really spent a great deal of time together. "It's when you got to your teens that you became such a moody little prick," Sammy had said, priming meticulously around the base of a chandelier. Having had such a positive time until that statement, Ray chose to ignore it.

When Sammy returned the next afternoon, he only had two new applications. Ray got near him to see if he could smell beer. He didn't.

They began to paint. Ray admired how carefully Sammy cut in around the woodwork. The room became light coffee around them. Twice the phone rang, and Sammy sprang like a panther to get it, but both times it was a telemarketer. "Bastards," Ray said.

"They're just trying to earn a buck, too," Sammy said. "I tried that shit. Telemarketing is fucking work. I only lasted two weeks."

He explained that his supervisor had called telemarketing firms the factories of the Information Age. "He told me that he had to let me go because I never stayed in script—and I sometimes swore."

Ray went to bed with the ache of overhead painting in his shoulders. Once he lay long enough, he felt the ache, too, of not painting in the studio. And, he felt an ache of loneliness that came from the idea of Diane. She'd surprised him so far by not calling once.

The next day he and Sammy finished the second coat in the afternoon. Nothing remained but to let the paint dry and put the room back together. Ray grabbed a couple beers and brought one to Sammy where he sat on the couch. They cracked them open, clanked cans, and drank.

"It looks good," Sammy said.

"We could go into business," Ray joked. He wanted to feel differently, but finishing the room had only left him feeling heavy, burdened. With the room done, he had to face the idea of the rest of the summer. Outside, the clouds let loose, and rain sprinkled against the windows around the room.

"Should have got a call by now," Sammy said.

"You'll get one."

"I don't know, Ray Ray. For some people the world just doesn't work out."

Something about Sammy's statement reminded Ray of his father. "Do you remember when Dad decided he wanted to go see the Pacific?"

Sammy screwed up his face. Then, a moment later, he began to nod. "I think I just turned sixteen."

"I was twelve," Ray said. "I remember Dad was about a week into a two-week vacation. He came into our room and said the three of us were going to California."

"Mom couldn't go, right? She had a sister visiting or something."

Ray nodded. "Dad did it on a whim. Remember, he woke us up around three in the morning because he couldn't wait."

"Yeah."

Ray set his beer down and started using his hands. "We slept while Dad drove. I remember when we woke up, too. We were just outside of Joplin, heading into Oklahoma. You and Dad started singing Bobby McGee."

Sammy laughed.

"Then, remember—"

"Well, I'd trade all my tomorrows for one single yesterday," Sammy sang.

Ray smiled and nodded, waiting for him to finish. "Remember Vinita? Dad wanted to take some highway so we could drive through the Osage Indian Reservation."

"Highway 60," Sammy said. He looked down into his beer can.

"Right. How do you—"

"That's when he let me drive. We were just a little west of Vinita. I was on my learner's permit."

"I don't even understand why he wanted to go that way."

"Don't you remember? He said he wanted to spread the wealth. He said we'd gas up and eat on the reservation—maybe even buy a souvenir for mom. Said the Indians didn't have a pot to piss in and if he was going to spend dough, he might as well spend it on their stuff."

Ray nodded, smiling. "That's right." He touched his finger lightly across the skin under his eye. The rain against the windows grew louder. "It wasn't too long later that the head gasket blew. What was that town? No..."

"Nowata."

"Right. Man, you've got a good memory." Ray recalled how the car was shot and not worth fixing. "Dad bought us bus tickets to get home. Remember?"

"Stopping in every pisshole town along the way," Sammy said, mimicking their father's deep voice.

Ray laughed and took a swallow of beer. "I can still remember that smelly motel we stayed in that night. I remember talking to Dad after you fell asleep." He looked at Sammy. "You were always falling asleep."

Sammy shrugged.

"Dad and I were in the same bed," Ray said. "We lay there, trying to sleep, staring up into the blackness, listening to cars go by, and then Dad just started talking." His father's voice had come into the room like an apparition. "You up, Ray Ray? I'm up. You up? You know, this whole thing don't make your old man a loser. I know you think so—I know you have your thoughts about me." Ray remembered this part of his father's speech, the beginning of it, but didn't tell Sammy. He told Sammy instead that their father's point was that you only get one life. "You take risks. This trip—in a ten year old car—that was a risk. It didn't pan out. It might a, though. Imagine the payoff—ocean all around and stretched out like God's love. That could have been something. And so it wasn't. Who gives a shit, right? Least I tried. I could name a hundred guys who wouldn't a even done that much. A big life wasn't in the cards for me, but I still tried to bluff my way with the hand I was dealt. What else do we got? Take it lying down?"

Ray looked at his brother's pale face. His eyes were fogged over. "That's what he said, Sammy. It's always been in my head. Got to take risks, Ray, I'd tell myself. That was Dad's voice in my head, sometimes haunting me into my best work. Even sticking with art—that was a risk. It's ironic, but I owe Dad something for that." The idea of it hummed around him.

Sammy stared off, seemingly through the wall in front of him. A tear broke the brim of his left eye and slid down his cheek.

Ray looked down, guessing that he shouldn't have been talking about their father already. The funeral was still too close, too raw for Sammy. Blurry in Ray's peripheral vision, Sammy dragged a sleeve across his eyes.

"Dad and I had a talk on that trip too," he said. "This time, you were asleep."

"Yeah?" Ray looked over at him.

Sammy nodded. "On the bus," he said. "Remember Dad bought that whiskey for the ride and was pretty well oiled for most of the trip?"

"Uh huh."

Sammy said the bus was somewhere in the middle of nowhere. "Second night we were on the thing. I had my face pressed to the

window, but there was nothing but black out there—anything but God's love." He said that their dad put his hand on Sammy's knee and shook it. "He said, 'Sammy, none of this surprises me.' His words were lazy like they'd get. He said, 'We just have bad luck. Born with it.' Then he jerked his thumb across the aisle at you sleeping and said, 'even with that little four-leaf clover over there.'"

Ray laughed.

Sammy didn't. "Dad said I was bad luck, too—just like him. He said I was bad luck sixteen years before when the condom broke, and I was bad luck as soon as I touched that steering wheel. He said none of it surprised him. 'Hard to amount to anything with that kind of luck,' he said."

Sammy's face was doughy as though it might at any moment drip in gooey strands from his skull. His sadness with only one beer in him was different than the sadness of his drunkenness. He palmed tears out of his eyes, but he didn't yell or carry on. He was just sad.

Ray put his hand on his brother's broad back and rubbed a few circles into it. "He said that? Well, he was drunk. He didn't know what the hell he was talking about. I mean, who was it that helped him fix up that old beater he bought when we got back to Ohio? It sure as hell wasn't me. Where would he have been without you?"

Sammy crushed his beer can. He held it in his grip for a moment then eased off and set the mangled aluminum on the floor. "You did make Dad cry, Ray Ray. You did." He leaned back onto the couch and looked up. "I was always jealous of that."

"Jealous?"

Sammy sniffed in a long breath. "Yup." He nodded. "Dad cried about you because he wanted you around. You were like one of his guns. He was so proud of his big shot artist son."

"I'm hardly a big shot."

Sammy shrugged. "I made Dad cry, too. All the time."

Ray sucked his lower lip between his teeth and bit gently. "Sammy."

"You know how I made him cry?"

Ray said nothing.

"He cried because I was still around. Always around. I was like one of his turds. He'd flush me, but somehow I'd drift right back up into his life."

"Don't even talk like that. Dad came to live with you after Mom died. He wanted to be with you. With you."

"And then I lost job after job until I lost everything." He rubbed his hand over his face. "That sounds like bad luck to me."

Ray stood. "That's the past. That's over. You're building new luck, now."

"I don't know."

Ray sat again. Silence settled around them. "I got an idea," he said. "We should keep going. Every room in this house needs fresh paint." He tried to remember the colors Diane had said would look good in each room. "Let's lighten the place up. Let's paint the whole place."

Sammy looked at him.

"Not for free. I'd pay you. I know it would be a lot of work."

Sammy shook his head and stood. "You ain't gotta pay me." He looked around. "What room you want to do next?" he asked, pulling the drop cloth from the couch with the flare of a magician.

Over the next week, they moved from the kitchen to the den to the dining room and then up the stairs to the bedrooms, the upstairs library, the upstairs bathroom. They worked their way through gallons of paint. Sammy checked the answering machine several times a day. Ray waited for his own call, but nothing rang true for either of them.

Chapter XI

While pouring coffee, Ray couldn't shake the thought that he needed to talk to Kleminger. He spread clumps of cream cheese across his bagel. Over the past few days, as they painted, he and Sammy had emptied their cache of subjects for conversation. They'd talked of their childhood, and then they spoke of their father. Sammy couldn't connect to Ray's memories, and Sammy's memories of the man only depressed Ray. They had little else to say, and eventually fell into a silence that soon drove Ray to find a radio. He played afternoon classical from the public station, which left Sammy asking, "When you think this shit's going to turn me into a sissy?" Ray surrendered to the tired guitar, bass, and drum set combo of a local classic rock station. When the songs struck him right, Sammy sang along and nodded his head.

Ray needed a day away from his brother. Although Carl was back from London, Ray's mind kept coming back to Kleminger. He was an artist. He had a calling. He believed in the sculptures he made from furniture. Ray needed to talk with him. At the very least, he needed to explain himself and the prank call, though he wasn't sure if an explanation was possible. Chewing, he wondered how it was that he had become so lost. Could Kleminger make him feel less so?

In a few weeks, he would have to start on his course materials to be ready for the first day of the fall semester. Thoughts of looking for files on his computer and running out to school to make copies left him feeling anxious and melancholy. Thinking about students drained him. Art students. They were always so needy—so wanting to hear that their meager attempts were artistic genius. What had happened to the summer?

Sammy plodded into the kitchen squeezing his hand on top of his head. He found a glass in the cupboard and filled it with water.

"You ever think of taking it easy?"

Sammy finished his water and set the glass down on the counter. He squinted at Ray. "We finished painting your house. I guess I thought it was okay to celebrate." He walked out of the kitchen. A moment later the stairs and then the upstairs joists moaned under his weight.

Ray picked up the glass and opened the dishwasher. Maybe, if he were willing, Kleminger would have some advice for him.

Claude Kleminger's place was on the Hoppler Creek a few miles north of Fisherville. His nearest neighbor was over a mile away. A dense stand of evergreens cut off sight of his home from the road. Ray followed the snaking driveway through the dark trees. They'd been planted too close and seemed impenetrable to walk through. Their branches grew thick and linked overhead, making the driveway a tunnel. Pine cones popped and crackled under the slow advance of his tires. Ray kept his right hand on a wine bottle to keep it from rolling off the passenger seat. His left hand sweat on the wheel at the idea of approaching Claude, and yet Claude seemed the only one that might be able to help him. Claude was a working artist—a real artist.

The pine forest broke and gave way to a front yard of dying wild flowers. Claude's ominous house loomed before Ray at the top of a small rise. Behind the house the air hung hazy and hot over a fallow field. He'd only been there once before, when he'd first been hired and the department held a welcoming reception for him that Claude had agreed to host. Because he'd come at night, Ray remembered only the inside of the house—all of its dark wood and beamed ceilings. He'd never really seen the outside. It was constructed entirely of round stones with many windows glinting in the sun, and two chimneys that rose upward like towers. His eyes were drawn to a copper-clad turret featured above the porch—an addition that Claude had added to the place a few years back.

While he studied the house, gathering the courage to approach the door, Elaine Kleminger came out. She wore a yellow summer

dress. Her long silver hair, pulled back into a pony tail, looked like a young girl's. She carried a slim, swan-necked watering container, which she raised to the flowering plants hanging from the porch. Reaching up, she moved the spout among the red, orange, yellow, white, salmon and pink of the blooms. Her hands came down slowly. She looked out at Ray's car and seemed suddenly nervous.

Ray opened his door and stood. He waved. "Hi, Elaine. It's Ray Casper. I'm just stopping out to see Claude." He pointed, smiling. "What kind of flowers are those? They're beautiful."

"Raymond?" She set the watering can on the rail and came down the porch steps. "It's good to see you." She looked back at the flowers. "They're begonias."

"They're really beautiful," he said. Diane would have known they were begonias. "You must have a green thumb."

They walked towards each other.

"Hardly. Everything else around here is dying," she said before hugging him. She held his wrists after the hug. "This is a surprise." She smiled and then squeezed before letting go.

Ray tried to read her face. "I haven't seen Claude in awhile."

She reached up and checked her ponytail, then fluffed her bangs. "He said that you called this summer. He was surprised by the call."

Swallowing, he searched her face again. Her eyes. Her mouth.

"He said you called so the two of you could meet." She smiled, and something about it was apologetic. "He really doesn't like to go out very often anymore. I hope you weren't offended when he declined."

"I understood," he said. She didn't know. Claude hadn't told her about the prank call. "I'm kind of unexpected today. Maybe he's not up for company."

"Nonsense. You drove all that way. He'll want to see you. He's having a good day today." She nodded, seemingly to herself.

"Are you sure?"

"Oh, yes. He's in the backyard working. Just go around back of the house," she said, motioning. She apologized. "I'm not going to join you. This heat is too much for me." She smiled and held up a finger. "He lets me have one room with an air conditioner in

the window. He says he hates what it does to a house's appearance when every window has a dripping air conditioner hanging out of it." She laughed. "There's no pleasing him."

Ray smiled. "It takes a sculptor to have that kind of appreciation for the appearance of things."

"It just takes a grumpy old curmudgeon is what it takes." She laughed and turned toward the house. "It was good to see you. Come in and say goodbye to me before you leave." She pointed. "Get him talking. He's just around that corner." Going up the steps, she bent for the watering container, and then disappeared into the house.

He stared after her for a moment. After a long breath, he started for the backyard. Then, he turned and jogged back to his car to retrieve the bottle of wine. He rubbed the sweat from the hand that he would use to shake Claude's. Despite the heat of the day, his palms were cold. Would Claude receive him as well as Elaine had? Maybe the prank call hadn't much mattered; maybe he'd even forgotten it. If he hadn't forgotten, then Ray would apologize and maybe try to explain the drunkenness that had lead to it.

Something hummed in the backyard. Turning the corner, he realized it was the crackle of a welding gun. The grass behind the house was yellow and patches of it were burned. The first tree from the backyard to come into his vision was an evergreen. All of its needles were brown. Why hadn't Claude cut the dead thing down?

He soon spotted Claude in the shade of an oak tree—its leaves prematurely yellowing in anticipation of fall. The man under the tree wore jeans, a long-sleeved shirt, welding gloves, and a welding mask. There was no mistaking Kleminger's hobbling walk, which seemed exaggerated, almost comical—like the gait of an oversized penguin. He held a welding gun in his right hand, while circling a framework of wood and metal. From its shape and the springs, Ray guessed that he was manipulating the skeleton of a La-Z-Boy. In other pieces, Claude stripped the furniture clean so what remained was metal and wood. The chair skeleton in front of him still hung with meaty strips of foam, like muscle and fat. Was he trying to get the chair to swallow itself? If he reached what

appeared to be his goal, the recliner would collapse into nothing and disappear.

He bent close to the sculpture and pulled the welding trigger. The light burned like a small sun. Ray shielded his eyes. When Kleminger finished, he raised his visor, examined his work, and then yanked on another piece of metal, bending it upwards and back.

"Claude?"

Kleminger continued.

"Claude?" Ray called again, louder.

He turned furiously, like an animal that had been startled while eating. The stare with which he regarded Ray was stern and seemed to ask, "Just what the hell do you think you're doing here?" A moment later it softened. He nodded and allowed a small smile. "Raymond," he said, the name a chuckle in his mouth. "Have you thought of more clever names to call me?"

Ray looked towards the house. An air conditioner droned in a ground floor window, and he imagined Elaine there. With luck, she was hearing nothing of what they said. He walked closer. "Look, Claude, about that...That was such a mistake. I really don't even—"

"Why are you here?" Claude didn't relax, as though he hoped that Ray were an apparition that would soon vanish.

"I was just hoping to talk. Do you have time?"

"Not really."

"Fair enough," Ray said.

Kleminger stood, his elbows unbending. He seemed hunched, ready to spring or crumple. He set the welding gun on top of the welder, bent down, and turned a dial. "I can take a short break," he said. "Days like this are few for me." He shook his hands, and the welding gloves dropped to the ground. Bowing his head like a knight, he reached up and removed the welding mask. His wavy gray hair was sweaty and clung to his skull. "We'll sit at the picnic table," Claude said, pointing toward the house.

The round table squatted in the shade under what Ray guessed was a kitchen window, given the tiny tomatoes ripening on the sill. He walked over towards it and sat. "You've got tomatoes," he said, pointing.

Claude grunted. "I guess that's what's supposed to pass for tomatoes around here. They look like radishes."

Turning back to face his sculpture, Claude rolled his sleeves and examined the progress of his work. His movements were slow and meticulous. When he turned and finally started towards the table, his knees had little bend to them. He leaned forward, and each step seemed ready to topple him. Ray didn't think that Kleminger could have been much older than his early sixties.

"Don't stare, Raymond. It's not polite." Claude laughed.

Ray looked down. A skeletal Irish Setter was asleep in the shade under the table. Ray's foot was on its tail. He moved it. "There's a dog under here."

Claude lowered himself onto the bench opposite Ray. "That's Fritz."

Ray smiled. He was glad the dog's name wasn't Degas or Rembrandt. Most of his colleagues had animals named for artists. Przybylski and his wife had a Cocker Spaniel named O'Keefe. Ray reached down and petted the dog. Its tail stirred listlessly.

"Fritz has three paws in the grave."

Ray looked up and directly into Claude's green eyes. The rest of him seemed to sag, but his eyes still burned fiercely, flicking about in his sockets.

"What do you have there?"

Ray looked for a moment at the bottle in his hand. "It's a nice little red. It's a gift for you. We can open it if you want."

"I can't drink."

Ray nodded. "Right. You're working."

"Working or not."

Ray stood the bottle on the table. "Well, for Elaine then."

"She doesn't like reds." Claude scratched a hand through his hair, ruffling it. "We'll keep it for guests."

As though she'd been watching them, Elaine came out through a back door and set a pitcher of tea and two rattling glasses of ice between them. She was almost to the door again when she turned around and filled each of the glasses. "Well, talk," she said. "Talk."

"We are. We are."

Ray thanked her.

Claude picked up his glass and studied the rust-colored liquid. "I'd be dead without her, but she's a pain in the arse." He took a drink. "I hate iced tea."

Ray took a sip, set the glass on the table, and wiped his hand on his sleeve. "Look," he said, "I'm really sorry about that phone call."

Claude studied him. Then, like a wounded animal, he turned around slowly towards the fields behind him. The steaminess above the stretch of land had thickened. "Too hot," he said. "This heat is going to take everything out of me." He faced Ray again and blinked deliberately. "Don't worry yourself about the call. I do, however, need to ask if you came only to apologize. If so, apology accepted."

Ray swallowed. "I was hoping to talk."

Claude looked at his welder and then back at Ray. "I can talk, but I don't have time for the things people say before they really say what they have to say. You'll have to get right to your thesis. Just tell me what's on your mind."

Ray said he really didn't have a thesis. A few clouds were stretched thin across the pale sky. He looked at the table and tapped the middle fingernail of his left hand against it. "I don't know, Claude. I guess I'm a little lost."

"Lost?"

Ray nodded.

"So, you're here to talk about you?" Claude studied him. He laughed agreeably.

Ray wasn't sure what to say. He felt his brow furrow.

Claude held up a hand. "No, don't get...It's fine. That's better ...Just go ahead and tell me what you mean by lost." He seemed to relax his shoulders.

Ray clicked his fingernails against his glass. "As an artist, I guess. Just it seems like I'm dried up. I have nothing. I keep waiting for something—an image, a vision, a dream—but nothing comes. I haven't worked all summer."

Claude sniffed a few times. "When did you do *Riverscape?*"

"That was last spring. I know it's crap. It was just—"

"It wasn't all bad."

Fritz's hind leg kicked at a dream. "I know it wasn't good," Ray said.

Claude took a sip of his tea, and the ice chimed against the glass. "Did you know that of everyone in our department, I always thought that you had the most potential? Potential to be a big artist that is."

"Really?"

Claude nodded. "Early on, there was something raw about your work. It imitated, and yet sometimes did something genuine in its imitation. I was on your hiring committee. I remember being struck by your work—not because of its academic perfection, but because of the truth. The people you painted were real."

"I guess I've lost that...barely even remember ever having it."

Claude admitted that it had been sometime since Ray had done anything genuine. "Do you remember those Hopper style pieces you did? They were all set in kitchens. They were part of your hiring packet."

He remembered. He'd modeled scenes on his parents' kitchen. His parents were the subjects.

"The woman was always wrapped up in food," Claude said. "The man was always at the window or moving towards it. There was always a road outside. You painted each with a longing. I remember seeing it in their eyes. The woman was the saddest because she looked into her mashed potatoes or BLTs as though she expected to find Nirvana there."

Ray hadn't thought of those paintings in a long time. They were somewhere in the college's collection. He'd never intended to capture anything. He simply painted a series of kitchen scenes that included his parents as he remembered them. "You liked those?" he asked.

Claude nodded. "I didn't care if they were Hopper-like or not. I just admired that they seemed to tell the truth."

"And since then?"

Claude said that Ray's Neo-Pollock period was not kind to him. "Abstraction is fine," he said, "but you don't borrow somebody else's abstraction. Abstraction is a transference of dreams and spirit to canvas. It has to be original and individual. Pollock was breaking new ground; you were just copying. You

can't adopt somebody else's subconscious or their way to their subconscious. When it works, it's big. But, it seldom works."

Ray remembered seeing his first Pollock. *Number 1A, 1948.* It was like no piece of art he'd ever seen. It was something new under the sun. He sat in front of the mammoth sprawl of color for hours. It was years later that, during another of his artistic droughts, he thought to try something similar.

"I think you have more going on than I do." Ray gestured to the welding equipment.

Claude exhaled a sound that could have been a laugh, but sounded much sadder. "I'm old, Raymond. I've done what I'm going to do."

Something rose in words to the surface of Ray's consciousness. "Though much is taken, much abides; and though we are not now that strength which..." The words dried up. He had had to memorize the poem for a literature class in college. "I forget how the rest of that goes—something about 'equal temper of heroic hearts.'"

"That's your problem."

"What?"

Claude's laugh was scolding. "Did you ever think about who Ulysses is talking to in that poem. For God's sake, do you know how many men of his crew died during the Odyssey? Why would they want to go with him again on another ego trip? They just wanted to get home the first time, and hoped that their self-centered captain would stop getting them into trouble. Just because he's feeling restless he..." Claude stopped. He took a breath. "That's not even the point. The point is we're talking here, and you're quoting Tennyson to me. You're talking to me, sitting here, and you don't even know."

"It's just a poem," Ray said, not quite understanding.

Claude finished his tea. He set the glass on the table, looked at Ray, and sighed. "Understanding mortality is the means to immortality."

"Who said that? Is that Van Gogh?"

"That's Kleminger."

Ray nodded, pretending to understand. He didn't want to embarrass himself by asking.

"You spend too much time in your own head." He pointed at Ray's forehead. "You over think everything. It's the college—it's teaching in a place like that. It makes you forget. It's a lunatic asylum. Art can not come from that which is not the world. You have to live in the world." Claude shook his head. "It's terrible that so many artists and writers have had to turn to teaching to make a living." He smirked. "I started reading a novel last week. It had a beautiful first line—that's why I bought it. How did that go?"

He looked up, as though the line were somewhere in the eaves of the house. "'Waking in the morning, she felt Lawrence's birds still faintly in her subconscious, her dreams or nightmares having released them there.' It's got mystery. Tension. Who is this Lawrence guy? Is he a new lover? Does he keep pigeons? Is he a falconer? It's just a good first line."

Ray thought about the line and nodded.

"It was by a novelist who teaches out in Iowa—some big writing school." Claude's hand flitted around mockingly. "The critics love her. Of course, the critics are probably all ex-students of hers. The main character in the book was a college professor. She was conflicted because she couldn't finish her dissertation on *Moby Dick*. She'd lost interest. But here's the catch—what she really wanted to do was write about D.H. Lawrence and his frequent references to avian life. She felt trapped because the college had hired her as their expert in 19th Century American Literature. She loved Lawrence's work. I mean, that's it. That's the book. At least the first hundred pages." He laughed. "Good God. That's what academic life does. It rips the guts right out of people. I threw that book in the garbage. Beautiful writing, but it was all false."

"That's too bad," Ray said, trying to understand how the novel applied to him.

"That's not to say it's not noble." Claude adjusted himself on the bench.

"What?"

"Teaching, Raymond. Even if it takes time from our work, we have to take it seriously. I hear students talk about your classes.

If even half of it's true, it's shameful." He picked up his empty glass and then set it down again.

Ray's cheeks warmed. He reached under the table and petted the dog. "I know I could give my students more," he admitted.

"Let them give to you, too. They live in the real world. Listen to their stories when they want to talk. The news of the world comes through the mouths of ordinary people. It's a way to keep your finger on the pulse of what's going on, a view of the collective concern."

Ray drank his tea. The ice cubes, shrunken down to slivers, slipped down his throat. He sat for a minute trying to decide if anything about the visit had been helpful. More than anything, he felt heavy with guilt.

"Are you any less lost? Is this the kind of talk you wanted to have?" Claude asked. He rubbed his eyes. "I really should get back to work."

Ray wanted to understand what Claude meant by "live in the world." But wouldn't he look like an idiot for not already knowing?

"If you want my opinion—my final thought," Claude started, standing slowly. "I think you're too self-involved. You can't be an observer in that frame of mind. Get over yourself."

Self involved. It was something Marcy used to say about him. Anger simmered in Ray's guts. He'd just wanted to talk, not to be psychoanalyzed. Where did Claude get off with all of the lecturing?

Claude lifted his legs carefully until both were on the other side of the bench. He stood into his rigid walk toward the welder. "I have to keep working," he exhaled.

"Look, thanks for talking," Ray said. "Thanks for—"

Something was happening. Claude's legs suddenly stopped moving. His torso didn't stop. He fell, and his body made a muffled thud against the ground.

Ray ran to him and crouched, putting his hands on his ribs. "Don't!"

"I was just—"

"I'm fine! I'm fine. I can get up by myself."

Ray stood and watched Kleminger struggle to his feet. His body seemed to wrestle against the effort.

When he was up again, he didn't look at Ray. He took a moment and steadied his breaths. "I'd walk with you to your car, but I can't. I need to work. I will see you in a couple weeks when classes start. I hope you start painting again soon." He staggered toward the welding equipment and didn't fall. He fit the mask over his head and drew on his gloves. He seemed to have forgotten that Ray had ever been in the yard, or at least he seemed to be trying to forget.

Having seen Claude go down, Ray was no longer angry. He felt he should go and ask him if he was okay. But then, why? He could already hear the answer. "Of course. Of course. It's just age. You'll get older too, Raymond."

Claude lowered the visor and hit the trigger. Ray turned away from the small, fierce light.

He went through the back door to say goodbye to Elaine and found her in the kitchen. Her back was to him. She didn't turn when he came into the room. Her elbow moved, and she knocked a steady rhythm with a knife against a cutting board.

Out of its ponytail, her silver hair fanned across her back. He liked that she hadn't chopped it short like so many middle-aged women do. Diane had promised him that she would never cut her hair.

Diane. Thoughts of her could still hit him like a sudden fever. "Are you getting ready to cook something?" he asked after a moment.

Elaine jumped. When she turned to him, she held half a carrot over her heart and still held the knife firmly in her other hand. Her face soon relaxed into a smile. "You startled me."

He apologized. "You said I should come in and say goodbye."

Nodding, she set the carrot and knife on the counter. "I know. I'm glad you did." She wiped her hands on a towel. "Sit down."

Ray pulled out one of the two chairs from under a small breakfast nook table. Pulling out the other, she set her own glass of iced tea between them.

"Did you have a nice talk?"

"Oh, sure. Claude's an interesting man."

She smiled. "Yes, he's got an answer for everything." She looked at Ray, and her eyes seemed to go out of focus. Then she blinked, and the focus came back. "So, what did you talk about?"

She didn't need to know everything. "Mainly art."

She squeezed the knuckles of her hands. Arthritis? Maybe the two of them were much older than Ray knew.

She looked at the table. "He didn't offend you at all, did he? I apologize if he did. In the last couple of months he's started to believe that he can say whatever he wants, however he wants— not that he's ever been much of a shrinking violet."

Ray said that he was fine. "I'm used to Claude. He doesn't bother me. I like his honesty."

She stretched herself up and looked out the window. "He's still working," she said, relaxing into her seat again. "Did he say anything else? Did he get a chance to talk with you about anything that he's been feeling?"

"Feeling? Not really. I don't think so."

She sighed. "I think he's really scared, but he won't talk. I tell him that he'll feel better if he talks, but he won't. Not to me, anyway. I thought he might with you." She said she was glad that Ray had at least tried. "It's very nice of you."

His eye twitched. "I'm not...I don't even...I guess I don't understand. Is something wrong with Claude?"

She lifted her head and looked directly into his eyes. If her face showed shock, it quickly melted into something more tender. "You don't even...I thought the whole department knew. I guess I thought that's why you came." She reached across the table and took his hand. She held it for a moment, and her eyes went watery. "Claude has MS."

Ray sat for a moment with the news and then, feeling compelled, squeezed her hand sympathetically. "I hadn't heard."

Chapter XII

Cars raced by him on US-10. A few honked. Ray pressed the gas and got back up to the speed limit. He changed lanes. Going by his driver's side door, cars after car bolted past, some of the drivers casting scolding looks. He was too slow even for the slow lane. Too much thinking.

Elaine had explained what had been happening with Claude. Five years ago, doctors diagnosed the MS. At the time, they put him on pills. His symptoms weren't bad, and the medicine made his life nearly normal. Trying to help himself, he lost weight by cutting out all processed flours. He started taking walks. A year after the diagnosis, the doctors were pleased with his control over the disease. They said he might very well live a normal life. "People with MS don't really live any shorter lives than anyone else," Elaine said.

Then, this past spring, his symptoms started to worsen. He had new symptoms: blurred vision, slurred speech, numbness, poor balance, forgetfulness. He went back to the doctors, and their conclusion was that for some unexplainable reason, the disease was progressing rapidly. It sometimes happened. Every month he got worse. They predicted that he would be in a wheelchair by the beginning of the next spring. "This is going to be his last semester of teaching," Elaine had said, weeping openly, "unless the new pills he's on do something." Ray couldn't do much more than say how sorry he was for the both of them. "He didn't seem that bad to me today," he offered, lying.

"It was one of his good days," she said.

The flat of Mid-Michigan slid past. Ray thought about what Claude had said to him. Live in the world. As he worked it over in his head, an idea came to him. The Museum of Modern Art in

Chicago. Only a five-hour drive. He'd done nothing else that summer to recharge his artistic battery. Maybe surrounding himself with the output of other artists—artists he seldom had exposure to—would be just the thing he needed. Kleminger said to live in the world. Wasn't Ray's world, even if it had its warts, the world of modern art? He needed to keep abreast of what was happening. His world certainly wasn't Dow University with its politics and has-been artists—a world that would soon be his reality. Commercials marketing credit cards to college students were already all over the television. The first day of the semester would be upon him in no time, not to mention the first day-long departmental meeting.

He pulled into his driveway. Since he was taking his own car, he could leave for Chicago the next day—no fuss with airline tickets, passports or travel plans. Something simmered pleasurably just below the surface of his skin. Maybe Claude was right. Maybe all he needed was to get out of the world he'd made for himself and into a world that had more to do with art.

Opening the door, he was startled to find a man he'd never seen before bending down into the refrigerator. Broad-shouldered, he wore jeans, black work boots, and a Detroit Lions t-shirt. When he came up from the fridge, he was holding a beer. He nodded to Ray.

"You Sammy's brother?" He sported a salt and pepper goatee. "Uh huh."

"Good to meet ya. I was just getting a beer." He held up the can as evidence, turned, and then walked into the living room.

The door between the rooms swung back and forth on its hinges in diminishing arcs. Ray watched it until it was still. The voice of the man he'd just met, and Sammy's voice, and at least one other man's voice came from the living room. They weren't talking to each other, but instead were thinking aloud about something that was happening on the television. They talked about rivers, back doors, big slicks, flops, blinds, and scare cards. An announcer's voice gave a play-by-play in a staged whisper. Calling up courage to face whatever he might find there, Ray went into the living room.

The odor of cigarettes came to him immediately. It wasn't strong, so he guessed that they hadn't been smoking in the house. They must have been making trips to the porch. The neighbors probably thought he'd opened a halfway house.

Sammy shifted his ass on a Windsor chair. Another man sat on the couch next to the man with the goatee. He wore camouflage pants, a t-shirt, and a baseball hat over his long hair. Ray wondered what kind of smells they were leaving on the furniture. He remembered the day he and Diane had bought the leather couch.

Sammy noticed Ray. "Hey, what's up, Ray Ray?" He moved forward on his chair and motioned towards the other men. His own movements became those of a salesman, exaggerated, as though trying to hide some kind of sleight of hand. "Just having a couple of friends over. Just some friends. This is Stevie and Dennis. Guys, this is my brother. Ray."

The men shifted their eyes almost imperceptibly toward him and then back to the television. "Hey," they said in unison. The one with the baseball hat took a quick sip of his beer as though to wash away a bad taste that the sight of Ray had left in his mouth.

To them, it seemed, the house was as much Sammy's as it was his. Ray didn't like the feeling.

"So where you been?" Sammy asked, grinning a little too eagerly.

Ray maneuvered so he could see the television. "I went to see a friend."

"Really? Good to have friends, right?"

The men on the television huddled around a flashy poker table. Close-ups revealed their histrionics. One, an Asian, wore Blues Brothers sunglasses. Another wore a cowboy hat and a bola tie. A third looked like he was part of the mafia. Another, with a long bang in his eyes, looked like he'd skateboarded to the game.

Ray couldn't understand why anyone would watch people play cards on television. It was like watching golf or fishing. Pointless. "I have a deck of cards in my kitchen if you guys want to play," he said, emphasizing the word "my."

The men flicked a glance at Ray, looked for a slightly longer time at Sammy, and then went back to the television.

"We're good," the one with the goatee said.

Sammy laughed. Ray heard the dual nature of the laugh. Part of it was for him, and it thanked him for his generous offer of the cards. Part of it was for Stevie and Dennis, and it apologized for Ray being so stupid. "This is Texas Hold 'Em," he said. "It's fucking great. Haven't you ever watched it?"

Ray felt like Felix Unger. "I really don't watch television," he said, guessing that he was only making himself look more suspect to the strangers on his couch. "I mean, I really only watch the news." He thought he heard a snigger.

"You should check this out with us," Sammy said. "You might like it."

Ray watched. Nothing that happened on the screen made any sense to him. He didn't like how these strangers on his couch had sapped all of the enthusiasm he'd had for his trip to Chicago. Without speaking or even acknowledging him, they seemed to be judging him. Who the hell were they? He remembered when he'd felt like this before—in his teens, when his father had friends over to watch football or baseball. While his father called him Ray Ray, his father's friends called him Fay Wray. They ranked art alongside needlepoint. His father never came to his defense. "Well," he'd say, "my wife wanted a boy and a girl, and sonuvabitch if her dream didn't come true." Later, he'd come into Ray's room, drunk and remorseful. "I'm just shitting with ya when I rib ya a little bit. I love your drawings, Ray Ray. You're going to be something, something a helluva lot bigger than me."

Ray looked at the men on his couch. Bums. Stanley Kowalskis —without the good looks. It didn't surprise him that they wanted to watch other men gamble on television. Gambling for themselves would take some courage, some initiative.

The show went to a commercial break, and the men peeled themselves from the leather.

"Can I get a smoke, Sammy?" the one in the baseball cap asked.

Sammy reached into his pocket and threw him his pack.

Ray surmised how his brother fit into this arrangement. He was the dupe. He was the eager moron with the refrigerator full

of beer, the cigarettes, and the big house. They didn't really like him, but he was an easy mark.

"Why didn't he borrow a cigarette from him?" Ray asked once the men were on the porch.

"Who? Stevie? Stevie smokes menthols."

"Oh." Ray sat on the couch.

"You pissed?" Sammy asked.

"Why would I be angry?"

He rolled his beer can between his palms. "Because I got these guys over that you don't know. I didn't ask or—"

"I told you to make yourself at home. You don't have to ask."

"They're not bad guys," Sammy said. "They're good guys. They've been helping me look for work. Stevie works at Oracle. He says he'll be able to pull strings for me this winter."

Ray asked about Dennis.

"He's got his own home repair business. Hasn't had a job in awhile, but times are tight. Nobody's spending. People are doing their own repairs."

"I'm sure."

Sammy looked at him. "Ray Ray, they ain't bad guys."

Ray played with his lower lip.

Out on the porch the two spoke loudly and made their points with profanity. It was two o'clock in the afternoon, and there were eleven beer cans on the coffee table. Ray imagined the cigarette butts on his front lawn. Sammy felt comfortable enough to have friends over when Ray was still in town. What might he do if Ray was five hours away and not due back for three days? Images of Sammy in tighty whities sliding around on the hardwood like Tom Cruise filled his mind. What kind of party would follow Sammy's rendition of "Old Time Rock & Roll"? The hookers of *Risky Business* didn't seem too far fetched for Sammy's plan, except in his case they would look nothing like Rebecca De Mornay. And the state of the house? Ray guessed that more damage would be done than a nearly invisible crack in a glass egg. His house would look like a war zone.

He couldn't go to Chicago. Or, if he really felt he needed to go, then he would have to bring Sammy with him. He shook his head and sighed.

"What's wrong, bro?"

Ray rubbed his palms on his thighs. "Look, Sammy, just try to hold off a little on the drinking today. I want to get on the road early tomorrow."

"On the road?"

"Yeah. I was thinking that with classes starting and you probably going to work soon that we should take one last summer vacation. I thought we could drive over to Chicago."

Sammy rubbed the back of his hand under his nose. "Why?"

Ray didn't think it would be a good idea to mention museums. "I don't know...we could soak in a hot tub at some downtown hotel, eat Chicago-style pizza, drink a few beers, take in a baseball game."

"Dad hated the Cubs."

Ray stood. "We can boo them." He picked up an armload of cans from the table and brought them into the kitchen.

"I ain't got money for a trip like that," Sammy said when Ray came back into the room.

The card game was on the television again, but Stevie and Dennis weren't back. Ray guessed that they were waiting for him to leave. "You wouldn't need money. My treat. Hell, I owe you for all the painting you did around here."

"You don't owe me nothing." Sammy leaned towards the porch door. "Guys, it's back on."

"In any case, let's plan on it. I'll get you up at eight. You can sleep in the car if you want. Just make sure you make some time to pack tonight."

Sammy shrugged. "What if someone calls about a job?"

"We can call and check my machine from the hotel."

Stevie and Dennis came in and found their places on the couch again.

Sammy turned to the television. "Hope you guys smoked one for me."

"Big pot," Dennis said, snapping his head toward the television.

They leaned in close to the screen. The announcer talked as though something important were about to happen.

Ray cleared his throat. "Sammy? Remember to leave some time."

He nodded. "Yeah, sure. Whatever. Eight o'clock tomorrow."

The men moaned about something happening on the screen.

"That sonuvabitch," Sammy said, when Ray went into the kitchen.

He stayed close to the door and listened.

"That chink shouldn't be allowed to wear them glasses," Dennis said. "How the hell is anyone supposed to read his eyes to see if he's bluffing?"

Stevie asked how anyone would be able to see his eyes even without the glasses.

They laughed.

Ray rubbed his hand over his face.

Chapter XIII

Ray let Sammy sleep in. Sitting near the front window, drinking coffee, he watched the rain's angry downpour. A small lake formed in the old couple's yard across the street. Crashing through the puddles on corners, cars nearly disappeared. The gutters raged with bonsai rivers, carrying a torrent of sticks, potato chip bags, and water bottles. He guessed it would let up, but it was eleven o'clock when he decided that they'd just have to risk it. According to the green masses in the weather report, it looked like they'd drive out of the rain if they were headed south.

Sammy stared out the kitchen window.

"Let's go. We're all packed," Ray said. "What are you staring at?"

"Just watching to see if a god-damn ark goes by."

Ray followed US-10 out of town and then followed the downward spiral of the on-ramp toward I-75. Even with his windshield wipers on high, he squinted to keep the road.

Sammy told him to take it easy. "It ain't a race. You can hydroplane in this shit."

Ray smirked at the irony. "Yeah, maybe I'd drive better if I were drunk." Trying the accelerator, he watched the needle climb the speedometer. Anything above forty-five, and the water on the road grabbed at his tires. It tugged him toward the shoulder or skated him toward the other lane.

"Can't we leave tomorrow?" Sammy sat upright, attentive, watching the road.

"We'll be fine. Take a nap. When you wake up, we'll be out of this rain," Ray said. Gripping the wheel, the friction of it hot under his palms, he tried to stir up the excitement he'd felt the

day before. It was like his recent ideas for paintings—an initial burst and then a hopeless recoiling.

No. He couldn't abandon the trip. It was a quest. It was at least something, something more than the summer had given him so far. Chicago or bust. Something good would come out of it. At least Sammy had fallen asleep. Ray turned on the public radio station and listened to a noon-hour jazz program, but the chaos of rain and music left him jittery. He turned it off and concentrated on the road.

An hour and a half later, he approached the outskirts of Flint, twice as long as the trip usually took. Sammy was snoring. Ray followed M-23, where it split away from I-75, working straight south toward Ann Arbor. A few miles after the split, traffic slowed, jerked along for a half mile, and then stopped altogether. He glowered past the convulsions of his wipers and into a river of watery brake lights. Ten minutes passed without movement. Turning on the radio, he found a local rock station. He wanted a news report, either something about what was happening on the highway or something about the weather. "Born in the U.S.A.," a singer bellowed, "Born in the U.S.A." The song faded out.

"That a cd?" Sammy mumbled. "You listening to The Boss?"

"I don't know what I'm listening to, I'm just glad it's over."

"You kidding? The Boss has some good shit. Even Dad liked him."

Ray shushed him. "I'm listening for a news report. Just be quiet for a second."

Mindless commercial segued into mindless commercial. Somebody actually got paid to write and produce that garbage.

"How long we been stopped?"

"Okay, quiet," Ray said, hearing a news break begin.

Sammy slid out into the rain. He slammed the door and then leaned against the car, flipping up the hood of his sweatshirt.

Ray wondered for a moment, but then saw the huddling and the flick of flame. He shook his head. A cigarette in a downpour. What a terrible addiction.

The newscaster, probably twenty years old, sounded like he was trying to make the weather hip and cool. "That big gray is turning south now, so we're going to be living with the wet stuff

a little longer. Speaking of which, it's a great Sunday to get close to your woman, get a little wet, and listen to classic rock on WIKD 90.3—Wicked Rock." The weather switched into a thirty second road report, which gave no indication why traffic hadn't moved in over fifteen minutes. "Drive slow and rock hard," the newsman offered.

Turning it off, Ray nearly yanked the knob from the radio.

Sammy opened his door and dropped into the passenger seat. No part of him was dry.

"So, was that worth it?" Ray asked.

"Rather be out there than in here."

"What's that mean?"

Sammy snickered. "You asked me to come with you, but you been a pissy asshole since you woke me up. I didn't fucking make it rain. It's not my fault were in a traffic jam."

He was right. "Look," Ray said, "I'm sorry. I'll be better once we get to Chicago."

"I gotta wait that long?"

Ray smiled and nodded. "No, you're right. I'll be better now." As a peace offering, he turned on the rock station again.

Sammy sat up at the sound of the guitar. "They must be doing a Springsteen tribute today." He moved his head and whispered the words to himself.

Ahead the brake lights began to flash out. They were moving. "Springsteen? I thought this was The Boss," Ray said.

Sammy looked at him. "Don't even, man." He gripped the neck of an invisible guitar and strummed the air in front of his belly. "Don't even."

Ray grinned. "So, you like this music?"

Sammy stared at him with suspenseful and dramatic eyes.

"What?" Ray asked, smiling. Traffic in front of them began to move. "Here we go," he said. He eased off the brake.

Sammy pointed toward the windshield and sang into an invisible microphone, drowning out The Boss. He sang about the highway being jammed and broken heroes and having no place left to hide. He fumbled the next lyric and mumbled along for a few lines.

"Your singing's not too bad," Ray said.

Picking up the gist, and recalling the words as though it were always a part of his unconscious, Ray sang along. He followed the other drivers, accelerating to ten, fifteen, twenty. He belted out a "Born to Run" that got Sammy laughing. They sang together, shouting the lyrics triumphantly. A moment later, Ray hit the brakes, nearly rear-ending the car in front of him. The stretch of road ahead turned red again. The song ended. The rain and the traffic jam continued like a long sorrow. Sammy soon fell asleep, and Ray turned the radio off.

It was nearly seven o'clock when they decided to take refuge at a motel they'd found outside of Kalamazoo. Sammy went straight to the pool. Ray sat on the bed and looked out the window into the darkness. Brief flashes of headlight came intermittently from the county highway that ran behind the motel. What turned out to be an accident south of Flint had kept them for another forty-five minutes. When they could speed up, the rain still held them well below the speed limit. The downpour finally became sprinkles near Ann Arbor. After several miles along I-94, where Ray set the cruise control at eighty, they decided to stop and take a late lunch in Chelsea at the Capri Diner. Famous for its hamburgers, its reputation went as far south as Toledo, where friends of Sammy's—men who hunted deer in Michigan—swore that the Big Capri, a one-pound burger, was better than sex.

Witnessing Sammy eat the Big Capri was nearly as uncomfortable as watching someone have sex. He made animal noises, and the eating of it left a greasy ring around his mouth. Ray poked at his "house salad," a bowl mainly filled with iceberg lettuce.

After the meal, they were able to go eighty for about ten minutes, until a construction zone slowed them to fifteen. The stretch of dirt, yellow trucks, and torn up asphalt lasted for twenty-five miles. Ray felt nearly dead by the time they reached Kalamazoo. When Sammy got back from the pool, they'd go to bed. In the morning, they'd get in the car and drive back to Bay City. Whatever had been pulling him toward the Windy City had drown in the day's downpour. The Museum of Modern Art, he thought, shaking his head. Why had he ever wanted to go? He'd been before, and most of it was nonsense. In one room he remembered that someone had put a bullet on the floor in the

glow of a reading lamp. Otherwise, the room was black. *The Infinitesimal Father, Son, and Holy Spirit.* What a title. Ridiculous.

Sammy burst into the room, dripping. The chemical smell of the pool water came in with him. "You should have went. That pool wasn't bad at all...even had a sauna," he said, pulling clothes from one of the two grocery bags he'd used as luggage. "Did you call the house? Were there any messages?"

"No."

"Hey, don't get like that again. At least we're out of that goddamn car." He laid out jeans and a Hawaiian-style shirt. "I'm gonna wash off this chlorine."

"Go ahead."

Sammy turned on the shower. "We should go out," he shouted.

"What?"

"We should go out to eat. Have a few beers. Or wine or whatever. We're on vacation, we should live it up."

"We're in a motel in Comstock, Michigan. That doesn't sound like a vacation. It sounds like hell."

"Kalamazoo's downtown ain't too far away."

Ray searched for the remote control, finding it in the drawer next to the bible. "I just want to go to bed and put this day behind us. How can you even be hungry? There must have been half a cow ground up in that burger." Despite his words, he was hungry. The salad had done little to fill him up.

Sammy turned off the water. The shower rings screeched across the bar. "Oh, I'm hungry alright. And, I'm not just talking about food."

Ray turned on the news. "Don't be hurt, but I don't think I can handle it if you get drunk tonight."

"I'm not talking drinking."

"What?"

He leaned out the bathroom door. He'd slicked his hair back. It was the cleanest he'd looked in some time, made cleaner by his smile. "I'm ready to prowl," he said. "I got a little tingle in my dingle." His head disappeared again.

In spite of himself, Ray laughed. "You're something else, Sammy."

"You can't deny the tingle." He came out of the bathroom and flopped on the other bed. One of his testicles poked out through a hole in the crotch of his boxers. "So, what do you think? You wanna go out?"

Ray turned his head away. "Yes. Whatever. Just put some clothes on."

They drove into town and found a pub near the university. Sammy ordered a New York strip, and Ray followed his lead.

"Red meat?" Sammy asked.

Ray said he liked a steak from time to time. "We're on vacation. Gotta live a little." Saliva seeped into his mouth at the thought. He picked up the wine list. It was decent. When the waitress came by, Ray ordered a shiraz.

Sammy took a swig of his beer and lit a cigarette. "You ever order a man's drink?"

"I like a good shiraz." Ray glanced around. "It puts a little tingle in my dingle."

Sammy laughed and raised his mug. "Well, shit, I can drink to that. I might have to order a glass myself."

Most of the other people in the bar were younger, probably students from Western Michigan University. Ray and Sammy watched them for a moment in silence.

"Have you ever thought about going back to school?" Ray asked. "I mean, you're not too old. Some of the people I get in my classes are in their fifties."

Sammy exhaled into the light above their table. The smoke circled slothfully around the bulb. "School was never really my thing."

Ray shrugged, sipped his wine, and drummed his fingers on the table. "That's the past. It doesn't have to be now."

"I know."

"I'd be willing to help you pay if you wanted to take some classes."

Sammy took a long drag and exhaled over his shoulder. "I probably won't get a call about a job, will I?"

Ray ran his finger along the stem of his wine glass. "I don't know, Sammy, you might. I'm just saying that having a degree or

even some college classes under your belt would probably give you more opportunities."

Sammy looked over Ray's shoulder. He sat up straight. "Is she—?"

"Professor Casper?" A woman's voice came from behind Ray. He turned.

"Oh my God. It is you. What are you doing here?" She was teeth, and curves, and long brown hair. She hugged him. "I can't believe you're here." She stood back and looked into his face. "What are you doing here? You don't even remember me, do you?"

For a moment he didn't. Then her name surfaced, and he smiled. "Of course I remember you, Chloe." She'd been a student of his in Drawing II, Painting I, and Painting II. She was very talented.

"Oh my God, I can't believe you're sitting here," she said, still smiling. She was wearing a polo shirt with the name of the pub stretched over her chest.

A waitress. So, this was where his best students ended up. "You work here, then?" He didn't like the way the question came out. "I mean in Kalamazoo? How did you end up here?"

She squeezed his arm. "Only because of you."

"Hmm?"

"Your recommendation letter. My advisor even let me read it. I couldn't believe you were talking about me."

"I guess I'm not sure—"

"I'm working on my MFA at Western. Don't you remember that I asked you for a recommendation letter?" She seemed hurt.

Recommendation letter. It was on the hard drive of his computer. When students asked for one, he called up the existing letter, changed the names and addresses, and sent it out. He'd used the same letter for years, though no recent student had asked for one. "Okay," he said. "That's right. Now I remember. Yes, okay, I remember that letter. 'When I helped her with her paintings, I felt like I was working with a colleague, not a student.'"

"Yes," she said, her smile coming again. "You still remember it."

He wanted her to keep smiling. "And now you're working on an MFA?"

"Almost done with it."

"And this?" he said, tugging the sleeve of her polo shirt.

"Summer work," she said. She looked into his eyes and smiled. "My teaching assistantship starts again in the fall. In fact, tonight is my last night here."

Ray released her sleeve and took a drink of wine. "It's really good to see you," he said.

"I'm chopped liver," Sammy announced, lighting another cigarette.

Ray looked at Sammy and then back to Chloe. He apologized. "This is my brother. Sammy."

She set her hand into his. Sammy kissed it.

"Careful, he hasn't eaten," Ray said, watching to see how Sammy would react to the teasing.

"You'd be just about the perfect mouthful," Sammy said.

Ray thought he saw him look at her chest.

Chloe laughed. "I didn't even know you had a brother," she said, retrieving her hand.

"Neither did Ray Ray," Sammy said, taking a drag. He looked serious but then forced a grin. "Unless you're a painting, he don't even know you exist."

"Ray Ray?" Chloe said. "That's so cute."

Ray blushed. "It's an old nickname."

Their own waitress arrived with a tray balanced on the palm of her hand. She eyed Chloe accusingly. It was the first time that Ray really noticed her, even though she'd been to the table several times. At one time she may have been as pretty as Chloe, but age, hard work, and years of cigarettes—evidenced in the wrinkles around her upper lip—had hardened her. Her hair looked brittle and was a decade out of style. The perk of her breasts was clearly more bra than flesh. Still, Ray found himself drawn to her, too. The night suddenly had him feeling open to everything. Was it the wine or the way the long drive had left him feeling punchy?

Of the two, the older waitress would make a better painting subject than Chloe. There was a truth about her, especially in the way she did such a poor job of pretending to care. She didn't care. She was a waitress. She was nice for the most American reason. Because she wanted money.

Setting their food down, she asked if they needed anything else, and then threaded back into the smoky movements of the bar.

"You'll be here for awhile?" Chloe asked.

Ray took a drink of wine and nodded. The older waitress lingered in his mind. He needed to remember her. Needed to paint her.

"We'll be here," Sammy added to Ray's nod.

She told them she was finished with her shift in a half hour. "Could I join you guys for a drink?"

"Of course," Ray said.

"Okay. Good." She smiled and then left for her tables.

Ray watched her behind. He turned back to the steaming steak in front of him.

"She wants you," Sammy said. He cut his meat up into child-ready pieces. He stabbed one of the pieces and hoisted it into his mouth.

"She's a student," Ray said, as much to himself as to Sammy.

"She ain't your student."

He'd already thought the same thing.

"Probably twenty-three or twenty-four," Sammy said. "Hard little body."

Ray had guessed twenty-six. "She is gorgeous, isn't she?" Shocking images came into his mind. He imagined his hands sliding up her belly and finding the firmness of her breasts. He sawed a piece from his steak and chewed it ravenously. "I can't believe how good this tastes."

Sammy nodded and smiled. Picking up a piece between his finger and thumb, he brought it to his mouth. "You know why guys like steak so much, don't ya?" He flicked the tip of his tongue against the meat. "Tastes like sex."

Ray took a quick drink of wine, as though absolving himself from what he'd heard. "Jesus Christ, Sammy." He shook his head. "You're a pig."

Sammy popped the morsel into his mouth and chewed. "Sorry. I forgot. You probably want to paint a picture of her."

Chapter XIV

Ray slid the plastic into the slot a third time. The wine he'd had tingled in his cheeks.

Chloe giggled. "You're not holding it in long enough," she said.

"What the hell was so wrong about having a key?" He pushed the plastic card into the lock again.

"There's the green light."

He turned the knob, and the strike latch slipped from the strike plate. He opened the door slightly and then paused.

The green light.

He turned and looked into her eyes. He had to know what this was going to be. If it was only going to be him looking at her slides, that was one thing. But, if not, that was another.

Her irises sparked for a moment, but she couldn't hold his gaze. She looked at the floor, seemingly shy. In one hand she held a slide box and in the other, a portable light table. Usually when students wanted to show him work—not that many did anymore— they brought laptops and jpeg files. Chloe's light table had him feeling like a grad student again.

He slipped his hand up to her face, held it there for a moment against her silken cheek, and then moved his fingers into her hair and behind her head. She leaned forward with the coaxing of his hand, and their mouths met. He tasted the rum and cokes she'd been drinking. He stopped. She was smiling, flushed. "Let's look at your work," he said, opening the door the rest of the way.

She nodded...

When her shift had ended, she'd joined them. They moved into the bar and sat at a corner table. Ray told her about the aborted Chicago trip. He didn't mention his own artistic drought. When Sammy went to use the restroom, Chloe confessed that

she once had a crush on Ray. "You were such a force in the classroom," she said. "I think every girl had a crush on you."

"I doubt that."

The conversation eventually turned to her painting. She talked about grad school, student teaching, and the difficulty of making time for herself in the studio. She said she really wished that he could see what she'd been doing. "Well, shit," Sammy said, "you gotta see her stuff. Take the car and go look at her paintings."

Chloe explained that her roommates would be home. Ray asked if the work was something they could look at in the motel room. "We'd just need to swing by my place to pick up a few things," she said. They decided that she would drive, and Sammy could take Ray's car. "Just take it easy," Ray warned.

Chloe walked out ahead of them. Sammy put his hand on Ray's shoulder. "If she's parked in the parking lot when I get there, I'll sleep in the car." Ray started to deny, but then nodded. "What are you going to do with the rest of the night?" he asked. Sammy shrugged and grinned. "Cruise around...see if the women in this town go for fat, unemployed guys."

Chloe set her slide table on the bed and plugged it in. "I can't believe you're here. In Kalamazoo."

"I can't believe we bought a bottle of wine and didn't think about a corkscrew." He looked at the stretch of her tan legs emerging from her work skirt.

"I don't think we need more to drink." She pulled her knees up onto the bed and leaned her weight on one arm. "Do you want to look at a few of my pieces?"

He shut off the lamp, and Chloe glowed angelic in the luminescence of the light table.

He walked over. "Let's see what you have here, shall we?"

Sitting down, he kept the light box between them. This was its own business, not to be mixed with sex. If there was to be something more, there would be time for it. First, they would look at her work. He was curious to see how far she'd come.

"I'm nervous about you seeing these," she said, pushing her finger through the slide box.

"Why?"

Silence.

Ray looked up. She was staring at him in the dim light.

"Don't you know?" she asked. "You were the one that made me an artist."

"As I remember, you were already pretty talented."

She said she wasn't talking about talent. "You made me understand what an artist does. You even told me that I should be careful about the MFA. You said I needed a vision and that sometimes too much school could make artists blind to their own vision." Her hand, holding a slide, hovered above the light table. "And now you're about to see what I've been up to. What if it's no good?"

"I'm sure it's good."

She put her other hand on top of his. Her palm was warm. "I don't want you to tell me it's good if it's not good. I want you to be honest with me."

He swallowed. "I'll be honest." He listened to himself say it.

She began to set the slide down, but then drew her hand back. She filed it into the box again.

"Why aren't you—"

She said there were others she wanted to show him. "I want you to see the ones I'm the most excited about." She pinched nearly a dozen together, drew them out, and began setting them on the table like a blackjack dealer. When she was finished, she drew her hand away and took a deep breath. "Now I wish we did have some wine."

Ray leaned over the light. Each slide showed seemingly the same thing. They were paintings of drivers, people behind the wheel. He looked closer. Though similar in theme, each painting was different. Some of the cars had a lone driver, some had a driver and a passenger, some had a man, a woman, and a child in the back seat. Others were from the opposite perspective, as though Chloe were sitting in the back seat while she painted. His heart pulsed against his ribs. The paintings were good. Incredibly good. Her technique alone—her ability to capture the distortion of the windshield, the shrinking perspective of the rearview mirror—was better than anything he'd seen in his own classroom in some time. "Chloe," he said. He reached out to touch her, but found only air. He set his groping hand on the bed. "These are

good. These are more than good. Christ, these are good." He leaned closer.

"You don't have to say that."

"I'm not just saying it." His face was inches from the table. "How did you...their faces. They really look like they're driving. I mean, the gaze of the drivers. It goes right past me, as though I can feel the road behind me that they are driving into."

Her voice quivered. "That was something I...I knew I had to get that right." She cleared her throat. "I mounted a video camera on my dashboard. When I made long trips, I filmed myself driving." She said she was able to get friends to let her do the same. "I have hours and hours of tape. People on country roads. People driving through cities, through rush hour in Chicago." She moved a few of the slides almost imperceptibly. "There's a face people get when they're driving. It's a look I've never really seen at any other time. I don't know...It's really amazing what we're doing when we're driving. Our lives are in our hands, we're steering a ton a steel, and yet our minds are almost in a dream state."

He moved one of the slides and singled it out. "The faces are perfect," he said, tapping the edge, "and what you just said... it's a metaphor, really. Our lives are in our own hands and yet our minds are almost in a dream state. It's a metaphor for life."

She said nothing, but he felt her excitement shimmering next to him. He was excited for her. His eyes passed around the slides and he nodded. He singled out a second one. "This one," he said, tapping the light table just beneath it. "This one is really good."

Chloe pressed something into his hand. An eye loupe. "Get a closer look," she said.

He leaned down, pressing his eye to the magnifier. The perspective of the painting was from the rear seat. The driver, a woman, leaned over into the mirror to apply makeup. Ahead of her, the cars were braking. Red. The red played off the red of her lipstick. Her speedometer remained steady at eighty-one. "The brake lights are perfect," Ray said. "Believe me, I know." He studied it a moment longer. "What were you after in this one?"

"That's one of my favorites," she said. She laughed. "Am I allowed to say that?" She leaned close until their heads were nearly touching. "I was after a lot in that one—maybe too much."

"What did you title it?"

She said she was never good with titles. "I called it *The Moment Before*." She waited.

"No, that's good," he said. "I like that."

She said it was a little obvious. "I mean, you can see that she's going to be in an accident. So, I don't know. You were always telling us to be careful about heavy-handed titles."

He looked at the painting. "Well, maybe. You can always change the title."

"For me, anyway, it's about more than just her lack of attention to the things around her. For me, she hasn't just forgotten where she is...She's forgotten who she is. Her whole life has been about denying herself."

He studied the painting while she talked. "What do you...I mean, I should probably...You shouldn't have to explain, but I guess I just want to hear you talk about it." He leaned to the eye loupe again. "These are just...They're so good."

She scooted closer to him. "Do you see how she's in a business outfit? I mean, from the back how it almost looks like she's in a man's suit?"

He nodded. "Yes."

Chloe said she did it very intentionally. "This is a business woman—a high power executive. I picture her making million dollar deals."

"Sure. Sure. Look at that dashboard," he said. "That's the dashboard of a luxury car."

"Yeah! That's what I...It's just that I wanted her to be powerful, yet still vulnerable. She's in that power world, but there are still powers that she must bow to. There are expectations. She still has to be a beautiful woman, despite her talents. She's got to have the makeup, the hai—all the things her male colleagues probably never give a second thought to for themselves. The world she's entered wants her to make a million bucks, but still look like a million bucks, too."

Ray's skin tingled. "That's good. Holy cow, that's good."

Chloe continued. "She's subverted everything feminine in herself, except her looks. She has the veneer of a woman, but the instincts of a man—in the worst sense. She's self-centered,

uncaring, opportunistic... I mean, who is she applying that makeup for in the middle of traffic? It's not for her."

"What's that on the shoulder of the road back there that you can see in her mirror? I can't really...Is that—"

"It's a car seat," she said. "A child's car seat."

He smiled. "So, these are things she's leaving behind—even her maternal nature?"

Chloe nodded. "It's just that I think that women have entered the business world not on their terms, but on the terms of men. They've co-opted all of the behaviors that the business world admires in men, but have brought with them none of the valuable aspects of being a woman—or at least traits that are considered womanly. Compassion. Empathy. Those are good traits, too—not weaknesses. I mean, the results of business as it is now are terrible. Environmental pollution. Exploitation. Deception. Maybe there wouldn't be as much of this if the business world could become more ying and less yang." She took a breath.

Ray pulled up from the eye loupe and looked at her face lit dimly from below. "I like that detail with the car seat," he said.

"It's because of you."

"What?"

"You pushed me. I started out just wanting to paint someone driving. I was driving back and forth between Kalamazoo and Saginaw almost every weekend when my mom was sick. I kept seeing that view. The road ahead. The road in the rearview mirror. I just wanted to try to paint someone driving. But, I remembered that you said that an artist gives us a vision of the world—not just a visual. Like you said: 'Mix visual with emotion and end up with art.'"

Something came to him. He touched the frame of the slide. "You could change the title of this one to *A Man's World*. That might really get your viewer thinking. Here's your subject—obviously a woman—and yet here's this title. What does it mean? The best title is like a pair of glasses. It gives the viewer twenty-twenty vision when it comes to the painting."

Chloe repeated the title aloud. "That's it," she said after a moment. "Oh my god, that's the perfect title."

He looked at the other paintings. The lone drivers. The couples. The families. Each was after something. Did the child strapped into the booster seat feel the invisible passenger in the mini-van with them—the impending divorce etched into the faces of his parents? "Have your professors at Western seen these?" Ray asked.

"No. I didn't do these for class. That's why I was so excited about them, too." She set her warm hand on his arm. "Do you remember the last day of our painting class? You said nothing that we had done during the semester was art. I remember being hurt. Then you said that art isn't assigned. You told us that art comes from the individual who is inspired by vision—by inspiration and desire." She touched a few of the slides. "The instructors I have now wouldn't like these. I think they'd see them as too traditional."

Ray sniggered. "These are good. I mean, you have enough here to have your own show." He set the eye loupe on another slide and leaned to it. The driver was a man, obviously lost, his look frantic at the road signs. And something about it, too, something said he wasn't reading the signs of life well. What was that on the dashboard? A statue of St. Christopher fallen over, torn from its circle of adhesive? "I wouldn't be surprised—" he started, and then he was surprised. Chloe's mouth was on his neck kissing a warm spot into it.

She stopped and moved the light table to the floor. She turned it off. He didn't move. Chloe came up again and pulled his face into hers. They kissed. Her warm tongue slid into his mouth. After a moment, a single word—a name—came into Ray's mind. Diane. He hadn't been with anyone else in so long. What he was doing with Chloe felt like cheating.

He pulled back. "I don't—" He could see her again, his eyes having started to adjust to the room.

"It's okay," she said. "I'm not your student anymore." She moved his hands to her breasts. "I want to," she said. "I've always wanted you."

They kissed for a long time. He couldn't shake the guilt he felt. Why be guilty over Diane? She left him. But then, if it wasn't Diane, why did he feel guilty? Was it Chloe? He'd lured her. He'd

wanted her. He'd wanted to fuck somebody because he felt so fucked. But then she'd shown him her paintings. She'd asked him to be honest.

Chloe stopped for a moment, reached down, and pulled her shirt up over her head. Her bra glowed in the dimness of the room. She reached around and soon dropped the bra to the floor.

Leaning forward, she kissed him again. "Touch me," she said. "It's okay. Touch me."

She giggled. "Your hands are cold."

"Sorry."

"It's okay."

She wanted him. Did he want her anymore? But then, what harm in seeing this to the end? He didn't know when a chance like this would ever come again. She wasn't talking about living with him or even starting a relationship. Her mouth, her hands, the small noises coming from her throat. They spoke of only one thing. Sex. He would talk back to her in the language she was speaking.

He lowered his face to her breasts. Her sighing moans were like Diane's. He pushed that thought out of his mind, but it was followed by another. Something wasn't happening. His blood was not moving where his blood needed to move. Don't think about it, he thought. They writhed further into where they were headed. Her hand soon found what he'd been trying to ignore.

She paused.

"I'm sorry," he said. "I don't—"

"It's okay."

What normally would have brought shame–it had happened a few times with Diane–ushered in a feeling of relief. This was for the best.

Chloe slid to the floor. Her head dropped into his lap, and soon he was in her mouth.

He thought to stop her, but it was working. It was something Diane had never done—at least not to jump start him. When it had happened to them, they laughed and watched a movie. Chloe wasn't going to give up that easily. His blood shifted, his flesh stood up.

Her hair fanned over his thighs. Soon he would be ready. He would fuck her. Whatever he felt afterwards, he would feel. This was going to happen. He put his hands on either side of her head, felt the hard skull under her hair. He raised his eyes and looked into the room. He found his reflection staring back at him in the mirror above the dresser.

What he saw sickened him. He was here with this young woman. If her paintings had been bad, he could have done this. But her paintings were good. She believed he was good. She believed he was an artist, and she wanted to sleep with him because of her belief. He wasn't an artist. Not anymore. He was a fraud, a has-been. She deserved to know it—or at least he didn't deserve to have her.

His reflection. His eyes. He had seen them before. They were Jolien Poiret's eyes. They were the eyes of settled acquiescence. They were sad eyes—the eyes of someone ready to give up, give in.

Chloe lifted her head, shifted onto the bed, and then onto her back. "Come on," she said, touching his shoulder.

He set his forehead against his hand. "I can't."

She reached into his lap and wrapped her hand around him. She squeezed slightly. "I think you can."

He moved her hand away. "I won't," he said, touching her cheek. "I'm sorry. I won't."

Chapter XV

It was after ten o'clock in the morning when Ray woke. The wine bottle was still on the television where he'd set it when he and Chloe had first come in. He winced.

After she left, he couldn't sleep. She'd been so upset. Having denied himself the pleasure of her favors, he hadn't expected that Chloe would cry. "I don't understand," she said. "Did I do something wrong?" He had no good explanation for her, barely having an explanation for himself. For whatever reason, sleeping with her felt wrong. Why? He didn't know. Lying in the strange motel bed in sight of the unopened wine bottle, he felt his simmering regret. He'd started mocking himself almost immediately after he'd made everything impossible. "I won't." He could still hear himself say it. He could see himself standing over her naked body. His tone was that of someone refusing to go to war, refusing to embezzle, refusing to rat out his friends. What a fool.

He'd been aware of her putting her clothes back on, he'd watched her file the slides away, and he'd seen her pick up the light table. "I'm sorry," she said before leaving. He told her that she had nothing to be sorry about. "It might not ever make sense to you, but this was all for the best," he said. He simply should have confirmed her suspicions when she'd asked if he was married. It would have made more sense. Instead, he told her that he didn't deserve to be with somebody like her. It sounded like an excuse for something else, and it made her cry again.

He could have had sex with her. He could have released into her everything he'd built up since Diane had left him, since Sammy had moved in, since he'd lost whatever it was that at one time had made him feel like an artist. He wanted to make sense of it. But

how? Maybe he didn't sleep with her because she was an artist, and she thought she was sleeping with an artist. His seduction was a deception, a lie. Or, he didn't sleep with her because he still had feelings for Diane. He still loved her, and sleeping with Chloe would have been a rejection of that love. Kleminger had advised him to live in the world. What he had denied himself seemed the exact opposite.

Trying to sleep, he had waited for Sammy to burst through the door like a drunken grizzly. It was like trying to sleep after hearing that a tornado warning had been issued. Still, at some point, he slept.

The sun made an orange rectangle of the blinds. He sat up. Why wasn't Sammy in the room? Chloe had left just after midnight. Sammy knew the make of her car; he and Ray had discussed it. What kind of trouble had his brother gotten himself into? With his drinking and with a car at his disposal, the possible tragedies were endless. He could be in jail. He could be in the hospital. He could be dead.

Ray pulled on his pants and went to the motel window. When his eyes adjusted to the glare of the sun, he scanned the parking lot for his car. Nowhere. "Oh shit," he whispered.

He went to the bathroom and wet down his hair. He wasn't sure where to begin. The window didn't offer a view of the entire parking lot. He could start there. He grabbed the key to the room and walked out.

Feeling relieved, he spotted his car parked in the furthest space under the shade of a birch tree. His heart slowed. Walking towards it, he examined the passenger side for damage, but saw none. Sammy lay in the back seat. Ray walked around the car. Nothing. Not even a scratch. He looked in at Sammy. Sammy rolled over. It took Ray a moment to identify the blood on his brother's shirt and the blood dried beneath his nose. His lip was split and swollen.

He rapped on the window. "Sammy. Sammy, wake up!" He remembered what Sammy's fist had done to the plaster. If he looked bad, what did the other guy look like? This could end in a lawsuit. He rapped again. "Sammy! Wake up!"

Sammy's eyelids fluttered. When they opened, he picked his head up off the seat and looked around gropingly. His hand went to his forehead and squeezed.

None of the doors were locked. Ray opened one. "Sammy, what the hell happened to you?"

"Ray Ray? Don't yell, man. My head's killing." He drifted up slowly into a sitting position. He held his face in his hands.

"Are you all right?"

Sammy lowered his hands. Blinking, he looked out the windshield. "God-damnit, it's sunny." He covered his face again.

Ray eased in next to him. "Are you okay?"

"I'm fine. I'll live. I don't even want to talk about it."

"Don't want to—"

"Ray Ray, please."

Ray shrugged and helped him from the car. At least it hadn't been damaged.

Sammy said nothing as they cleaned themselves up, packed, and then loaded the car. He was asleep before they hit the interstate. He didn't wake again until they were nearly twenty miles west of Flint.

"We gonna stop for food?"

Ray said that they could. "Really, though, we're only about an hour from home."

"An hour? Holy shit, how long did I sleep?"

"About two hours. I took I-69. We've had no traffic, no slowdowns. Nothing. I guess we should have taken 69 yesterday."

Sammy jabbed Ray in the leg. "Always gotta take 69 when you can get it." He laughed.

"You feeling a little better?"

Sammy shrugged.

"Do you want to talk about what the hell happened?"

He stretched and yawned. "I don't much understand it. Shit like that always happens to me."

Ray waited.

"Okay," Sammy said. "After you two left, I didn't. I figured one bar was as good as the next. I stayed in the lounge and found a smaller table." He said as the place filled up it was pretty clear

that it was a college hangout. "I could have stayed there all night just looking at all those fine young ladies."

Ray sighed.

Sammy said he ordered a pitcher. "I was just sitting there, enjoying the sites. Then, these two guys come over and wanted to bum some cigarettes. Big weight lifter guys. I told 'em they could smoke on my dime, but they'd have to sit with me. I was bored and some company sounded good."

The highway slipped under the tires. "I'm sorry," Ray said. "I should have stayed and hung out with you."

"I don't blame you for taking that sweet piece of ass back to the room."

"She's not a piece of ass."

Sammy sighed. "Anyway, back to my story. So, I had these guys laughing pretty good. You would a thought I was Jeff Foxworthy or something."

"Who?"

"Never mind. Doesn't matter." He cleared his throat. "So then these guys tell me they're in a fraternity—alfalfa beta vhs or something. Hell, I don't know. They said they were having a big party that night 'cause school was starting soon. They gave me directions and said I should stop by."

Ray glanced at him and then turned back to the road. "I take it that you went."

"Why wouldn't I? They said the place was gonna be crawling with women. Sounded like a good party to me. They had a keg, women everywhere...holy shit, the bodies on these chicks."

Ray checked the speedometer and let off on the gas. "I should hope they'd have nice bodies. You're old enough to be their father."

Sammy laughed. "No offense, Ray Ray, but look who's talking."

"Yeah, yeah. So what happened at the party?"

"I don't know." He touched his nose and winced. "I guess they decided that they didn't want me there anymore. A few of them came over and told me it was time to go."

"What had you been doing?"

"Nothing. I was just being myself."

"Were you drinking the whole time?"

"I'd had my share."

"Drinking and being yourself? Do you really think that was a good idea?"

"This was my vacation, too."

Ray exhaled. "So then what happened?"

"Well, I told 'em that I wasn't gonna leave. They decided to help me make up my mind differently. Took about five of them, but they got me outside and took a few pokes."

"Did you hurt any of them?"

"Them? Shit, Ray Ray, there was five. You act like I was trying to start something. I was gone...drunk as hell. I'm sure I threw my fists around, but I didn't hit shit. I'd know it." He held the back of his hand up and examined the knuckles.

Ray gave a low whistle. "You live some life, Sammy."

Sammy shrugged. He lit a cigarette and rolled down the window. "I drove the car a few blocks away, parked it, and then passed out. About five this morning, I woke up and drove over to the motel and fell asleep again."

Ray didn't ask anymore questions. Sammy stopped talking. He asked if he could turn on the radio and Ray said it was fine. He took the onramp and merged onto I-75. His mind came back to Chloe. What had been regret that morning had turned into something different. He couldn't help but think that he'd done the right thing. He looked at the highway ahead. It was time to stop running. Denying himself Chloe was his first positive move.

Sammy touched his swollen lip and grimaced. "I got the shit kicked out of me, and you rolled around in heaven. I hope it was worth it."

Ray tightened his hands on the wheel. "I think it was."

Chapter XVI

Ray found them pushed to the back of filing cabinets and buried deep in drawers. He found them stacked high and dusty on shelves or in boxes under his desk. He found them in old files on his computer. His teaching materials. How long had it been since he'd used any of them? Recently, his instruction consisted of telling his students to "just paint." He could hear himself: "You want to be artists? You'll never be artists if you need people to tell you what to do." Then he would slink down to his office. He hoped that they took the freedom as a compliment, though he knew that it was really just a copout so he wouldn't have to teach. Sometimes, out of guilt, he'd drag an easel into the room and paint in front of them. He wouldn't speak, but just painted, listening for the small sounds of their admiration, if not respect. In the past few years, that was the extent of his hands-on teaching.

Within an hour he had quite a collection around his feet. Slides. Student examples. Handouts. He had mini-lectures regarding line, value, shape, color, texture, volume, space. His students would speak in the vocabulary of painting. They would talk about color discord and the six categories of light. To help them, he planned to use demonstrations, peer critiques, and one-on-one instructing. He would have students in his office again. They would have sketchbooks. He would collect the sketchbooks, look through them, and comment on what he found within. He hated sketchbooks, but it didn't matter. He would do the work.

Though it wasn't exactly the world he wanted, it was the world he had. He planned to live in it. Even if he wasn't painting. Even if Diane was gone. He would at least be a good teacher again for his students. Maybe among them there were more Chloes —more would-be artists needing a catalyst. How many students had he

failed over the past five years? Considering grades, he hadn't failed any. He'd learned that any mark below a B+ made students come looking for him with their complaints. It was easier just to have them be happy with their grades.

No, his failure had been as a teacher, as an inspiration. No more. As Kleminger had suggested, his role as a teacher was noble. Important.

His telephone rang.

"Professor Casper speaking." How long had it been since he'd answered the phone with such formality?

"Ray? This is Tim Hernandez in Registration."

An hour ago Ray had left Sammy with Tim to take placement exams before scheduling classes. He had never seen his brother so nervous. Sammy stammered and sweated and said he "sucked" at tests.

"What can I do for you, Tim?"

Tim cleared his throat. "Well, your brother just finished the tests."

"Yeah?" Ray huffed a short laugh. "So, did he get in the Honors Program?"

The other end of the line went quiet.

"Tim?"

"Look, I know he's your brother...it's just...It's just that he can't attend here with those kinds of scores."

"What kind of scores?"

"I'm not supposed to..." Tim exhaled. "I guess since he's your brother." He took a breath. "He scored an eleven on Compass for writing, a sixteen in reading, and a twelve in math."

Ray leaned back in his chair. "I don't even know what that means, but it doesn't sound good."

"Well, just for an idea, his reading score would be considered fourth grade level."

"What?"

"We just don't offer the courses he needs. A lot of the departments have gotten rid of their developmental classes." Tim sniffed. "I'm sorry, Ray."

"Fourth grade." Ray exhaled into his free palm. "Where's my brother now? Does he know?"

"He left before he even submitted the test. I had to go to the computer and hit send for him."

"He's probably on his way here," Ray guessed aloud.

"Well, when he gets there, if you want to send him back, I'll explain the results to him."

Ray thought for a moment. "If it's all the same, I guess I'll tell him."

"That's fine, too."

Ray thanked him for calling.

"Have you considered Tri-County?" Tim slipped in.

"Tri-County?"

"T.C.C. Tri-County Community College. They're just down the road. They have an open-door policy."

Ray had heard there was a community college. He didn't know much about it. "I guess we can look into that."

"If he can pass a few courses there and retest, we'd look at him again."

Hanging up, Ray imagined telling his brother the news. What man in his fifties would want to hear that he reads no better than a fourth grader? Even Sammy would have to be hit hard by something like that. Ray decided that deception might be the best answer.

It wasn't long before Sammy's squeaky steps pulsed down the hallway towards his door. He leaned against the door frame, sweating. "I got lost. All these buildings look the same in this god-damn place."

The guest seat was still cleared from when Billy had sat in it. Ray told Sammy to sit down.

"I fucking hate tests."

Ray nodded. "Well, it might be that you took them for nothing."

"What?"

Ray set a hand on each knee. "I got a call from Registration. You would need to be my wife or my child to get discounted tuition." He sighed.

Sammy's face went distant, slack-jawed. "So, what does that mean?"

"University classes are expensive, Sammy." Ray rubbed his palms on his thighs.

Sammy looked at the floor. "Oh. Right. I see."

"But it's not like that has to be the end of it. There's another college not far from here. Their courses are a lot cheaper." Ray knew that much about community colleges. "I could pay for classes there."

Sammy shrugged.

An hour later, Ray waited in the lobby of Tri-County Community College's Registration Office. The secretaries and admissions people scurried about helping a steady stream of would-be students with questions about financial aide, course availability, and wait lists. Like any dentist or doctor's office, the waiting area had a bucket of toys, coloring books, and a wooden train track glued to a table. All ages of women filled out applications while their children circled around their legs.

Sammy appeared from a back room. He slumped in the chair next to Ray. "Same damn test," he said, sighing.

"I guess that's just the way."

A few minutes later, Sammy was called back to meet with an advisor. He asked Ray to go with him.

The plump woman smiled broadly and introduced herself as Shelly. Her shirt was intricately patterned in cocker spaniels. "Did you have a major in mind, Mr. Casper?"

Sammy stared at his hands in his lap. "I was thinking nursing."

"Nursing?" Ray said.

Sammy shrugged. He clicked one thumbnail off the other. "That's where I heard there's jobs," he said, not looking up. "Good pay, too."

"That's true," the advisor said. "The medical field is a good way to go. We have a great Nursing program."

Ray imagined his brother's bedside manner: "If you don't quit squirming, I'll shove the catheter up your ass!" He grinned. "Isn't Nursing a pretty rigorous program?" he asked.

Shelly looked at Ray. Her smile flickered. "It has to be. But, we provide services to help students pass the required classes. We have tutoring and peer mentoring. Many students whose

chances looked slim go on to graduate from our Nursing program."

Shelly looked at Sammy. "Mr. Casper?" She waited until Sammy looked up. "How many classes were you thinking of taking?"

Sammy looked at Ray.

Ray shrugged. "I think two would be good for now."

She nodded. "That sounds about right." They talked about what time of day Sammy wanted to go and ended up deciding that night courses would be best.

"You could use the car then," Ray said.

Sammy nodded, studying his hands again.

Shelly's fingers were like pistons on the keyboard. "I've found openings in an English 95 and a Math 90. You'll be coming out here four nights a week."

Sammy said nothing.

"What courses are those?" Ray asked.

"They're part of our developmental program. English 95 focuses on paragraphs and grammar, and the math course deals with the basics and works towards getting students ready for pre-algebra." She turned away from Ray. "Does that sound good to you, Mr. Casper?"

"Whatever I need to take."

They sounded like middle school classes. "Someone actually teaches those courses here?" Ray asked.

His tone seemed to test the strength of her smile. "We give our students what they need to succeed," she said. "It's what we do."

He felt scolded.

In the days before classes began, Sammy lingered around the phone, as though trying to will it to ring. He went out walking at night, came in well after Ray was asleep, and slept until past noon.

"Where do you go walking at night?"

"Just over to Midland Street."

Ray knew about all the bars on Midland Street—at least ten in a three-block stretch. Sammy's Medina. "You're not going to be able to do that once classes start."

"I know. I know. I just wish one of those factories would fucking call."

The brothers saw little of each other in the passing days, which seemed to suit both just fine.

Classes at Dow began the next week. Ray immersed himself in his teaching. He stayed in his classroom, did demonstrations, took brushes from students' hands and showed them the effect of different strokes. They seemed surprised by his attention, and he guessed that they'd heard bad things about him. By the third week they trusted him. He saw improvement and heard them using the vocabulary of painting. The gist of his lessons, handouts, and demonstrations was taking hold. Students came to visit him in his office and talked with him about their work. It brought him a certain satisfaction, which was dulled by the aching knowledge that he still wasn't working on paintings of his own. He did think of Diane less. Maybe he was finally starting to get over her.

Sammy didn't say much about his own classes. He said he had plenty of time to do his homework during the day. "My math teacher is okay, but the English guy is a little light in the loafers."

Ray rolled his eyes and sighed. "You don't have to like them. Just do the work and learn what they have to teach you."

"I am. I am."

It was early in October, a half hour after Sammy had left for his Math class, when the phone rang. Ray was cutting up vegetables for a stir fry. He set down the knife and picked up the phone.

"May I speak with Sam, please," the man on the other end asked. His voice was high and scratchy.

Ray didn't recognize him as any of the drinking buddies that called for Sammy from time to time. "He's not here. May I take a message?"

The man hesitated. "Can you tell him that Mr. Klein called?"

"Mr. Klein?"

"Yes. I'm his English instructor from Tri-County."

Ray paused. "Is there anything you want me to tell him?" He looked out the window. The last of the sun, split by the shadow of the roof's peak, lit the grass on the far corners of the backyard. The short days of winter were coming.

"I guess I was just calling to see if anything was wrong."

Ray picked up the knife again and a carrot. He pinched the phone between his shoulder and ear. "Why would something be wrong?"

"I really called to speak with Sam."

"I'm his brother. If you want me to give him a more specific message, I can."

"No. I guess I don't really have a message. I just wanted to find out if something was wrong because he hasn't been to class for the last week."

"Hasn't been to class?" He stopped his knife. "He just left for class."

"We don't meet tonight."

Ray set the knife down and held the phone again. "Then his math class is tonight. But, you're telling me he hasn't been to your class in a week?"

Mr. Klein didn't speak right away. "I really shouldn't have told you that. It's really a violation for me to have—"

"No. No. I'm paying for his classes. I should know if he's not going to them."

"Okay. But could you tell him to call me?"

Ray said that he would and wrote down the number. "Can I ask you why you called?"

"I said because Sam has been absent."

Ray imagined calling his own students' homes. Even with his teaching going better, he still was pleased by excessive absences, which usually meant that the student had dropped. Dead weight out of the way as far as he was concerned, and less paintings to look at and evaluate. "You always call your students when they've missed?"

"I make a point of it. Sometimes when I call we're able to work something out."

"That's dedication," Ray said, meaning it.

"That's my job," Mr. Klein returned. "Just please let Sam know that I called."

Ray waited up as long as he could. He had an eight o'clock class of his own in the morning and knew that he had to go to bed before too long. He soon found out that going to bed didn't

mean sleeping. Had Sammy been playing him for a fool? He was staying in his home, eating his food, using his car—and lying to him. Ray boiled in his anger, but was almost asleep when he finally heard the front door open. Five minutes after one o'clock. The speed with which he moved from bed to hallway to down the stairs surprised him. He turned on a light.

Sammy stood in the middle of the room like a blind man, half crouched, his hands feeling around out in front of him. He stood up sheepishly. "I was trying to be quiet. Trying not to turn on any lights."

"Late night study session?" Ray asked. Since July, when his brother had moved in, he had seen him look worse. Still, he was drunk.

"You could say that."

Standing in his boxer shorts, Ray felt the cold night air that had followed Sammy in. "You drove my car drunk again, didn't you?"

Sammy looked at the floor. "Don't worry about it. I been drinking cokes for the last hour."

"Yeah? With how much rum in them?"

"Fuck off, Ray Ray. I'm not in the mood."

"Fuck off? No, why don't you fuck off, Sammy. When were you planning to tell me that you stopped going to your classes?"

Sammy's gaze came up from the floor and settled on Ray's face. "Last I remember, I buried my daddy in Ohio, so drop the act."

"The act? The only person acting around here is you. I'm glad lying to me came so easy for you—really shows how much you appreciate what I've been doing for you."

Sammy looked at the ground again. He breathed in deeply and then exhaled. "I didn't want to tell you, okay?"

"Didn't want to—"

Sammy held up his hand. "I didn't want to tell you that I was flunking those god-damn bonehead classes. I'm just stupid, okay?"

Ray sat down on the stairs. With his brother, his anger so often turned to pity. "Sammy—"

"I'm too old for school. I wasn't good at it when I was younger, and I ain't good at it now."

Ray sighed. "Did you even try?"

"Shit yes, I tried. I couldn't do it."

"And you used the tutors?"

"Fuck, tutors ain't gonna help me. I just ain't made for school."

The front door creaked open. Sammy couldn't even close a door right. "So then what?" Ray asked.

"I don't know." He teetered but caught himself.

Ray stood after a moment, following the thought that cemented itself in his mind. "This isn't working, Sammy. I give up. Whatever you're going to do, you're going to have to do it on your own. I can let you stay here another month, but then I want you out." He studied his brother standing in the center of the oriental rug like a big, stoop-shouldered child.

"You asked me to come here."

"And now I'm asking you to leave."

"What am I—" His voice cracked. "What am I supposed to do?"

"I don't know. Work at McDonalds. Work at Walmart. I've done what I can do." Sammy didn't move, didn't look up. "I'm going to bed," Ray said, turning around.

"There's a lot of us, Ray Ray. We don't know what to do." Sammy walked around the couch and collapsed into one of the chairs.

Ray massaged his fingers into his eyelids. He came down the stairs. "What are you talking about now?" He walked over and closed the front door.

Sammy leaned his head back and stared up into the ceiling. "Guys I talk to in the bar. Dennis. Stevie. They all feel it. They all talk about it."

"Talk about what?"

"There's nothing for us. We go out and look and don't find shit." His head dropped down and he looked at Ray again. "It's like you're up in a tree and the branch you're standing on is all rotted and about to break. You look up and the branches are too thin. You look down, and all the branches that got you there have fallen off."

"What?" He could smell Sammy's beery breath filling the room.

"Nothing. I don't know." He slapped a hand through the air. "It's just that we thought...it's just that we don't know what the hell we're supposed to do."

"So getting drunk every night is your solution?"

Sammy exhaled, his breath escaping like air from a punctured tire. "I'm not going to make you understand. It's like you talking to me about art. Them are dead end streets."

Ray felt something in the room with them, something his brother's words had called forth, as though this were a séance. He came around the side of it and sat on the couch. "What are you trying to say?"

Sammy's eyes flickered in concentration. "Nothing is like it was. It's like we had something in our hands. We thought it was solid." He held his hands in the air in front of him around an invisible ball. "It was something, and now it's gone." He clapped his hands together. "It's gone, and it took us with it. We didn't see it coming."

"So that's it? It's gone and you give up?" Ray pointed at him. "You know, you can get your life back. People do it. They come out of worse situations than yours and they put their lives back together."

Sammy shook his head. "It's bigger than our lives. It's like oxygen or something. I mean, I can't even breathe. It's not anything you bounce back from."

"That sounds like quitting to me."

Sammy looked at the floor. "I told you I wouldn't make you understand."

"All I'm understanding is that you're throwing in the towel."

"You can't fight this. We're old dogs."

"Old dogs aren't dead dogs."

He looked up into the ceiling. "And so what the fuck do we do, Ray Ray?" he yelled. "Wander around a grocery store parking lot collecting up the carts? Make six bucks an hour like a god-damn teenager?" He balled his fist, raised it, and then slammed it down into the arm of the chair. "I had a fucking house. I had a fucking fiancé. I had —"

"Just shut up." Ray stood. "I'm not going to talk to you like this. I'm not going to watch you have a fit and break something else of mine. You get your own place and break as much as you want. I don't know what you're going to do, but you're going to have to figure it out. Letting you stay here isn't helping." He turned back to the stairs.

Sammy exhaled. "Turn off the light then. It hurts my fucking eyes."

Ray hit the switch and left his brother in the darkness. He went up the creaky stairs. The house was so quiet, the wood sounded as though it would split under his feet.

Chapter XVII

It was Halloween when Ray picked up the phone and heard Diane's voice on the other end. Children were calling to each other outside of his house. The neighborhood glowed benevolently.

"Di?" His fingertips tingled with a joyful numbness.

"Did you buy enough?" She was asking about candy. Ray's house was on a boulevard known for attracting hundreds of trick-or-treaters. Kids whose own neighborhoods were too dangerous in Saginaw were dropped off by their parents at one end of his street and picked up eight blocks later at the other end. It was one of Diane's favorite nights of the year. "We're handing out happiness," she'd say.

"I think I'm covered," he said. His heart was like something Edgar Allen Poe had imagined.

Outside, the sidewalks flickered with movement. Porch lights and decorations lit up the street. The neighbor next door had a smoke machine and played eerie music. Ray started to ask how she was doing, but kids thumped up his steps and screamed their Halloween demands at him through the screen door.

Diane laughed.

He opened the door, lowered a bowl to them, and told them to take their own.

"You better tell them just one a piece."

"They're being good," he said.

More kids followed and more behind them. They came in groups as large as ten. The night buzzed with their excited talk and shouts. Parents lingered, watchful shadows on the sidewalks.

"You're busy," she said. "I should have known not to call at this time."

He said he could shut the lights off. "Remember how we always had to when we ran out of candy?"

"No, don't do that. I can call you back later."

Ray tried to swallow. "But what if you don't?"

"I will. Just hand out the candy. The kids should come first." She said goodbye.

The parade of children was relentless. They came as ghosts, princesses, vampires, aliens, clowns, angels, devils, ninjas, knights, super heroes, wizards, witches and every other imaginable manifestation of human wickedness and virtue. Sammy had mentioned that he wanted to help hand out the candy, but at four o'clock he went for a walk and never came back. The one time he actually could have helped me out, Ray thought. There was every possibility that Diane wouldn't call back. Hers could be a world of whims.

When he did run out of candy, he shut off the light. Others in the neighborhood were doing the same. The street slowly lost its glow.

Sitting in the darkness, listening to Chopin on public radio, he heard the children who refused to believe the stillness of his house. They came up on the porch. They shouted. Their little fingers rang the bell and their tiny fists pounded the door. Ray heard the parents call them away.

The street was quiet and dark when he finally rose from his chair, brought his empty wine glass to the kitchen, and came back to the living room. He turned off the radio. Diane wasn't going to call back. Carrying his own weight up the stairs was almost too much burden for him.

Lying in bed, he picked up the phone too quickly when it finally rang.

"Did you have enough?"

He said they'd cleaned him out by seven thirty. "It's almost midnight. Why did you wait so long to call back?" He was shaking.

"I was at a friend's."

A friend's. Was that why she had called—to tell him that she had met somebody? He remembered when Marcy had phoned to tell him that she was engaged. The idea of Diane doing the same left his blood suddenly thicker.

"Your friend doesn't have a phone?"

She said she was sorry. "When I called, I wanted to have time to talk. My friend—Melissa—she has three kids. They were pouring out bags of candy and running all over her house. It wasn't the place to make an important phone call."

Melissa. A rain of relief washed away his tension. He relaxed into the mattress.

"Are you in bed?" she asked.

"I am."

"I wish I were there with you."

If he had been getting over her, he wasn't anymore. His love surfaced and tingled over the stretch of his skin. "I wish you were here, too."

She was quiet for a moment. "Do you ever go out on the balcony?"

"No. It would remind me too much of you. I think your can of butts is still out there."

"I don't smoke anymore."

She'd always said that she was never going to quit.

"That's great," he said. The phone was hot against his ear. He switched to the other.

"So, how have you been?" she asked.

He didn't want to sound too pathetic. "I've been busy. There's really a lot happening. Classes started again, and I'm trying to be a better teacher."

"You were always so good."

"Maybe once. Remember that you haven't been my student in a long time. I was in a slump for awhile." She'd been in his class when he was at the height of his output. He was always a better teacher when his own work was going well. "I work at it every day, but I'm a good teacher again. At least better."

She said she was glad for him.

"How about you? How have you been?"

"It's hard to say. I've been a little out of sorts."

He switched ears again. "Is everything okay?"

"I think so, now. More than anything, I've been nervous about calling you."

"Nervous?"

She said she didn't know if he would want to hear from her. "I think about the way I left you. It really wasn't fair."

"You were right, though. I should have supported you. I should have gotten behind anything that you were doing."

She let a few seconds of quiet pass. "Ray, I never asked for your support. That's not why I left."

He sniffed. "I know."

"I left because you were in a hole, and you were letting yourself stay there. It's hard to watch someone you love do that."

He felt tears welling in his eyes. "I imagine."

She was silent.

"How did your show do?" he asked, not liking how the conversation had arrived at a dead spot.

"The show itself was really well received. It got some nice reviews in local papers." She laughed. "Monetarily? Well, not a lot of people want to buy used drop cloths—art or not. If I still smoked, I wouldn't be able to buy a pack from the money I made from the show."

"It's tough," he offered.

She sighed. "I didn't really call to talk to you about painting."

He stared at the spot on the bed where she'd sat the night she said she was leaving him.

"Ray," she started, "do you think there's any chance for us?"

"For us?" His heart became a small animal frantic in the cage of his ribs.

"Do you think we could try again?"

He sat in the silence of the dream-like moment. "It's what I've hoped for."

She took a few breaths. "Things would be different."

He guessed what she meant. "I'm still not painting yet. Not really. But, things would be different. I'm trying, and I would support you in—"

"I'm not talking about painting."

He scratched his cheek. "What are you talking about?"

She paused. "First, I'm asking to be with you again because I love you. I never stopped loving you. The way I left you was childish. I blamed you maybe when I should have been helping you. Leaving just seemed like something I had to do."

"Maybe it was...maybe you had to leave to know that—"

"I'm pregnant," she said.

Gravity seemed to double. He pulled the phone away from his ear, looked at it, and then brought it back.

"I'm not sure what you're thinking," she said. "I wanted you to know that it's yours. I'm guessing after that last night that...it's just that I haven't been with anybody else."

He looked around at the ghost-like shapes of the things in the room existing in the half light. "I'm going to be a father?" It wasn't anything he'd ever thought of himself being. He couldn't name the emotions surging through him.

"If you want to be. If you want me to come back."

"I'm not sure how good I'd be at something like that. I didn't have much of a role model."

"Sometimes people who never imagined themselves as parents end up being the best at it."

"Where did you hear that?"

She laughed. "I guess I just made it up."

Chapter XVIII

Ray followed I-75 toward Ann Arbor. He yawned and blinked against the itchiness in his eyes. He and Diane had stayed on the phone for nearly three hours the night before. Listening to her, he had heard Sammy come in, though he'd never heard him make it up the stairs. When Diane asked about Ray's recent months, he couldn't help but mention everything he'd been through with Sammy.

"It sounds like he's had such a sad life."

Ray told her not to be fooled. "Sometimes sad lives are a symptom of sad living. He puts in no effort."

He had come down the stairs that morning and found Sammy, dressed in a cowboy hat and chaps, passed out on the couch.

"Sammy."

Nothing.

"Sammy! Wake up."

He stirred. "I'm up," he managed, opening his watery eyes.

"I'm leaving," Ray said. "I'm going down to Ann Arbor to pick up Diane."

Sammy sat up. His eyes looked like eggs spiced with too much Tabasco. "Who?"

"The woman I told you about—the one that used to live with me. She's moving back in."

"Really?"

"Yes...she's pregnant. We're going to have a baby."

Sammy rubbed his eyes. His head lolled unsteadily on his neck. "I'm going to be an uncle?"

"I suppose so."

"And she's moving back in?"

"Yes," Ray said. He cleared his throat. "And, you're going to have to move out. I can't have you here when we get back." He'd rehearsed what he was going to say while he'd been in the shower.

Sammy lay his head down on the arm of the couch and closed his eyes. "Ray Ray."

"I'm not kidding, Sammy. I gave you a month. The fact that you did nothing with it isn't my fault."

Sammy put a hand on the top of his head and squeezed. "What am I supposed to do?"

"That's a question I can't help you answer anymore."

He opened his eyes and looked at Ray. "At least give me until tomorrow. Give me a little time to figure something out."

"You've already had..." Ray sighed. "Fine. Tomorrow." He didn't like the tone of the conversation. He shrugged his palms. "You have to understand that everything has changed. I'm going to be starting a family here."

"Sure, Ray Ray. Sure." Sammy put the cowboy hat over his face. "I understand."

Ray opened the door.

"Congratulations, bro."

Ray stood for a moment with his hand on the doorknob. The November air blew cold around him. "Thanks." He closed the door behind him.

The hour and a half drive from Bay City to Ann Arbor went by quickly. The radio had been on, but he couldn't say what he'd heard. He spent most of the time thinking about Diane and what it would be like to be with her again. He imagined them falling back into the routine of their lives together, which he had always loved. Still, he knew their routine would be different. He tried to picture the house with a baby in it. He had so little experience. Would he be a better father than his own had been? It frightened him to think that he might be worse.

Many of his colleagues had started at the university without children and then went on to have them. Some had been serious artists in the beginning, or at least gave the impression that they still wanted to work. When their children came, the only art they seemed interested in was that produced by their scrawling three and four year olds. Their office doors were covered in crayon-

rendered pictures of dogs, Christmas trees, cars, and flowers. Much of the work resembled nothing, just wild lines and asymmetrical shapes, the child-like spirit that Cy Twombly had been trying to capture in *Bolsena*.

Whatever a child would bring into their lives—even be it the death of his own art (which seemed dead anyway)—Ray felt how much he had missed Diane. His world had always been at its best with her in it. He thought of her phone call from the night before and brushed tears from his eyes at the idea of this chance to begin again. She would soon be back in his house. The highway felt generous. He held his speed at eighty.

Diane opened the door to her tiny apartment.

They said nothing, grasping for each other immediately. He reached in between them and unzipped his jacket so he could feel her against him.

She asked him if he'd flown down on a plane. "I wasn't expecting you so early."

"I should have left right after we got off the phone," he said. "I don't think I really slept."

"I didn't either."

They held each other. He wanted to feel no other way than what he felt at that moment.

"Okay, Ray," she said, "we should go in."

Her living room was half the size of his bedroom. Most of the floor space was taken up with four boxes and an easel. He looked at the couch, the coffee table, the chair in the corner. He looked at her.

He said they could probably rent a trailer for her furniture. "The Saab has a hitch on it." She'd told him on the phone that she'd sold her car, explaining that nobody really needed one in Ann Arbor.

"The furniture isn't mine. It stays with the place. Everything I'm taking is in those four boxes."

He looked at the boxes again. "You don't have any canvases or anything?"

"I haven't really had time to paint." She moved toward the kitchen. "I'll make us some coffee."

The kitchen was narrow. If the refrigerator door was open, nobody could get in or out of the room. He sat at a small table near a tiny window that looked out over an alley.

Diane's lithe body maneuvered around the space. She'd been a dancer before she was a painter. "I can't see you working at Meijers," he said. Near the end of their phone call the night before she'd mentioned it.

She poured water into the coffee maker and nodded. "I did. I guess that's what a degree in art qualifies you for. I was in customer service."

"Which means?"

"Which means I was yelled at a lot."

He said it sounded awful.

"It was. But, I think there's material there, too. It's given me some ideas for paintings." She scooped coffee into the filter.

Ray studied her, feeling his incredible luck. Yes. She was what he needed. She was his again. "You don't really look pregnant. I mean, you look really good. Like yourself."

She said she was only four months along. "The doctor says I'll really pop out next month." She lifted her sweater and exposed her belly.

Ray's blood tingled.

"See," she said, turning her body sideways. "It's a little rounded." She lifted the sweater up over her bra. "Something's definitely happening. I'm in a B cup now."

Ray tried to swallow, but couldn't. He nodded.

Diane looked at his face and laughed. "Ray." She pulled the sweater the rest of the way over her head and dropped it on the floor.

He felt his blood shift.

"If you think the kitchen is small, you should see the bedroom."

On the tiny bed, they found each other in the ways that they had made familiar, as though for the past three months they'd been making love every night and hadn't been separated by 100 miles. He didn't want to stop touching her.

He hesitated.

"What?"

"What about...Can we even? Won't I hurt the baby?"

She laughed. "We're fine. Don't worry. Some people are still having sex when they're nine months along. Sometimes their water breaks during it."

He felt the blood drain from his face.

She laughed again. "It won't happen now. The baby is going to stay right where it is. It won't even know what's happening."

He relaxed his hips, and she guided him in. Though it took a moment, they found their old rhythms. Soon they lost themselves in the blinding release.

Afterwards they lay together. Their bodies idled down from where they had just been. They were close, and yet so were the edges of the bed.

"How did you sleep in this thing?"

"I never noticed until now."

"Well, we can't stay here tonight."

"I was hoping we'd head home," she said.

He liked the word in her mouth. "With you back there, it will feel like home again." He imagined the ways that she would fill up the house.

The sounds of others moving around in the complex creaked in the load-bearing walls.

"Are you afraid?" she asked.

He'd been able to keep his fear beneath the surface. Her question released it. "I am afraid. I hope that doesn't bother you. It's just that I have no idea what this all means. I can't see the future."

She said it didn't bother her. "I'm afraid, too."

"I just don't know what kind of father I'll be. And I don't know what kind of changes a baby will bring."

She kissed his cheek. "Everything will change. That doesn't have to be bad."

"I guess I would be more afraid of trying to live the rest of my life without you." He brushed her hair from her face. "I tried it for awhile, and I wasn't good at it."

She said she was sorry that she'd put him through all of that. "Even as I was pulling together the things that were mine at your house—"

"Our house," he said.

She smiled. "I could feel that it was wrong. Something about following through, though, felt right. I guess I had to come down here...to be away from you to realize that I wanted to be with you."

"How long did you know about the baby?" He combed his fingers through her hair, lifting it and letting it fall.

She said she took the test in August.

"And then you called at the end of October?"

"I just wanted to be sure. I didn't want to be calling because I was afraid and had nowhere else to turn. I didn't want to be calling only because I was pregnant. Like I told you on the phone last night, I love you. Even without the baby, I think I would have eventually called."

She took his hand and moved it to her belly. "Do you love the baby, Ray?"

Did he love the baby? "I'm just getting to know the baby—the idea of the baby. I love that I'm heading into this mystery with you."

She squeezed his hand. "I've had a lot of time to adjust to this. You're getting hit with it all at once."

He touched her lips, her nose. "I suppose I'm too happy right now to be overwhelmed. I didn't know feeling this good was possible."

She laughed. "Maybe you just hadn't had sex in awhile." She cleared her throat. "Or maybe I'm wrong," she said softly.

He was glad he didn't have to lie to her. "I haven't slept with anyone." He didn't need to mention what *did* happen with Chloe. "Have you?"

"No, Ray, I have not," she said into his eyes.

They talked more about the baby. Would it be a boy or a girl? She mentioned that it wouldn't be long before they could try to find out. "But I don't even want to find out," she said. "I want it to be a surprise."

They discussed whether or not the child would be an artist. "I can already see you hovering over the table as she draws with her crayons. 'What are you after? What are you after?'" Diane laughed.

"She?" Ray asked.

"Or, he. It doesn't really matter." Their talk turned to how they would paint the baby's room. They discussed murals they could work on together. "We have to do that," she said, sitting up. "Tomorrow. We'll start tomorrow."

He agreed. "The guest room is the ideal nursery," he said. "There's no wallpaper. We can just start painting."

"Well, Ray...what about your brother?"

He rolled on his side. "I told him this morning."

"What did you tell him?"

He said he told him everything—about the baby, about her moving back. "I told him that he needed to get out."

"No..."

The word stung. Had he been too harsh? "What? We can't have him there. He shouldn't be there when you're pregnant and we're trying...I mean, he's drunk nearly every night. You can't start out right with something like that around."

She pulled the covers up to her neck. "Where is he going to go?"

Rolling onto his back, he looked up into the ceiling. "I don't know. He'll need to figure that out."

"Does he know anybody else in Bay City?"

"He has a few friends."

"Friends who will take him in?"

"Diane, I don't know. Somebody probably will." He felt the small room constrict around them even more. "The guy just needs a fire under his ass." He felt her shift and her hip, which had been touching him, move away.

"From what you told me on the phone, it sounds like he needs help."

Ray swung his legs out of the bed and pulled his underwear on. "I know it sounds...but you haven't been living with the guy for four months. I have." He bent for his pants. "Every month has gotten worse."

He wasn't looking at her. He didn't want to see the judgment he'd find in her eyes.

"He's your brother."

He zipped his pants. "I know, but I gave him a chance. He threw it away. I gave him a lot of chances."

The bed springs creaked under her adjustments. "Do you know what it's like to live like that...to be alone and have nothing?"

He admitted that he didn't.

"I lived it when I came down here. I thought it was going to be exciting," she said. "Not knowing, though...it's really just scary. I stayed in a homeless shelter for the first week."

He looked at her. Her eyes were watery. "What? Why?"

"I didn't know the first thing. I didn't even know where to start looking for cheap apartments. I only had eight hundred dollars with me."

"Well, why didn't you...I mean, there must have been something. Someone."

She shook her head. "I was lucky to get the job at Meijers. I didn't really have any work experience. First I was married to Dan, and then I lived with you."

He pulled his shirt over his head. "I had no idea."

She said it was the same for Sammy. "He's probably afraid."

It was difficult for Ray to imagine Sammy as afraid.

Diane twisted her torso over the edge of the bed. A phone came out of its cradle. She turned and held the receiver toward him. "Tell him he can stay."

He thought about it. "No, Diane. It's done. I told him this morning. He's probably already found a place."

"Probably not," she said. "Just call him."

"No. I'm not going to have him there with us." He pointed at her, but pulled his finger back. "We have enough to think about. He'll be fine."

"He's your brother."

He nodded. "Yes, and I know him. You don't. Don't give me a hard time about this, please. I gave him four months. Now I need to think about me...us. Sammy will just make it harder than it's probably already going to be." He looked into her eyes. "Really, Di, please trust me on this. I've already felt sorry for him. It doesn't do any good."

Looking at him, she chewed her lower lip. "Ray."

He sat on the bed and put his hands on her belly. "Everything —all of our charity—it needs to go here." He felt the nervous clamminess in his palms against her warm skin. "We're going to have to be a little selfish if we're going to make this work."

She nodded. "It just makes me sad."

"It makes me sad, too. But if you're with him for awhile, your sorrow goes numb. Then it turns to anger. That's where I am with it. I don't want him in my house any more. Whatever it's going to be, it's going to be his future to make. Okay?" He rubbed the small rise of her belly.

Her lips collapsed remorsefully against her teeth. "Okay. I won't talk about it anymore."

"I don't want you to be sad about it, either. I want us to spend a great day together, and then I want to drive home."

She sniffed. Then she smiled. "Okay, Ray. Okay."

They spent the day wandering around Ann Arbor's downtown, and enjoyed its attempt at being a big city. She showed him the small gallery that had displayed her work. "It's closed now," she said. They went to other galleries. Ray enjoyed the streets, the honking horns here and there, the buzz of the sidewalks. "I could live here," he told her while they waited for their meal at an Indian restaurant. She said they couldn't afford to live there. The few friends she made didn't even live in the city. "They live in Ypsilanti. That shoebox I'm living in costs eight hundred dollars a month. This is a town of big wallets." She waved her hand through the air, indicating the restaurant. "I'd heard about this place ever since I got down here. This is the first time I've actually been able to afford to eat here."

After lunch they returned to her apartment and made love again. He reveled in her soft hair, soft lips. The room smelled of curry. They napped.

It was after six o'clock when he started to carry the boxes down to the car. He worked slowly. Holding the third box in his arms, he turned around and leaned against the doorframe. Diane sat on the couch sipping tea.

"That was a good day, wasn't it?" he said.

"Great day."

"I don't want to see it end."

She puckered her lips and blew across the surface. "Nothing is ending."

He nodded.

Dusk had darkened to night by the time they reached the outskirts of the city. From the bridge he could see the Huron River below them, its slick stretch darker than the rest of the night. County Route 14 merged into M-23. They drove north into the darkness. Diane released her seatbelt and lay her head on his lap.

"I'm tired. You don't mind, do you?"

He stretched his arm across her and rested his hand on her thigh. "No. Go Ahead."

She picked up his hand and moved it under her shirt and to her belly. She set her own on top of his and was asleep before they reached Whitmore Lake.

The highway hummed its steady song beneath them. Diane's face glowed in the dim light of the dashboard. Ray felt her skin warm beneath his hand. Below it, a human being was growing. Their baby. He imagined it floating as it was in the warm, wet darkness of its world—its small hands, probably no bigger than ladybug wings. He feared and loved the promise of what was coming. Shifting his thigh slightly, he tried to wriggle away the tingle of its sleepiness under Diane's head.

Taillights glided along the highway in front of them. Beyond the highway glowed the spotted lights of houses surrounded by the black of trees. He thought of Chloe and her road paintings. He didn't remember any of them depicting night scenes. It seemed rich in possibilities. He imagined a painting. A would-be father at the wheel drives into the stretch of night, the mother asleep on his lap, his hand on her rounded tummy. He imagined the hues, the gray-blacks and dark blues of the night sky. The luminescent green of the dashboard. And the father's face would have to reflect the awe and fear of his insides. What was this night he was driving into?

The lights of Fenton soon lit up the highway. Then, Flint. Just south of I-69, a GM factory glowed like a small city on the east side of the interstate. Everything around it was darker by

comparison. How many people worked in such a Goliath? Thousands, he guessed.

After Flint, the land grew flatter and the highway more barren. The sky, a bluish black, took up more of the space around them. He felt its vastness and the promise of his coming days. I'll be a good father, he decided. He worried about his hand getting too hot on Diane and the baby. He moved it away.

Soon the familiarity of the route came to him. Birch Run meant they would soon pass the Frankenmuth exit, and then Bridgeport. It wasn't long before the dim sparkle of a wheezing downtown Saginaw flickered in the western distance. Diane stirred as they drove under the bright lights that lined the sides of the Zilwaukee Bridge.

He told her that they were almost home. He warmed in the news, as though his announcement made it real.

She sat up and stared out through the windshield. She blinked. "How long did I sleep?"

"Over an hour."

"I seem to need so much more now."

He told her she could get into bed as soon as they got home.

"No. I'm okay now. I'll want to unpack and get settled in again." She finger combed her hair.

Ten minutes later they crossed the bridge over the Saginaw River and came into the downtown.

"Bay City," Diane said.

"It's not Ann Arbor."

She shrugged. "I missed the grittiness of this place. I don't think you can really be an artist in a place like Ann Arbor. It's too—"

A chaos of light startled them as they turned onto their street. Red lights flashed through the stark branches of the trees and reflected off the siding of the surrounding houses. People moved about on the sidewalks, some dressed in shiny black and others glowing ghostly in terry cloth robes.

"What the hell is—" Flames leapt wildly from the windows of his house. Water sprayed about in great, solid arcs—some on his house and some on the nearby houses.

He slammed the brakes and parked in the middle of the street. "Stay here."

"Ray!"

He felt his legs running under him. The inferno of his home loomed closer. Lights. Voices. The colossal sounds of water. "There he is," a voice shouted out from an eddy of robes near the sidewalk.

Something stopped him. He couldn't deny the grip of the hands on his shoulders.

"You can't go past this point, sir."

"That's his house," a voice shouted.

The face that belonged to the hands holding him was luminescent with sweat. "It's my house," Ray said. "It's my house." The fire was bigger than anything he'd ever witnessed. Cancerous, it was spreading to the roofs of his neighbors. It seemed angry, ready to take the entire town.

"We're doing what we can. I can't let you go any closer."

Glass shattered and flames burst through the guest room window. "My brother," Ray shouted. "My brother was home!"

The hands kept him from moving as though he were a child. "He's here. He's fine." The fireman looked over his shoulder. "Frank!"

Another fireman, black garbed like a rider of the apocalypse, came into focus.

The first fireman spoke above the noise of the fire. "This is the homeowner. Take him over to see the guy in the ambulance. It's his brother."

"He's okay? My brother is alive?"

"He's fine. He was already out when we got here." Frank held Ray's arm and pulled him through the shifting crowd of firemen and police officers. "The homeowner," he said, when people gave him looks.

Sammy sat, head down, in the open doors of the ambulance. A blanket had been wrapped around his legs. He looked like he'd just lost a prize fight.

"Sammy?"

Sammy looked up from under his overgrown bangs. His skin was stained the color of an ashtray's bottom. "Oh," he moaned. "Oh, Ray Ray. I'm sorry, Ray Ray."

"You're okay?"

A sob shook him. "Ray Ray, I'm sorry. I didn't...I'm so sorry. Ray Ray."

"Are you okay?"

"We checked him out," Frank said. "He's fine. He got out early." He patted Sammy's knees. "I'm going to let the two of you talk."

The smoke of everything Ray was losing was thick around them. More glass exploded. The fire sounded like a blizzard.

"Sammy. I don't...what happened? What happened here?"

"Don't make me talk...Ray Ray, I didn't mean..."

A nude portrait of Jolien Poiret leaned against the ambulance. Near it sat the crate of their father's guns.

"Sammy..."

Sammy lurched forward and fell onto the ground. The blanket pulled away, showing him naked from the waist down. "Jesus Christ, I'm sorry, Ray Ray." He wrapped his arms around his head and sobbed.

Ray looked back at his house. Every window was alive with flames. Most of the water blasting from the hoses seemed directed at the houses around his.

"Sammy," he said. "My house, Sammy. My house."

Sammy wailed. His buttocks reflected the orange of the fire. The inferno howled.

"Sammy. Get up. What are you...Get up. What is going on here? What happened? What are you...I don't...Where are your pants? What the hell happened to your pants?"

Chapter XIX

Outside, a few snowflakes drifted down toward the street. Intermittently, cars passed their apartment building. Ray hit the icon for his email. Twenty-two messages. He scanned through them and deleted most without even opening them—promises of longer-lasting erections and cheaper Rolexes. He did look at an email from his real estate agent, Bob Foster, which contained the pictures of and specs for a few new houses that had just come on the market.

The telephone rang in the kitchen. Diane picked up. Ray listened—maybe it was Bob—but she didn't call for him. He went back to the screen.

He started an email in reply, explaining that he'd like to see one of the Victorians. Diane came into the room as he hit send.

He spun in his chair.

"What are you up to?" She leaned against the doorway. Ever since her tummy had popped out, her hands were always on it, rubbing circles.

"Just checking email. Bob sent a few new houses over this morning. The guy's a diehard—even works on New Years day."

"Are you going to look at them?"

"One of them. Here, look..." He leaned back so she could see the screen. It was the closest thing on the market to what his old house had been.

She looked for a moment and then looked at her hands. "Nice."

"What's wrong?"

She seemed entranced by the motion of her hands. "Nothing." She stopped rubbing. "I don't know. It's just that we're finally settled in here."

"But we said that it was just going to be temporary," he said. Hearing about what they'd been through with the fire, the landlord had agreed to write up a special lease which allowed them to rent the place on a month-to-month basis. "Bob set this place up for us."

"I know. It's just that it's grown on me. It gets great light, and I just don't think I could move again so soon. I like the way it feels here."

He looked at her hands. They whispered against her shirt. "How long would you want to stay? Would you want to be here when the baby comes?"

"I don't see why we couldn't. I talked to the landlord, and he said we could paint the spare bedroom if we wanted to turn it into a nursery." She looked up at him.

"He said we can paint murals on the walls?"

She smiled. "I think he just meant that we could paint it a different color."

"But didn't you...I thought that you wanted to paint murals and—"

"I did, but now I guess I just want some permanence. I get really nervous when I think about looking at houses and moving again. I'm just thinking about so many other things."

For the last month he had escaped everything else he was thinking by devoting himself to looking for a new house. House hunting. It helped him to forget. "So you're saying that I should stop looking?"

"Just for now. Maybe in the summer we can look. I'm just getting really nervous now with the idea of anything being up in the air."

She had always wanted to be spontaneous in the past. "That's fine," he said, shrugging. He said he could email Bob. "We don't have to look anymore—it's just that I thought you wanted to be in a house."

She thanked him.

Turning back to the computer, he could feel her still standing in the doorway. "So, who was that on the phone?"

She was quiet for a moment. "Hmm?"

"On the phone. You answered the phone about ten minutes ago."

She moved behind him and rubbed his shoulders. She kissed the top of his head. "It was Sammy."

Something cold traveled along his spine. His fingers stopped on the keyboard. "What the hell did he want?"

She slid her hands down his chest and held him. "The same thing he always wants. He just wants to talk to you."

"It's cold," he said, "but I doubt hell has frozen over."

There was nothing sensual in the way she kissed his ear. "All of it was an accident, Ray. How long does somebody have to suffer for an accident? He's your brother."

"An accident," he repeated. Sammy had been reluctant, but said he'd tell the truth if Ray would forgive him. "Someone who burns down a house can't demand promises from the owner...Now be honest with me because you owe me at least that much," he had said.

Sammy told his story. Left alone in the house, he'd finished fifteen beers during the afternoon. Then, he went down to Ray's studio where he knew the nudes were. He'd kicked off his pants and underwear and masturbated to the renderings of Jolien Poiret. After almost finishing a cigarette, he fell asleep on the couch. The foul smoke of the burning carpet and canvases had woken him. Coughing, nearly choking, he'd had enough left in him to save one of the paintings and the case of guns. Then, he'd rushed outside and passed out on the lawn. The blaze had already raged up to the first floor when a neighbor finally noticed and called the fire department.

"It was an accident," Diane said. "How could he have meant for any of it to happen?"

"What the hell am I supposed to say to him? I've heard him apologize a thousand times." He clenched his fists, felt his nails pressing into his palms.

She rose away from him. "He said he has news. He wouldn't tell me what. He said he wants to tell you." She left the room.

Everything on the desk blurred in his vision. He stayed that way for a time.

It was nearly an hour later when he picked up the phone. He had the number. Sammy was living in Stevie's basement. That much he knew.

Stevie answered.

"I'm calling to talk to my brother."

"Is this Ray? Okay. Good. Hold on, I'll get him."

Walking the phone into the study, he heard Stevie shouting Sammy's name on the other end. The shouting grew fainter. Ray fought the urge to hang up. He sat in his chair and looked out the window. The snow had stopped and more cars were on the street.

Sammy picked up. "Ray?"

Ray made a noise.

"Ray Ray? Jesus Christ, Ray Ray. I'm so fucking glad you called."

His brother's voice made him sick, his foul language making everything too familiar, as though he assumed that he was about to be forgiven. "Stop swearing," Ray said.

He apologized. "I just can't fucking believe you called."

"Sammy."

"Sorry. Sorry."

Ray rubbed his eyes. "I can't believe I called, either. Diane said you wanted to tell me something."

"I do. I got good news. I got a job. I start working on the third."

Ray waited, but felt nothing. "Well, that's what you've wanted."

"Yeah. It's a pretty good place. Oracle. Ever heard of it?"

He remembered something. "Is it that place on the highway south of I-675?"

"Yeah. Yeah. It's good. I'll be starting at sixteen bucks an hour making engine parts."

Ray hated the excitement in his voice. "Well, sounds like you'll be making enough to keep you in booze."

Sammy said nothing for a moment. "Ray Ray, I quit. Ever since...well, I just quit. I haven't touched anything—not even last night. Stevie quit with me. We're both dry. Him for a month and me for two."

"Well, good luck with that." It seemed like a perfect line to hang up after.

"I want to give most of it to you. The money. I want to pay for a new place for Diane and you."

He exhaled dismissively. "I don't want your money. Insurance covered everything. You keep your god-damn money."

"Ray Ray."

"What, Sammy? What? Do you want me to say I'm happy for you? Fine, I'm happy. You got a job. Good for you. Now just stop calling. I don't want anymore of your god-damn regret."

"I just...I just want—"

Ray stood. "What? What? What the hell do you want from me?"

Sammy's voice cracked. "I just want to know if you'll ever forgive me."

He shook his head. "You burned down my house. Do you know how much of my life was in that house? Do you even...? You know what, fuck you. Fuck you, Sammy. Stop asking for my forgiveness. You won't get it. How am I supposed to forgive you?" He took a breath. "I don't know if I can ever stop hating you."

"Ray Ray..." Sammy's next word dissolved in sobbing.

"Don't call me Ray Ray. Just forget you had a brother. All right?"

"Ray—"

He pressed the button. The dial tone replaced Sammy's crying.

Ray took a long breath, made as though to throw the phone across the room, but then stopped himself. He held the phone, dial tone still droning, and stared his anger at the wall.

Chapter XX

It wasn't a blizzard, but the snow came down thick and heavy. Cars parked overnight on the street had become white mounds. It was only late January, and the recorded accumulation had already surpassed the last two years combined. News casts showed footage of people in their driveways, their snow blowers unable to shoot the snow up over the high banks. It was one thing Ray could say for apartment living—at least he didn't have to shovel.

He shifted his eyes toward the clock on the nightstand. It was just after one in the afternoon. He and Diane lay down for a nap together two hours before. She'd wanted to have sex.

"I don't blame you. I can't be attractive right now," she'd said.

"It's not that. I'm just tired. Don't turn this into a fight, okay?"

They lay in an awkward silence until sleep had finally taken him. He wasn't sure if she ever did fall asleep. Sometime while he slept she had risen. He heard her moving in the apartment. A radio was playing what he guessed was jazz, its muted discordance coming to him through the walls. He should have had sex with her. She was the one seven months pregnant. She was the one with the back pain and the bladder that wouldn't let her sleep more than three hours at a stretch. If he could have given her something, anything, he should have. But, the idea of sex left him feeling exhausted.

He seemed to drag her down more than support her. Being a helpful partner was one more thing he was failing.

He only had the strength to stare at the snow falling outside the window. Three times he'd decided that he had to get out of bed. He couldn't even sit up. His body was a burden, a dead thing to be dragged around. He had hoped to wake feeling better, but the nap had given him nothing. He looked at the clock and

managed to roll his legs over the edge of the bed. He stared again at the snow. So white. So void. Diane back in his life, a baby on the way, and the only emotion he could feel was loneliness.

In time, he dressed and walked down to the kitchen. When he came into the doorway, Diane stepped out from behind an easel. She looked flushed, alive.

"You're painting?"

She nodded. "It feels good. I think I'm after something." She looked down at the paint smears of green and yellow on her shirt where it stretched over her belly. "Not used to painting around this," she laughed.

He looked at the coffee pot. Empty. Its aroma was still in the room. "You couldn't have saved me half a cup?"

Her smile fell. "I didn't know how long you were going to sleep."

Nearly everything he said lately was followed by regret. "That's okay," he managed. "I can make more." He started for the pot, but then didn't want the hassle. He looked at the back of the canvas. "So, what are you painting? Can I see it?"

"Oh, no. It's too early. I don't want to jinx it." She set her brush down.

He nodded. "That's probably good thinking." Maybe she could sense that he was a jinx. Or maybe she remembered how critical he'd once been of everything she tried.

"Do you want me to make another pot? I can," she said.

Leaning against the counter, he shook his head. "You can work in here? It feels so constricted."

"I don't feel it. The light is great." She motioned to the window. "It's so bright today with all of the snow."

"I would feel suffocated in here." Even when he'd done *Riverscape* outdoors, he'd felt confined, hemmed in. *Riverscape.* Another failure...downtown for everyone to see.

"Why don't you paint with me?" She picked up an apple and ran it under the faucet.

"What?"

"Paint with me. Remember when we used to paint together?"

The memory brought with it images of his studio, his house, everything he'd lost. "I've got nothing in me right now," he said. It wasn't true. The weight of everything was in him.

"Well, just for fun. Just so—"

"Diane. I'm not going to paint. I'm not."

Her face softened sadly. Ray looked at her fingers holding the apple. Why couldn't he do anything right?

"It just seemed like it might be fun." She abandoned the apple to the counter.

"Maybe it would...I don't know. But I couldn't today, anyway. I'm supposed to meet Carl down at the Seagull at two. He called last night while you were at the store." She'd asked Ray to come grocery shopping with her, too. Why did she always want to be with him? He couldn't stand being with himself.

When Carl called, Ray had agreed to meet him. It seemed like it could be something good. Then, waking, he'd spent the morning trying to cancel. Carl's phone rang and rang. He didn't have an answering machine. God-damn Luddite, Ray thought.

"We're just going to have a couple beers, I guess. I don't see myself being there very long." He pushed his feet into his loafers.

She smiled. "Oh, Carl? Well, don't rush back on my account. You probably need to get out. You've never been a winter person."

Could it be that simple? His misery was just a reaction to the weather? He'd heard of seasonal depression. "I guess I didn't pick the best place to put down roots." Why hadn't he put more effort into finding work somewhere warmer? That's my problem, he thought, I let things happen to me instead of making them happen.

"Where would you have rather lived?"

He shrugged. "I should get going. I'm walking."

She hugged him. "Have a good time, okay?"

A door from the kitchen led to an outside staircase. He put his hand on the knob. "I'm going to try."

He kicked a path down the buried sidewalk. The snow gathered heavily on his hair. Another weight. He blinked as it fell into his eyelashes. Jamming his hands deep into his pockets, he bent his head. No hat. No gloves. He'd never reasoned with winter very well, choosing to deny it rather than adapt.

Diane was probably behind her canvas again, relieved to have him gone. It'd been a long time since he'd seen her with a brush and easel. She had experimented so much over the last few years: Found Art. Photography. Freeform Sculpture. She could be a dilettante. It was odd to see her working as a painter again. As the snow seemingly worked to erase him, he could only describe what he was feeling as jealousy. Seven months pregnant, and she had it in her to start a new piece.

His teaching had fallen off again. Whatever had started in the fall, he wasn't able to maintain its momentum. He didn't abandon his students in the classroom. He also didn't do very much while he was with them. They seemed afraid of him, and he wondered if they wouldn't be more comfortable if he did leave. Diane. His students. His absence seemed to bring everybody comfort.

The Seagull was empty. He found a table, and when the bartender found him, Ray ordered a pitcher. He let it and the glasses sit where the bartender put them. He stared at a muted news program on a television above the bar. It showed scenes of a bombed-out village in Afghanistan. A mother held a little boy with a bloody strip of cloth tied over his eyes.

Light flashed in from the open door. The silhouette that was left after its closing stomped its boots. Then it stood still.

"Do my eyes deceive me?" It was Carl. "Is Raymond Casper actually on time?"

Ray lifted his hand. It felt like a dead bird. The thought of idle banter, made real by Carl's arrival, haunted his insides with the twin ghosts of repulsion and exhaustion.

Carl set his coat and gloves on the seat next to where he would sit. He was smiling. "How are you, Papa?"

"I probably won't be able to stay long," Ray said.

Carl looked at him for a moment, his smile fading. "All right." He slid into the booth and gripped the handle of the pitcher. "Can I help myself?"

He was clearly puzzled by Ray's mood. Ray tried to shake it off. "Pour away," he said. "Fill mine too while you're at it."

Carl nodded, his smile gathering again. He poured them each a beer. Sliding Ray's across to him, he touched his fingertips along the edge of the ashtray. He pulled it to sit in front of him.

Ray watched.

Carl's grin was hangdog. Reaching into his shirt pocket, he pulled out a pack of cigarettes. "I kind of picked up a nasty little habit again while I was over in England. You want one?"

Ray shook his head. "I never started." Maybe it was the only thing he ever did get right. He looked at the oddly familiar package.

"They're French," Carl explained. He put one in his mouth and struck the lighter. A small flame leapt up.

Ray recognized the brand as Jolien Poiret's cigarette of choice.

The harsh smoke wafting around the booth brought Ray back to Jolien's bedroom. He thought of Sammy, too. He hadn't heard from him in nearly a month.

Carl exhaled toward the ceiling. His face came down, and he studied Ray. "So, when I last sat here with you, you were a lonely bachelor. What happened?"

"Obviously, you've heard."

"Yeah. Well, you feeling pretty good about everything?"

He didn't have the energy to begin to explore the truth of what he felt. It was there under his sternum, a knot he couldn't swallow. His sadness had become physical and, like a tumor, it shallowed his breath. "More than anything, I don't know what to feel. I feel overwhelmed."

Carl took a drag. "Well, you should. Diane's back. You have a kid on the way. I mean—"

"Don't forget my house."

Carl's face changed. "I forgot...Christ, I forgot about your house. I mean, with the baby and all...I was just thinking about a baby—"

Ray told him it was okay. "That's why I like you. Your mind goes right to the positive. I wish I could forget about the house." Almost every one of his paintings had been destroyed. A few remained. A nude of Jolien. A few of his ridiculously conceived action paintings in the faculty display. Whatever paintings were in the college's collection—two or three of his earlier works. And, of course, *Riverscape*. He swallowed.

Ray picked up his beer and took a long drink. "But, you have things to tell, too. How did England go?"

Carl told him stories about the plays they'd seen and how the students had reacted. He told him about long nights they'd spent in pubs discussing the performances. "The students really came alive," he said. Some still sent him emails from time to time to let him know how much the trip had meant to them.

Listening, Ray felt his jealousy. Not jealousy because Carl had gone to Europe and he hadn't, but instead jealousy over Carl's ease with his calling. He was meant to be a Shakespeare professor. He obviously loved it. He changed students' perceptions of literature and drama, and seeing that change was enough for him. If he had other passions or regrets, he never talked about them. Ray wondered why, with his own love of art, he hadn't simply taken a degree in art history. Wasn't it enough to know that there were thousands of great works? He envisioned a life spent in museums looking at the masterpieces of the world and talking to students about them. He sometimes lingered outside the dark classrooms of his art history colleagues, listening to them discuss the slides that they projected onto the screens behind their podiums. No ambivalence. No frustration with the lackluster work of students or the lack of work in themselves. Their job was to know as much as they could about the works that already existed. Great works. They didn't have to face their own blank canvases. It seemed so much more simple and pure than what he tried to do. Trying to teach students to be artists. Trying to be an artist himself. Ridiculous.

And yet, he couldn't shut off the desire he had to make something from nothing.

He poured the last of the pitcher into Carl's glass. "Sounds like you had a great trip."

Carl nodded, lighting another cigarette. "They're a hassle to arrange, but there's always a payoff."

"I imagine."

They sipped at their beers. Ray said he didn't want to order more. He felt ready for another nap. Before it, though, there would be the walk home. His feet in the snow. The cold. It already

weighed him down like an epic journey. Maybe the bartender could call a cab.

"Hey, do you remember that student that was in here the last time?" Carl asked.

Billy. Ray could picture him sitting in his office. He nodded.

"Did you hear about him?"

Ray shook his head.

Carl took a drag. "He had a breakdown in a sociology class at the beginning of the semester."

"Whose class?" Ray asked.

"Don't know. It happened over at the community college."

"What happened?"

Carl shrugged. "I only know what I've heard. He stood up, I guess, and started shouting that everything was bullshit. Sociology is bullshit. School is bullshit. Life is bullshit. It wasn't long before he was throwing books and running around the room. The instructor called campus police, and by the time they got there, Billy had his shirt off. I guess the students were terrified."

The way Billy had spoken in Ray's office suggested that he might be capable of a nervous breakdown. It had just seemed like so much talk at the time. How many students had told him over the years that they were about to snap? None ever did. Why would Billy be any different? "What happened to him?" he asked.

Carl said he hadn't heard anything else. He finished his beer. "You sure you don't want to get another?"

Ray shook his head. "Have you tried to get a hold of him?"

"Of who?"

"Billy. Wasn't he one of your students?"

"Over a year ago he was." Carl's voice was down an octave, defensive, as though he were denying an accusation. "Why would I get a hold of him?"

Ray shrugged. He recalled Sammy's English instructor calling because Sammy had been absent a few times. What would that instructor have done if he'd heard about a student's mental collapse? Probably start up some kind of fundraiser.

Ray understood Billy's feelings. Over the past month, he'd felt himself on the verge of shaking apart. Nothing made him feel right, not even Diane's rounded middle. Seeing her standing

naked before the bedroom mirror rubbing her belly only filled him with more fear. More unknown. He ran his fingers over the words and names that had been carved into the tabletop. He couldn't help but think that he was somewhat responsible for Billy's troubles. He'd pretty much dismissed him that day in his office.

"You all right?"

Ray nodded.

"Well, look, I think I'm going to get going. You said you had to head out pretty soon anyway, right?"

"I guess," Ray said.

Carl set a couple of bills on the table. "You sure you're all right?"

Ray looked up at him. He tried to smile. "I'll be fine."

Carl started to leave.

"Hey, what's Billy's last name?"

Carl looked at him for a moment. "Price," he said.

Ray nodded. "I'll call you. We should do this again." He didn't blame Carl for wanting to go. Ray hadn't been very good company.

After the door's brief flash of light, and Carl's exit, the darkness of the bar settled in around him. With it came a greater darkness, one that suffocated him into immobility. It was like a veil had been lifted to reveal the only true mechanisms of life: loss, sadness, and misery. Getting something only started the sadness that would come with losing it. Joy fostered pain. Health was foreplay to decline. Most people, like Carl, Ray thought, don't see beneath the veil. Nobody could function if they did. They were blind in their way. Functionally blind. But Billy...he had seen, too. Why otherwise his breakdown at such a young age? Ray stayed in the booth for a long time in the lingering of Carl's cigarettes, thinking of Billy, only dimly aware of the bartender's occasional questions and his own disembodied responses.

Chapter XXI

The sonographer said she would be right back before she stepped out and left them alone in the small, dark room. Ray sat on a stool next to the table where Diane lay stiffly. Her pants were unzipped, and she'd rolled the bottom of her shirt above her belly. Her taut skin stretched over the inert swelling. Her navel, like a mushroom cap, looked ready to pop off. She stared up into the ceiling, inhaled thoughtfully through her nose, and then turned her gaze toward him.

He put his hand on her hand and tried to smile. "You okay?"

She sniffed in a quick breath and nodded. Her eyes were moist.

Ray rubbed the back of her hand. Her skin slipped back and forth across the bones underneath. "It's going to be okay," he said. "The doctor just said that he wants to be sure. He said this is just to be safe."

Tears pooled along the rims of her eyelids. "I know," she said. She blinked, and a drop started down her cheek before she brushed it away. "I know."

She cried so easily when it came to the baby. The only time he'd ever seen her cry in the past was over beautiful artwork. He found her a box of tissues.

The baby hadn't moved in the past three days. Diane became alarmed during the second night of inactivity. She read through her *What to Expect When You're Expecting* book, her bible. It said that it was probably nothing, but she should still see her doctor.

She stared again into the ceiling. Ray held her chilled hand, wondering if maybe the baby wasn't experiencing sympathy lethargy. Could the fetus sense its father's lack of desire to move?

"Aren't you worried, Ray?"

Her question, spoken aloud, startled him. The dim room, lit only by the glow of the ultrasound equipment and a few small auxiliary lights, seemed like a place for whispers.

"The doctor didn't really seem worried," he said. "You know, it's like when you're on a plane and there's turbulence. They say you only need to worry if the flight attendants look scared."

She narrowed her eyebrows and shifted her back. "Doctors can be wrong. I mean, he sent me for the ultrasound, didn't he? He was the one who said that the baby might not be getting enough oxygen."

Ray shrugged his free palm upward. "He said he just wanted to be sure, Di."

She pulled her hand from his and set it on her belly. "I know."

He slipped his hands between his legs and squeezed them with his thighs. "I think everything's going to be okay."

She was quiet for a moment. "And you want it to be?"

"What?"

"You want the baby to be okay?"

"What are you...Diane?... I'm not even—"

She rubbed her eyes and turned to him again. "I'm not saying that...I mean, I don't think that you wish the baby were...But if... I mean, don't you think there's some part of you that would be relieved?"

"Relieved?"

"I just mean that if we weren't even having a baby."

"No," he said. "No. I want to have this baby with you. I want—"

"You don't act like it. You don't act like you want anything." Her tears were gone.

He recognized the resoluteness in her eyes. He took a long breath. "Diane. I—"

"What, Ray? You what? What am I supposed to think? For the past month it's been like living with a zombie."

He stood. "I know I haven't—"

She pointed at him. "Because if you don't want this baby— if you just want to get out, then get out. The hell with you, then."

He rolled his gaze toward the ceiling. "I don't want out. I know I haven't been there...but it's not the baby. It's everything—

losing the house, all my work." He picked her hand off her belly and held it in his. "It's not just the baby."

She looked at him, her eyes doubtful. "Just?" She took her hand back.

The sonographer opened the door. "Found it." She held up a plastic bottle and apologized for keeping them waiting. "But, we wouldn't have gotten far without this," she said, squeezing a glob of clear gel from the bottle onto Diane's tummy. Spreading the gel, she pressed the transducer against Diane, and a tinny, amplified sound breathed into the room.

Diane inhaled deeply.

"Just relax," the sonographer said. She slid the instrument over her shiny belly.

"I don't hear the heart," Diane said. "Why can't we hear the heart?"

"It's okay," the young woman reassured her. Her hand didn't stop gliding the transducer over the hill of skin. "Sometimes it takes a minute to find it."

"We'll hear the heart?"

Diane shushed him. "Is something wrong? Shouldn't we be hearing it by now?"

Ray's own heart began to race in rhythm with the urgency of Diane's fear.

"Sometimes, it's...I'm not sure how the baby is lying...I'm wondering..." She shifted the transducer again. "It could be..." Then something changed. A new sound came into the room. "There it is," she said. She looked at Diane and smiled. "There's your baby."

A sound like someone galloping two fingers against a tabletop filled Ray's ears.

He listened. "That's the baby's heart? Our baby?" It was a desperate sound, nearly frantic. He wanted to hold it, try to calm it.

Diane laughed and a few tears slid from her eye and over the side of her face toward her ear. She laughed again. "That's the baby," she said. "That's the baby's heartbeat."

The little rhythm filled up Ray's mind. It seemed so insistent, so wanting to be alive. "Is it supposed to be so fast? It sounds fast."

"Actually," the sonographer started, "that's exactly how it's supposed to sound. Should be about one hundred and fifty beats per minute." She looked at Ray. "That's about twice as fast as the average adult."

"Then everything's okay?" Diane asked. "Everything's fine?"

She didn't say anything for a moment. "You have to talk to your doctor."

"But everything looks okay? I mean, to you?"

She looked at Diane. The corners of her mouth rose sympathetically. "I'm really not supposed to...I can only say that I'm not seeing anything that concerns me."

"Oh, thank god."

Ray picked up her hand again. "See."

"But, you have to talk to your doctor."

"Of course. Of course." Diane squeezed Ray's hand.

The sonographer's hand stopped a moment later. "Okay, don't look if you don't want to know the sex."

Diane turned her head away.

Ray stood and started to lean.

"Ray! Don't look."

"What? I just want..." It would be something at least . . . some certainty about this life coming into his life. "Di...I won't tell you. I won't." He leaned again.

She grabbed his arm, laughing. "No, Ray. We don't want to know."

The sonographer moved her body, exposing the screen. "He can look, now. I'm just showing the head."

The screen showed a blur of dark and light, something like a Rorschach or an abstract charcoal drawing. "That'...?" He squinted. "I don't..."

She pointed. "Can't you see? That's the nose right there."

"No, I don't—" Then it came to him. A tiny face on the screen faded in under the sonographer's finger. The nose. The closed eyes above it. The sweep of forehead. Wide lips. It was angelic,

cherubic—nothing like the shrunken skull picture Diane had shown him months before.

He felt Diane's moist hand in his. "Look at the proportions," he said. "It's like...do you remember figure drawing class? I mean, it's like a perfect drawing. Everything's exactly where it's supposed to be."

She smiled at him. "It's our baby. Our perfect baby."

He studied the sleeping face on the screen. It was inside her. It was his baby. He wanted to touch it, run his fingertips over the screen. Over the pouting lips. He wanted that face, that little stranger, to never know pain. "The baby doesn't feel it when you press like that?" he asked.

The sonographer grinned. "No, the baby is plenty protected." She looked at Diane. "We'll be done in just a minute."

A moment later Diane jumped. "It moved. I just felt the baby moving."

The sonographer nodded. "Sometimes the ultrasound wakes them up."

Diane grabbed his sleeve. "It's moving again, Ray." Her tears returned. "The baby's moving."

The pulse in her palm beat against Ray's palm. He felt his own warm tears.

It came too soon that the woman lifted the instrument away and the tiny face disappeared. The desperate rhythm was gone, too. She swiped a paper towel over Diane's glossy belly. "I'm going to send the information right to your doctor's office. I'm supposed to tell you that you can drive straight there from here. He'll be able to talk to you today."

Diane was quiet in the car.

"Something wrong?" Ray asked, still picturing the baby's face.

"It's just...I mean, the doctor could still—"

"Di. Everything will be fine," he said, trying to comfort himself as much as her.

They waited a short time before the doctor came in. "Well," he said, "the nonstress test and the ultrasound look really good." He said nothing in the results worried him. He looked at Diane. "Plus, you said that the baby's moving again so—"

"It's moving right now," she offered.

He smiled and nodded. "So, I'm not worried at all. What I'm guessing is that the baby just got on a different sleep cycle. When you were sleeping, it was moving. That happens quite often. It's like with an infant. They'll hit a growth spurt and, boom, when they were once sleeping through the night, now they're up at three o'clock in the morning ready to go." He looked at Ray and grinned. "And you thought this stuff was hard." He winked.

He told them to keep an eye on the baby. "If anything seems odd or worrisome, don't hesitate to call." Giving them one last reassuring smile, he left the small room. They heard him knock on a nearby door. His voice came through the wall. "So, how are Mommy and Daddy holding up?" He had used the same greeting with them.

Ray helped Diane to her feet. They held each other for a minute.

Ray maneuvered the car along the snow-covered streets. The tires caught in the greasy ruts, and the steering wheel tried to wrench itself from his hands. "Heavy snow," he said.

Diane sighed. "I'm sorry, Ray."

He put his hand on her leg. "You don't have to apologize."

She shifted in her seat. "No, I do. I shouldn't have said... shouldn't have accused...it's just that I was afraid. I didn't know what was going to happen. I didn't..." She looked out her window. "I didn't know that I could ever love something so much, something I've never even really seen or held."

"You don't have to explain. I haven't been good lately," he said. He could still feel his misery like something haunting the car. He squeezed her thigh tenderly. "I understand why you said what you said."

Soon, they were in the driveway. He looked up at the apartment building. It would all be so much easier if they were only pulling into the driveway of the old house. The memories of sifting through the charred remains always came into his mind when he least wanted them. Standing where his studio had been, he'd found his steel lyre easel, blackened and warped. He'd stood where his staircase once had been and watched the snow drift down and accumulate around the burned up foundation. He'd compared it to being trapped in a Eugene Berman painting. Of course, when

he'd made the comparison, he was talking to a colleague, showing off by dropping an obscure artist's name. Really, no artwork could reflect the depths of his misery. Art failed.

Strangling the steering wheel, he tried to will these thoughts away.

"You all right?" she asked, her hand on the door handle. She smiled encouragingly, but her eyes looked frightened.

He nodded. "I'm okay," he said, wanting desperately to believe himself.

Chapter XXII

Ray followed Billy's mother down a flight of stairs into the stench of cigarettes. Wide-eyed, the little blonde boy in her arms stared at him over her shoulder. Ray smiled, and the boy smiled back.

It wasn't hard to get Billy's address. One question to the department secretary, and she had it for him a moment later.

A few rugs were tossed around on the cement floor. A queen-sized bed was pushed into a corner and next to it a baby crib. Billy sat forward on a couch playing a video game. A van on the screen blew up. People were screaming.

"Billy? Billy, there's somebody here to see you," his mother said. "Turn that down."

He glanced away from the television. "What?" He looked at Ray. "Hey." His face registered his recognition. "Hey!" He flipped his hair out of his eyes. "Professor Casper. What are you doing here?"

Ray smiled. "I just wanted to come by and talk to you."

Billy set his controller down. When the character on the screen stopped moving, a number of men came out of an alley and began beating him with baseball bats and crowbars. The cries coming out of the speaker were very real. The character moaned and tried to cover his head. A green bar across the top of the screen faded away until it turned red and then disappeared. "You've been snuffed, sucka," the speaker announced.

"Oh, God, Billy." She looked at Ray. "I hate these games." She looked back at her son. "Why do these games have to be so violent?"

"It ain't real."

"Well, it ain't nice, either."

"Mom."

"All right. Fine." She sighed. "I'm going to give William his dinner." She started toward the stairs. The child's eyes were fixed on the screen for as long as he could keep them there. "Sucka," his tiny voice echoed in the stairwell.

"William," Mrs. Price said. "No. No."

"No. No." he repeated.

Billy laughed and patted the couch. "So, sit down." He tossed his hair again. "Guess you're here because you heard that I flipped out."

Ray sat down and sagged lower into the cushion than he'd expected. He tried to adjust. "Well, I did hear something."

"Probably heard the truth—don't think anyone could make that sh...stuff up." He touched his foot on the silver game console. The television screen went black.

"I just wanted to see how you were doing."

"Well, I couldn't be doing any worse. That day was bad, dude." He picked up a pack of cigarettes from an end table. "Bad."

Ever since talking to Carl, Ray hadn't been able to get Billy out of his head. Compassion. Guilt. Curiosity. They'd blended together and made the visit a mission. He wasn't sure what he expected. "Why do you think it happened?"

Billy flicked a flame out of his lighter and sucked it into his cigarette. He exhaled. "I just freaked. It was everything. Everything I told you about and then other crap piled up on that."

The sweet sounds of Mrs. Price trying to coax William into eating drifted down the stairs.

"He's a picky little dude."

Ray smiled. "He's cute."

Billy nodded. "Got that from his mom, not me."

Ray shifted again on the couch's spent springs. "Do you even want...I mean, can I ask you about it?"

Billy shrugged. "I told the shrink, I can tell you. It's not like you don't already know a lot of it."

He talked and smoked, lighting a new cigarette each time the one in his hand burned down to the filter. "It really started when Kari and me got tired of not being together." He explained that in August they got an apartment together. "Cheapest place we

could find was a little efficiency in a bad part of Saginaw. Shit really hit the fan with her folks, but we didn't care." He said they didn't know how bad the neighborhood was until they moved in. "We didn't know anything about anything. Shit, there were gun shots almost every night." Kari got a job, and they worked out their schedules so they could keep taking a class each. He said that for awhile it really felt like it was working. "I guess it really just felt good to be together. William slept in our bed between us, and I'd wake up at night and find him there all warm. Then I'd look over at her..." He shook his head fondly. "It was like... Dude."

He explained that the first couple months of the fall semester went pretty well. Then, they noticed that they were spending more money than they were making. Some things, like groceries, started going on the credit card, and the balance really stacked up. Billy couldn't get anything above a D+ on his Comp II papers. "In November, William got really sick. Emergency room sick. He had a hundred and five degree fever and wouldn't stop crying. That was scary shit."

All of this, Ray realized, was going on at the same time that Sammy started skipping classes to get drunk, Diane called to tell him that she was pregnant, and his house was razed by fire. Simultaneous misery.

"Things got a little better around Christmas," Billy said. "My folks just gave us money, and her folks warmed up a little and bought us a whole set of these really awesome pots and pans. Calphon." He said December was a good month. "Then in January, it all started again. Bills too high, William getting sick all the time, me not getting enough hours at work. But the whole thing cracked apart when we went back to our apartment after visiting her folks one night and found a smashed out window and all our shit gone." He said they'd taken anything worth taking, and the rest was scattered around the apartment. Snapshots that had been in a box buried in their bedroom closet were spread all over the kitchen floor. "That's what freaked Kari out...that they'd seen pictures of us. She said she couldn't stay there anymore. That's pretty much when I lost it. I was back in class two days after the robbery, and it all just hit me."

"I can see how something like that would put you over the edge."

Billy shook his head. "You ain't kidding, dude."

William crawled across the floor above them. Billy's mother was after him on hands and knees. "Gonna get you, William," she cooed. He squealed, and his thumping pace quickened.

Ray shifted again on the quicksand cushion. "What about now? How are you, now?"

"Well, better. Like I said, it'd be hard to be much worse."

Ray nodded. "I'm glad you're okay."

"Thanks to my mom and dad, I am. They really bailed us out."

"Is this where you're staying, now?" Ray nodded toward the bed.

"Yup. Long as we need to, they said. We can at least be together that way."

"What about Kari's parents?"

"They don't like it, but they'd rather have us here than over in Saginaw. That town's just getting worse, especially with everything that's going down."

Ray nodded. "Are you taking any classes?"

Billy laughed. "Tri-County don't want me around until at least next winter. Counselors there thought I should take some time off."

"Probably should, I guess."

Billy nodded.

"What's your plan, then?"

He laughed. "No plan. I'm pretty much in the same place I was in when I saw you in your office."

Ray stopped shifting and let himself sink. "You're just taking things day by day?"

"What else can I do? If I start looking too far ahead, I get that sick feeling." He shook a cigarette out of his pack and stood up. "My dad says when he was my age, he knew exactly what he was going to do, and he did it." Lighting his cigarette, he started to pace. "Shit. Me? I don't have a clue. I try to picture some kind of future. Everything's too fuzzy, though."

Ray nodded.

"I think about school, but I just don't think there's anything there for me."

"Well, I wouldn't give up on that. It's your best bet."

Billy shrugged. "I don't know. I got a friend who's had a teaching degree for a year and a half. He can't get anything better than subbing jobs."

"I don't know what to say. There aren't any guarantees, I guess." He wanted to leave. Billy's pacing, and his arms slicing the air had him nervous.

"No guarantees? Ten to twenty thousand bucks to flip the bill, and it doesn't guarantee you anything?"

Ray agreed that it wasn't fair.

"It's bullshit."

Ray slapped his hands on his knees. "Well, I'm just glad to hear that overall you're okay."

Billy took a long drag. "I'm scared to death."

His words haunted the room. "Of what?"

"Of everything I don't know, dude. I mean, it shouldn't feel like this. Last semester my English teacher said he felt immortal at my age. I sure as hell don't feel that way."

Ray thought of his own youth. Paris. An experienced older lover in his bed every night. Working on paintings that felt like they might change the world. Maybe most of it was a fantasy. Isn't that what youth should be? He wished he could still feel even a hint of those days, those long summer nights.

Billy mashed his cigarette into the ashtray. "I don't know, I guess it doesn't matter."

"What do you mean?"

"My mom and dad said that we could live here as long as we wanted. They'll take care of things. They just want to see me happy." He drew another cigarette from his pack. "I think my little breakdown really got to them."

"I would imagine." Ray struggled out of the couch and stood. "But so I guess that's it from here, huh? I mean, until whatever happens, you'll be here."

"It's not that bad. Kari should have her degree in a few more years."

Ray patted his pocket. His keys jangled. "And you? I guess you just don't know."

"My therapist told me not to think about it. She said that's what gets me all cranked up."

Ray said that her advice made sense. He held out his hand.

Billy grabbed it and went through a series of shifting handshakes. Ray followed as best he could.

Billy smiled and nodded. "Thanks for stopping by, dude. That's cool shit." He walked with Ray to the landing.

Ray told him he hoped everything worked out for the best. Before he was at the top of the stairs, the sounds of the video game started again.

Mrs. Price was in the living room on the floor changing a diaper. "You probably need your coat," she said.

"No hurry. Take your time." Diaper change. It was something he should watch.

"This little prince is such a little gentleman," she said, kissing William's pale, dimpled belly. "He doesn't give Grandma any trouble."

Ray watched her hands. She opened the soiled diaper, wiped, wrapped the dirty wipes in the diaper, and pushed the mess to the side. Holding William's ankles in one hand, she lifted his legs until his behind followed. She pushed the new diaper under him. Clockwork. "He's a little prince," she sang.

"I've got a child on the way myself," Ray said.

Mrs. Price pressed the tabs down. "Oh? Congratulations."

William sat up. He patted his chubby hands on the diaper. "Ah fesh," he said.

Mrs. Price laughed. "Yes, he's all fresh. Fresh as a daisy."

"Daydy," William repeated.

"I hope I can do it as easily as you make it look," Ray said, smiling at the little boy.

Mrs. Price stood up. Her knees popped. "This age is easy. Diapers. Feedings. There's hoopla, but it's nothing, really. It's when they get older that things get tough."

He imagined what she'd just been through with Billy.

Stepping toward the doorway, she talked toward William. "Grandma's going to get the man's coat. I'll be right back."

He patted his diaper again. "Ah fesh."

"Yes." Smiling, she left the room, leaving Ray and William alone.

William fell forward onto his hands. He started to crawl.

"What are you doing?" Ray asked.

William stopped and looked at him. He smiled. "Do in," he said. Turning away, he started for the coffee table.

"He's moving," Ray called. Where was she? He felt his lens shifting, zooming in on William. The rest of the world disappeared.

The boy reached the coffee table and stretched a hand to its surface. He pulled himself up. Standing, he smudged tiny palm marks on the glass. "Up," he said, maneuvering himself toward a pack of cigarettes on the table.

"Don't..." Following an impulse, Ray bent over and picked him up. He turned him in his hands, and they faced each other.

William's eyes grew wide. He didn't smile. "Tanger?"

"Yes," Ray nodded. "Danger." The child was solid in his hands, a perfect heaviness. Ray smiled. "You're a big boy, aren't you?" He wondered about his own child floating in Diane's darkness.

"Tanger?" William asked. He looked like he might cry.

"No. The danger's all done," Ray said softly, wanting William to smile again.

Mrs. Price came back into the room with his coat. "I think William wants to know if you're a stranger." She put Ray's coat on a chair and set her hand against William's cheek. The tiny smile returned. "He's not a stranger, William. He's a friend of Daddy's."

He smiled at Ray. "Da da fend."

Ray's own smile felt pulled up by strings. He couldn't help himself. After a moment, he set the boy down.

"What was he doing?" Mrs. Price asked.

Ray watched him crawling away toward the table again. "He was standing up at the coffee table."

She said that it was okay. "That's how he cruises. He'll be walking soon." She watched him. "We were worried. It was taking a long time for him to even start to stand."

She had crow's feet around her eyes and the wrinkled upper lip of a smoker. She looked tired. She probably never imagined that she would be raising an infant at her age.

She turned her gaze from William to Ray. "So you were one of Billy's professors?"

"I just knew him from around D. U."

"He knows so many people. People like him."

He slipped his arms into his coat. "He's a nice young man."

"And so the two of you talked?"

"We did."

She said it was nice of him to come over.

"I just felt that I should."

She followed him to the door. Ray put his hand on the knob.

"Do you think...does it seem to you that he's going to be okay?" she asked.

"I don't know." He didn't like the way that his words seemed to sadden her face. "I think so. I hope so."

They watched William pull himself to standing at the coffee table. "Up," he said proudly. The boy could eventually be miserable. Another Billy? Another Sammy? They started so perfectly. Then what happened? "It's a tough world," Ray said.

Mrs. Price nodded. "I don't understand it."

Chapter XXIII

Ray crouched in the quiet space where the college had its collection of faculty art. Most everybody had already gone home. Twilight, a time of limbo at the university. The intermittent footsteps of those who were early for night classes echoed around the hallways. The inner workings of the building's heating system hummed in the walls. *Kitchen Study #12* and *Kitchen Study #27*— two of his earlier paintings—leaned against the storage sleeves in front of him. There was too much Hopper in them, but there was something else, too. He grinned at the titles. Twelve. Twenty-seven. He'd only done four or five paintings of his parents in the kitchen.

They were right in front of him. His parents. In both, his father is looking out the window. He's in his work clothes. His hands are dirty, and a few knuckles are scabbed. In one he's setting his coal-black lunch bucket on the counter. In the other he reaches down to untie a steel-toed boot. The look in his eyes reminded Ray of a wolf he'd seen when his dad had taken him and Sammy to the Cincinnati Zoo. Unlike the other animals that seemed content to sleep through or adapt to their captivity, the wolf paced the outer edges of its cage. Its eyes were hungry, restless.

His mother stands in the foreground. In one, her hands, each holding a wooden spoon, toss a salad. The lettuce, the tomatoes, the cucumbers all appear wilted and rotting. In the other she's stuffing a turkey. In both, her eyes stare helplessly at the viewer. They seem to ask, "Is this it?"

At thirty, he had given his parents such little thought, sometimes barely enough to remember to call them on their birthdays. He stared at the paintings. Why had he been so fascinated with them in his twenties? The paintings were good,

like Kleminger had said. They were after something. They weren't just renderings of his parents. In their simplicity, and honesty, they were archetypal. He kept coming back to his mother's face. It was her. Sure, it looked like her, but it was also her essence. She was always so sad.

When he was younger, in high school, he used to carry her sadness with him as though it were inherited, like something he'd picked up from her blood while he was in the womb. Her disconnection from the family seemed something like his. He had wanted to ask why she always looked so forlorn. What had she wanted from her life? Even while he was in Paris, his thoughts would go to her, alone as she had always seemed, living in the flatness of Ohio. He never did ask for the source of her sorrow. The closest he came was whenever he asked over the phone how she was doing. "Oh, I'm fine. Just fine," she'd always say. Then, she turned questions to him. How was his painting? How was his teaching? How were he and Marcy? And later, how was he doing without Marcy? She always gave and never seemed to ask for much even from her own marriage. He wondered if he had been a good son to her. Aside from the occasional phone call, he had let her drift from his life. He'd abandoned her.

That was his world, the world he'd grown in—a world of emotion, simple and complex. He'd painted it honestly, and the paintings were good. His mother's face stared back at him. What did she dream about as a little girl? He didn't know if she'd ever had a job before getting married. He didn't even know if she'd ever been in love with anyone else. He guessed that she couldn't have really loved her husband, his father. She did love her sons, even during the last five years of her life when Ray had done very little to deserve her love.

The paintings told him everything. Her parents had wanted a son. They didn't encourage her. When a young man took interest in her—Ray's father—they practically threw her out the door into his arms. He was selfish, but a provider. He was moody and could be mean for no reason. She learned to be quiet around him and that everything went easier when his whims were tolerated, even encouraged. Then her sons came. She found her calling in raising them. She gave them everything she could give.

Soon they grew up. One grew away altogether. The other stayed and turned out to be too much like her husband.

When the doctor diagnosed her breast cancer just after Christmas one year, he gave her six to eight months to live. Chemo. Radiation. It was all in its infancy, its brutal infancy. Ray planned to see her. That January and February, classes and bad weather kept him from going. When spring break came in March, he had an opportunity to go to a conference in New York City—a free trip on the college's dime. He skipped most of the breakout sessions and instead went to museums. He got to stand before the Pollock again. A few hours after arriving back to Bay City, he received a call from his father. "She's gone, Ray Ray. Our angel is gone," he sniveled. His mother had had a heart attack brought on by the chemo.

Staring at her face on the canvas, he pushed his fingers into his eyes and dabbed away the tears collecting in the corners. He carried the paintings out to his car.

In the apartment, Diane lowered herself onto the couch next to him. Opposite them, against the fireplace, leaned the two paintings.

"Those are good," she said. "Wow. Those are really good."

He reached with his left hand until he found her rounded tummy. She put her hand on top of his, and he moved them together in slow circles. He did it because he knew she would like it. For himself, feeling that curve of belly under his palm only heightened his anxiety.

"Have you been painting at work?"

He shook his head and explained he'd done them while he'd been in Paris. "They were in the college collection."

She looked for awhile. "Who are they?"

He stopped his hand. "My parents."

She leaned as far forward as her belly would allow. "She's so sad." She squeezed his hand. "What's she thinking?"

It was their old game. She would point at someone in a painting—often just some non-descript person in the scene—and ask him to tell her the person's story. Sometimes he could spin some believable yarn for fifteen minutes.

He took a breath and stared at his mother's face. "She's wondering where her energy has gone," he started. "She's wondering why the wooden spoons feel so heavy, as though they're tree trunks. She's wondering why food doesn't taste good and her husband's touch does nothing for her. She's always dreading that something will happen, though she doesn't know what. She doesn't like to be around people. She doesn't like to be alone. She's wondering when she'll be able to think clearly again. She knows that she's failed at everything she's tried, and she feels guilty for every failure." He leaned back into the couch. "She's a burden to everyone. The future is a void. She knows she can't do anything about it. She doesn't sleep well, and when she does all of her dreams are disturbing. She takes naps. She's absolutely alone."

Diane tried to get his hand moving again. "Do you think she'll ever feel differently?"

His hand slid off her belly onto the couch. "She wants to. She remembers times when she was a different person. It helps her to believe that she might yet come out of this hole."

"I wish I could help," she whispered.

He didn't want to say anymore. He pointed to his mother. "She would have liked you. She would be happy to know that I'm with someone as good as you."

Diane said she wished she could have known her. They sat quietly looking at the paintings.

"What about him?" she said, pointing at Ray's father. "What's his story?"

He looked beyond his mother to the wolfish father in the background. "I think they have the same story. He tries to run from it, and she lets it come over her like an avalanche."

Diane pushed herself to standing. "Well, they're good. I really like those paintings, even better than your abstract pieces. Much better than *Riverscape*. You should hang them up." She smiled. "You can really paint."

He said he didn't see things anymore the way he did when he was a young man.

"Maybe you're just not looking."

He shrugged. "Maybe I just can't."

Her hands went to work. Circles. Circles. "Get better, Ray," she said, following her belly out of the room.

Two days later, a Saturday, the telephone rang. Ray picked up.

"This Ray?" a familiar voice asked.

"Yes."

"This is Stevie." Stevie cleared his throat. "You gotta come see Sammy."

Ray sat up. "Why?"

"Not my place to say. You got a pen because I'll need to give you directions."

He found a pen and paper. "What's going on?"

"Just come over here," Stevie said. "Today."

Ray scraped ice from his windshield. Gloveless, his knuckles reddened, and his hands burned in the frigid temperatures. The night before, the weatherman had predicted the cold snap, though he couldn't say when for certain it would end. "This one's like a relative who's come for a surprise visit," he said, smiling into the camera. "It doesn't really have a departure date in mind."

Ray twisted the key and the engine struggled. How old was the battery? When it finally started, he leaned back into the cold leather. The vents blew frosty air over him. He shut the heat off. There was something about the phone call. He knew he would be bringing Sammy back to the apartment with him. Somehow, his brother had worn out his welcome. It could be almost anything that he'd done. He'd let Ray down so often in such a short time.

He imagined Stevie's voice again. So distant. So resolute. Yes, he would be taking Sammy back. One or two nights—a week at most, he thought. Sammy would have to be out before the baby came. He had a job. It was time for him to have his own place. Why had Stevie let him stay so long?

The world crackled under his tires. Nothing changed as he came block by block closer to Stevie's house. He expected to see a crumbling neighborhood: paint peeling away from siding, gutters dangling, even the occasional abandoned car heaped over with snow in a front yard. Instead, the houses, though not gigantic Victorians, were well-kept Cape Cods and ranches. Many of the front yards were cluttered with sleds, pieces of winter clothing (a scarf or mitten peeking up), and the ruins of snow forts and

snowmen. The big red hearts of the approaching Valentine's Day dangled in a few windows. Every fourth or fifth yard had a real estate sign jammed into its deep white. Stevie's was one of the houses up for sale. Pulling into the driveway, Ray wondered if that was why Sammy had to move out.

Stevie opened the door and nodded his head. "Hey."

Ray wasn't sure what to say. "You're moving?"

"We are now." Stevie looked out at the sign. "Come in."

A woman was on a sofa. She looked up at Ray. Her eyes were red and watery.

He slowed, guessing that the tears had something to do with something his idiot brother had done. "Are you—"

"That's my wife. That's Suzy."

She tried to smile.

"This is Ray," he said, motioning with his thumb. "Sammy's brother."

She started to rise, started to say something. Her face broke up into silent crying and she covered it with her hands.

"Never mind her. She'll be fine." Stevie ran his hand under his nose. He sniffed. "He's in the basement." He led Ray to a door in the kitchen. Opening it, he pointed down into the darkness. "Just down there."

Ray tried to make eye contact, but couldn't. "What's going on, Stevie?"

"Sammy's down there. Just through the door at the bottom of the stairs." Stevie hesitated and then walked back into the living room.

Ray looked into the basement. A thin line of dim light shone from under a door at the bottom where the stairs ended. Groping for a switch or banister, he started down. He found no light and nothing to hold. A moment later, he stood before the door, his pulse beating in his ears. He took a breath and knocked.

No answer.

The doorknob was cold. Sammy lay on a bed in the flickering light of a basketball game. The sound was turned down low.

"Sammy?"

His big head drifted away from the screen. He squinted. "Ray Ray?" A cherubic smile spread into his cheeks. "Ray Ray, what are you doing here?" he asked sleepily.

Ray set his hand on the doorjamb. "Didn't Stevie..."

Sammy just smiled. "Come on in. Don't stand way over there."

Ray closed the door. Finding nowhere to sit, he kneeled by the bed. Four or five prescription pill bottles stood on the nightstand.

"What's—"

Sammy reached out and put his hand on Ray's shoulder. He squeezed lovingly. "Ray Ray," he said. He sighed a small laugh.

The faint light flickered around them. Sammy's smile infected Ray. He breathed his own little laugh and put his hand on top of Sammy's. "What's going on here, big fella?"

He tried to push himself up in the bed. "Just let me look at you."

"Sammy. What are you—"

Sammy squeezed again. "It's just good to see you. I'm glad you came." He blinked, as though suspecting that Ray were just his eyes tricking him.

"So, what's going on?"

He took his hand back and folded the pillow behind his head. He propped himself up. "So, am I an uncle?"

Ray shifted the numbing from his knees. "The baby isn't here, yet. I would have called."

Sammy lifted a glass of water from the nightstand. He took a long drink and then set it back. "Couldn't blame you if you didn't call."

"I'll call," Ray said, patting Sammy's broad chest. "When the baby comes, I'll call."

Big tears gathered in Sammy's eyes. One slid down his cheek. "How long before the birth?"

"About a month." He sighed. "So, what's going on? What's wrong?"

Sammy looked past him. "Another three pointer," he said. "That guy's friggin' amazing."

Ray turned. The players scrambled down the court. He turned back. "Sammy, are you going to tell me what's going on?"

Sammy took his eyes off the television and looked into Ray's. Ray had to look away after a moment.

Sammy took a long breath. "I just want to ask you if you can forgive me. I just—"

"Sammy, I didn't think I could...but I think I already have. It's not that I'm not sad about...but I guess I do forgive you. I don't feel the hate anymore. You didn't mean for it to happen."

"You forgive me?"

"Sammy, I'm still...it's not like I'm not sad. Sad isn't even the right word. It's not like I'm not—"

"But you forgive me?" His voice cracked.

Ray thought for a moment, then said, "Yes, I suppose I do. I suppose—"

"Don't just suppose. Don't just—"

Ray patted his brother's chest again. "Sammy, I know you're sorry. I know you didn't mean for it to happen. So, I forgive you. I don't hate you anymore."

Sammy cried. The tears made shiny streaks down his face. "Oh, Jesus Christ, Ray Ray." His face melted into sobbing.

"Take it easy, Sammy. It's okay." Ray got to his feet and crouched over him. "It's okay."

Sammy wrapped his arms around Ray and pulled him down to him. He held him in a bear hug and rocked him from side to side.

"Okay, Sammy. Okay," Ray laughed. "You're crushing me."

Sammy released him and ran his sleeve over his face. He snuffled. "I just...I just...I just—"

Ray sat on the bed. "Get your breath. Take it easy. Just get your breath."

Sammy sniffled for a minute.

"Just calm down," Ray said, petting Sammy's damp hair.

Sammy inhaled. "I just wanted you to forgive me before anything else...because otherwise it wouldn't really mean anything because you'd have to. I just had to know that brothers can forgive each other."

Ray nodded. "You weren't really in control of yourself when the fire happened. You were hurting too much." Some of the words were Diane's, but he was starting to believe them more.

Sammy nodded, and the tears started again.

"No," Ray laughed in frustration. "Take it...don't start again. Just take it easy."

Sammy sniffed a few times. "I'm okay." He sniffed again. "I've got it."

"Is this why Stevie called me? He wanted me to forgive you?"

Sammy shook his head. "He probably called because I said I wouldn't."

Ray kneeled again. "Why wouldn't you call?"

"Because of the last time we talked and what you said."

Ray looked at him until Sammy looked up into his eyes. He smiled. "Well, that's over now. We just settled that. You're forgiven."

Sammy's lips buckled against his teeth. He nodded, sniffling.

"Hold it together."

"I am," Sammy said from between tight lips. "I am."

Ray waited a moment. "So, why did Stevie call? You guys have a falling out? Is he kicking you out?" It was best to get right to the point.

"No. No. Stevie and me are getting along good. He's the best."

"Okay. Well, then—"

Sammy propped himself up farther on the pillow. "Remember when I told ya about that job I got—the one at Oracle?"

Ray nodded.

"Well, I had to do a physical..." Sammy looked at his hands, his fingers. "The doctor didn't like things he heard, and that meant meeting with another doctor and then tests." He sniffed in a long breath. "The short of it is that they found cancer in me."

Ray tried to swallow. "No."

Sammy nodded absently. "Pretty far along, too. Started in my lungs, but it's spread some. It's in some glands, my liver...it's in my brain."

Ray reached out. He found nothing to steady himself with. "Was that...is that what gave you all those headaches?"

Sammy said that the doctors weren't sure. "Maybe just hangovers." He picked up a prescription bottle from the nightstand and shook it like a joyless maraca. "Whatever pain comes now, I got my Percocet."

The memories of his mother's cancer came back to Ray. "When do you start chemo?"

Sammy set the pills back on the nightstand. "I don't."

"What? What do you mean?" Ray felt something like static electricity tingling over his surface.

Sammy smiled. "I mean that I ain't going to fight it."

"Is that what the doctors said you should do?"

Sammy laughed. "Don't ya remember Mom's doctors? Hell, if you only had six hours left to live, they'd have you on chemo for five of them...talking about how maybe it could buy you five more minutes." He laughed again. "No, it wasn't them. They wanted me to fight. It's just me. I ain't up for it."

Someone walked gingerly above them. The joists creaked.

Ray took a long breath. "If it's money, Sammy, I got—"

"I couldn't take another dime from—"

"Sammy, you know—"

"It's not just money, Ray Ray." Sammy sank down again into the bed. "I just ain't got no fight in me."

The room tightened. Ray looked at the television where two tall men in suits were smiling and recalling the best moments from the game.

"Pistons lost," Sammy said.

Ray wondered what he might do in the same situation. Would it feel easier just to give in? He looked at his brother. "Aren't you afraid?"

Sammy shook his head. "It's stupid, but it feels peaceful. For so many years I had no idea what was gonna happen. That made me more afraid than anything." He sighed. "I guess I been fighting for a long time."

Ray put his hand on Sammy's. "Fighting what?"

"I don't know, but it kicked the hell out of me." He pulled the blanket up and settled his head into the pillow. "I'm tired now. It's the pain killers." He yawned. "They take it out of me."

Ray asked Sammy about his job. "Wouldn't that be worth fighting for?"

Sammy yawned again. "Maybe if there was a job, but there ain't. Oracle closed down the Saginaw plant. You didn't hear?"

Ray shrugged. "No."

"You never did know nothing." He smiled. "Head in the clouds all the time, Dad said." He closed his eyes.

Ray sat in the flickering light watching Sammy's chest rise and fall, half expecting that it might stop. He looked at his brother's face, his mouth slightly open. His breaths wheezed. Ray's sorrow rose up in him like a sudden storm. Nothing like the long, dry sadness he'd been carrying with him for weeks, this came up wet and loud, and he had to crawl away from the bed to keep his sobbing from waking Sammy. He lived in his vacuum of misery for a time. Then the storm calmed.

He went back to the bed. Sammy had rolled away toward the wall. His side rose and fell like that of a slumbering hound.

"How's he doing?"

Stevie's silhouette stood in the doorway. "He was tired," Ray said.

"He's tired a lot."

"I'll bet."

"You got a second?"

Ray nodded and followed him out the door, closing it quietly. They didn't go up the stairs. Stevie leaned in the darkness against the faint square of a washing machine. Ray sat on the steps.

"Did he tell you? You okay?"

Ray nodded, his nose still running from the crying. "It was a shock. I mean, it shouldn't have been because he lived so hard, but I guess it's always a shock." A faint odor of cat urine wafted around them.

"He wasn't going to call you."

Ray thanked Stevie for doing it.

"What you said—about hating him—that was hard on him."

"I was just angry. I mean, you know what happened to my house."

Stevie put his hands on the washer and pushed himself up onto it and sat. "Losing a house...that's a helluva loss."

"Yeah," Ray nodded. "Takes time to get over something like that, especially when you have someone to blame."

Stevie drummed his fingers, raising a hollow echo from the machine. Then he stopped. "I'm going to be in Decatur for awhile."

Ray had heard of the town. "Illinois? Why?"

"Oracle's got a plant there, and it's doing okay for now. Got a few openings, and I got enough seniority that I got a spot." He hopped off the washer. "Not sure for how long. Whole damn company's going belly up from what the rumors say."

Ray ran his finger along the carpeted step. "If you sell this place, you're going to move there?"

"Got to go where the money is. Decatur plant's paying nineteen. Better money than any other place I could get around here."

Ray said he hoped it worked out.

"Don't know what else there is if it don't. Got a little place up north I'm going to have to sell. Kinda had our eye on retiring there." He jammed his hands into his pockets. "Already sold my boat."

"I couldn't imagine."

"It sucks." Stevie turned to the washer. He set both hands on the lid and bowed his head, looking ready to pray. "It's going to be just Suzy and the kids here while I'm in Illinois—at least until the house sells. Kids want to finish out the school year."

Ray nodded.

"It's gonna be a lot on Suzy with me gone and her trying to sell the house...all them showings. It wouldn't be otherwise, but Sammy staying here..."

He understood what Stevie was trying to stay. "Of course, he'll come with me," Ray said. "When he wakes up, I'll take him home."

Stevie turned toward him. "If it weren't...if I didn't have to...he could stay right here. I feel bad—"

"Don't. He should be with family. I want him home."

Stevie sniffed. "I just feel like I kinda owe the big bastard." He looked up at the wall. "Got me to quit drinking."

"He's been dry?"

Stevie nodded. "When he quit, he quit. Boom. Done." He chopped a hand through the air. "Not another drop. That fire put a world of hurt in him. He even quit smoking." He laughed. "That one I couldn't do."

Ray tried to imagine what it would feel like to have the guilt of burning down somebody's house. It'd be like carrying a tapeworm of self-reproach.

When Stevie walked up the stairs past Ray, he stopped and set his hand on his shoulder. "'I don't understand him, but I love the hell out of him.' That's what Sammy said to me about you." He cleared his throat. "Guess that's the way you feel, too?"

"He's my brother," Ray said.

Chapter XXIV

The hospice nurse, Carlene Davis, a dove-voiced woman in her sixties, came to the apartment to help them adjust to Sammy's dying. She sat with them around the table in the kitchen while Sammy napped on the couch. She explained that they'd do nothing invasive. No IVs or shots. Mainly she would monitor his pain and keep him on a routine of pills. Because of the brain tumors, there was a risk of seizures, so medication was prescribed to control them. If they wanted, they had people who could also help with Sammy's personal care, like sponge baths and massages. "I'm here for Sammy's comfort. I'm here to talk with him if he wants to talk. I'm here to make this as easy as I can, as easy as something like this can be." She said she was there for them, too. "Knowing that a loved one is going to die can be difficult. Even if you have each other, sometimes it helps to have someone else to talk with."

"I want you to come every day," Diane said. She looked at Ray. "I don't think I can be alone here with him while you're at school. I just don't think I can." Her hands worked her belly nervously.

Ray looked at the nurse. "Can you come every day?"

"Of course."

They rented a hospital bed for Sammy and set it up in the living room. He watched television and slept a great deal. Sometimes he looked out the window. "So much snow falling," he'd say.

Ray sat with him as often as he could. He tried to get him to talk.

"He doesn't seem like himself," he told Carlene one day. "He's gotten so quiet."

She explained that when the cancer is in the brain, it can change neurological function. "It can upset everything, even the most routine tasks." She said that the day before she'd asked Sammy if he wanted a blanket. "He said no, but then he started laughing. He knew what was happening. He wanted the blanket, but his brain changed the answer." She took a coffee filter from the cupboard.

Ray looked out the window into the neighbor's snowy backyard. A few chickadees flitted around a feeder. "You know, for the past ten years Sammy and I haven't been very close. I don't understand why I'm feeling this so hard."

She poured water into the back of the coffee maker. "Death can make you remember the closest of times. Maybe you've been thinking about your childhood together?"

He nodded. "I've been thinking about the past quite a bit. When we were young, we were really close. Eventually our differences drove us apart, but he was my best friend for so many years."

She started the coffee and leaned against the counter. "Those old feelings can rush up in times like this."

Ray smoothed his hand over the table. "He never picked on me. He included me in everything. He had a big heart."

"I can sense that about him."

"I guess he just had a hard life," Ray said. "Things didn't work out for him. If you have a big heart, maybe you feel the failures more."

"That makes sense."

An incoming blue jay startled the chickadees, and they scattered off into the tall evergreens around the yard. "I just wish I would have done more."

She said it was common during these times of loss to feel regret and guilt. "I've spoken with Sammy about how he came to be in Bay City. It sounded to me like you've done a lot for him—and have had your own losses." She poured him a cup of coffee.

He took the cup from her and felt its heat against his palms. "Do you think he should have fought it? The cancer?"

She sat opposite him. She said it wasn't for her to say. "He seems at peace with his decision." She sipped at the rim of her cup. "He said the idea of it makes him feel relieved."

Ray stared out the window. "Maybe he's just being brave."

"Maybe." She set her cup down. "Or maybe it's just his time."

The chickadees returned once the blue jay ate its fill.

Two days later, Ray was leaving his office. Down the hallway Claude Kleminger's door was open.

Claude sat under the harsh fluorescent light staring at the wall in front of him. The antique chair he used, an infraction of university furniture policy, resembled a throne. He looked as though he'd lost weight.

"Knock knock."

Claude turned. "Raymond." He moved his hands meticulously to his thighs. "Why are you here so late?"

Ray leaned against the door frame. "Just catching up on some work."

Claude nodded slowly and grinned. "Before the baby comes?"

"Right." I should be on the road home, he thought.

"I haven't seen you to tell you congratulations." Claude extended his hand.

The firm grip surprised Ray, as though the sculptor thought he was grasping a welding torch.

Claude held his hand for a moment. "I was sorry, too, to hear about your house. Damn shame."

Ray nodded. His sadness crested for a moment and then subsided.

"Are you teaching?" Ray asked.

Claude said that he was taking a reduced load. "I teach two night sections of Sculpting. Next fall I'll be done altogether."

"Oh?" Ray didn't know why he'd stopped by. It was a sad little room.

Claude smiled. "You can sit down if you like. I don't have class for another forty-five minutes." He started to get up, faltered, and then sat again. He pointed. "Just clear that stuff from the chair."

His visitor's chair looked like Ray's did most of the time. He set a few sculpting books on the floor and sat.

"You have so much going on in your life. Tell me how you've been." Claude leaned back into his chair.

Ray started to talk about his brother, but stopped. He studied Kleminger's flickering eyes, his twitching fingers. Elaine wanted Claude to talk—to open up. "I'm getting by," Ray said. "What about you, Claude? What's on your mind?"

"Me?"

Ray scratched the back of his neck. Claude's tone told him to mind his own business. Ray rubbed his palms together and decided to risk the scolding or dismissal that might follow. "I just mean, how are you holding up? With everything, I mean?"

Claude squeezed the armrests of his chair. He sniffed in a breath through his nose. "I'm okay."

Ray recognized the answer as the same kind he gave Diane lately when he was feeling anything but okay. If only she would push a little more, he might collapse into the truth. Another question came into his mind. It seemed like such a simple question, the stuff of small talk—one that Claude might even critique for its banality. Still, the question felt necessary. He cleared his throat. "Are you afraid?" Ray asked cautiously.

Claude said nothing for a moment. His fingers trembled, but he managed a small smile. "No. I'm not afraid." His smile faded and he looked down slowly into his lap. "I'm fucking terrified."

Ray felt as though his breath had been stolen.

Claude looked up. "This is the worst thing I've ever had to face. I'm not a strong man. Not in that way."

Ray listened.

Claude adjusted himself. His hands flipped around like wounded birds while he talked. "I've heard people mourn their children, people who have suffered while their children suffered. We have friends who lost a child in a drowning. Maybe if Elaine and I had had children this would feel different. Maybe I'm just too selfish. I don't know. I feel so sorry for myself every day."

"Maybe you just feel sympathy for yourself."

Claude laughed hollowly. "It's pity. Self pity. I know it. I am selfish and I always have been. But knowing it doesn't make me stop. I cry some days for myself. I don't let Elaine see."

"Keeping the crying from her...that doesn't sound totally selfish to me."

Claude shrugged.

"She is a good person, isn't she?" Ray watched Claude's flickering fingers.

"For putting up with me for all of those years...my moodiness? She's a saint. I always thought I'd pay her back by taking care of her. She was always the frail one." He shook his head. "Now I have to watch myself become the burden."

"I don't think Elaine would see it that way."

"You're probably right."

Ray thought lovingly of Diane.

"I can still work in the studio a few hours each day," Claude said. "I'm thankful for that." He said that when he was working he could sometimes forget about what he was going through. "In a way, though, that comfort is pathetic. Does everything have to come down to art? It seems so shallow. I get MS and my only thought goes to how much time I'll get in the studio? Ridiculous."

"It can be a blessing...when you just lose yourself in the work."

Claude's left hand jumped up off the armrest. He lowered it into place again. "Lose yourself. That's an interesting way to put it."

Ray said nothing.

"Have you been working?" The fingers of Claude's hand worried over his face. They seemed like something separate from him, acting of their own will.

Ray shook his head. "Too much going on."

"You have to make time."

"It's not just that—not just time. It's just too much sadness. Too much pain, I guess."

Claude looked up at the ceiling. Then he looked at Ray again. "'What marks the artist is his power to shape the material of pain we all have.'"

Ray looked at him.

"Trilling," Claude said.

Ray smiled. "The critic? I've never much cared for—"

"Use the pain, Raymond. The pain will give your art life." He explained that in January he had been at a Multiple Sclerosis benefit

at the hotel in Bay City. "That's the problem with your painting in that lobby. No pain. I mean, maybe you were feeling pain, but you weren't using it."

Ray pinched his nose between his finger and thumb. "Maybe."

"You forgot about the pain. The struggle. You got caught up in everything that makes modern art cheap."

Ray nodded. "You're right. I just don't—"

"Pushing the limits of what is art...I don't think that's your calling. It's an odd calling, really. A single dot in the middle of a canvas. Is it art? The question doesn't even interest me. What is art? What are its limits? When artists started asking that as their main question, that's when the public turned away. Art shouldn't be about art or the definition of art. Such endeavors breed charlatans." Claude lowered his hands. They seemed always to float up and away from him.

"I'm not even sure what I should be painting."

"Don't you know? People, Raymond. When you're doing it right, your art speaks the truth about people. I'm talking capital T truth. You capture the truth about the individuals you're painting, but then in that truth there is also a universal truth. I've seen it in your old paintings."

Ray looked at the floor. He thought of his renderings of Jolien Poiret and those of his parents. "I just don't know if I can anymore."

"You need to go back."

"Back?"

"Yes. Get out of this modern phase. Look at the Ashcan painters. Look at the realists. They'll show you the way. Not Pollock. Sure, he was a visionary, but also a deadly pied piper."

Ray was quiet for a moment.

Claude settled into something calmer. "Maybe that's hard to hear from me." He smiled. "I guess the realists didn't work with La-Z-Boys. Some might say I'm the Art Van of art."

Ray laughed.

Claude massaged his thighs. "I'm sure in its way my work seems like a gimmick. But, for me at least, I am revealing a certain kind of truth. I don't think I'd be able to work if I wasn't."

"Of course."

He said that his work dealt with forms. "Furniture is all forms. We judge it by its shape and outer appearance." He said that nobody gives much thought to the inner foundation of a chair or sofa. "They don't see that it has—in its framework—the possibility of being almost anything, something beautiful or terrifyingly horrible."

Ray looked at Claude. Footsteps were coming down the hall towards them. They kept coming. A student to see Claude, Ray guessed.

"It's no abstraction to me." Claude's leg kicked out. "I'm sculpting people."

The footsteps kept coming.

Ray stood. He reached down and touched Claude's arm.

Claude looked at Ray's hand. Then he looked up into his face. He smiled. "Thanks for stopping, Raymond. Thanks for listening to me."

Ray nodded. "I'll see you again soon."

"I'd like that."

Chapter XXV

Ray crouched in the bushes outside the lobby entrance, sweat dripping over his ribs. The decorative stones shifted and settled under his feet. It was sometime after one a.m. Taking it from his backpack, he tried to picture Sammy loading the flintlock. It came to him vaguely, and he started to pack the powder and the ball with the tiny ramrod. His fingers were stiff in the night air, but jittery. In the silence, the hotel hummed with its inner workings, all the wiring, plumbing, and cable keeping so many lights, toilets, and televisions going. Ray's insides hummed in their own machinations—heart drumming, wind of breath, the faint ringing in his ear he heard only in moments of concentration. He was resolved. He was going to do this. On his way to the water, he had started past the hotel. Then he saw *Riverscape* through the lobby windows and the plaque damning him as the creator. It struck him like a vision that there was a much better target than the Saginaw River for the flintlock's twenty-first century debut.

Having watched him for nearly a half an hour, Ray knew that the night clerk spent very little actual time at the front desk. There were no guests to serve. Now and again, the young man would emerge from what Ray guessed was a back office. He checked the computer, grabbed a few receipts or not, and then disappeared again. *Riverscape* hung on a wall perpendicular to the front desk. Behind it was a small meeting room. He knew because it was where they'd had the reception for the unveiling of his painting. A little wine, a little cheese. It was a room sure to be empty at this time of night.

Firing the flintlock. It had been a request of Sammy's. "Dad never got the chance, and now I won't either," he'd wheezed. Ray

promised that he would fire the pistol. He had imagined driving the gun out to the woods, but then he wasn't familiar with any of the wilderness around Bay City. He'd never been one to go to nature. The land around Kleminger's place was the most woods he'd seen in his life. His father had been unable to deliver the looming trees of the Redwood Forest as he'd promised, though he tried.

Scanning the hotel's parking lot, Ray hoped Diane was sleeping. She was three days overdue. The doctor said that if she wanted they could induce the labor if nothing happened soon. She had heard that sex could trigger the start of the birth. Earlier that evening she'd wanted to try.

Ray's blood was shiftless. Having sex to help start contractions? It didn't do much for him. Hurrying the baby along only frightened him.

Diane pulled her hand from his boxers.

"Sorry," he said.

She got up. "It doesn't really matter. It was just an idea." She pulled a robe around her. "I just want this baby out of me."

They'd gone into the kitchen. She took two tea cups down from the cupboard.

Ray looked out the window. Dark. The shame of what hadn't happened in the bedroom still hung on him, along with everything else he'd been carrying. He sighed.

"I don't think I can take you like this much longer, Ray."

He turned away from the window to her. She looked tired, haggard. "Like this?" he asked.

She touched her lips. "Don't pretend you don't know." She pulled out the chair opposite him and negotiated with her belly until she was sitting. "Maybe you should talk with someone—a professional."

"Come on, Di. I just buried my brother."

She made a scolding sound with her tongue. "No, Ray. You've been like this for a long time. This goes beyond Sammy. That's not fair to try to make me feel bad."

"I'm not trying...Look, I'm going to be okay. Okay? It's just everything is weighing down on me. I'll snap out of it. Even today, with the warmer weather, I was already starting to feel better."

"I hope you snap out of it," she said. "We have a baby coming. You have to decide to get all the way in or all the way out. I don't want to do it alone, but I can." She left the room. The springs of their bed moaned. A moment later, the tea pot whistled. He took it off the burner and shut off the gas.

Coming out of the memory, he started for the lobby doors, the gun heavy in his grip. He was almost inside when the clerk came out of the back room. Ray edged back toward the bushes, heart pounding. He waited.

When Diane didn't come out again for her tea, he poured himself a cup and went into the living room. The windows were black. He turned on the television, and the channel was airing a game of Texas Hold 'Em poker. They hadn't turned the television on since Sammy had died four weeks before. He looked at the space where the hospital bed had been. Near the space lay the storage crate with all of their father's guns. Diane had been after him to do something with them. It felt like a good night to do just that. He put the flintlock, balls, and black powder into a backpack.

He had heard it before—guns going off in the city from time to time. Sure, it was rampant on New Years Eve, but even a May or June night might be punctuated by the report of a handgun. Neither morning news programs nor the next day's paper ever made mention of a murder or shooting. It just happened. It was something the city simply absorbed. What would it matter if he walked the flintlock down to the river after midnight and shot it into the water? It was the first idea he'd had in some time that seemed to lift him from the vacuum he lived in.

Standing in the doorway of their bedroom, backpack shouldered, he'd watched her shifting around in the grayness of the bed. The sheets rustled. Lately she got so little sleep. Her aches wouldn't let her get comfortable, much the same way his hollowing thoughts gnawed at the edges of his own drowsiness. Between them, they only got three or four hours of sleep a night.

He said her name.

She sat up. "What? Ray?"

She'd moved so quickly, so instantly alert. "Sorry," he said. "I can't get tired. I'm going to take a walk."

Sighing, she collapsed back to the mattress. "I was almost asleep. What time is it?"

He told her it wasn't very late. "I think a little exercise will help me sleep."

"What's the matter, now? Why don't you just come to bed?"

"I won't be gone long."

"Whatever. Take the cell phone."

He turned, but then turned back to her. "I love you, Di. I love both of you."

"I love you, too."

Walking toward the river with the weight of the gun jostling in the backpack, he'd thought of Sammy. In his last two weeks he'd declined so quickly. He lost feeling on the left side of his body. The visits from other members of the hospice staff became more frequent. Physical therapists attended to him. He was sponge bathed and massaged every day.

"I ain't ever been treated so good." His words seemed to gurgle. His mouth and lungs were always full of fluid.

During the last few nights, Ray lay on the couch, listening to his brother's breathing like percolating coffee. He was in the room with him the night he died. It comforted him to remember that his brother hadn't died alone.

Sammy had said something.

Ray stirred from a half sleep. "What?" Sammy often woke in the middle of the night with a request for water. Or, just to talk.

"I'm afraid—" His words drown in his mouth. He coughed.

Ray patted his hand. "Remember that the nurse said not to think about—"

"Ray Ray..." He sat up and looked into Ray's face, his eyes. Sammy's eyes were wide, expectant. He took Ray's shoulders in his hands and then lay back and died. Like their mother, his heart had given out.

His passing was barely a hiccup in the town. Stevie's wife came to the funeral. While offering her condolences, she said that Stevie was coming back from Illinois the next week. "The Decatur plant had to lay him off already." She cried.

Dennis came, and Ray smelled the booze on his breath. Carlene sat in the front row of seats with Diane and held her

hand. They'd gone together to find her a black maternity dress. A portrait Diane had done of Sammy sat on an easel next to the casket. It captured his eyes.

The next day only Diane, Ray, and the funeral director watched the deceased descend into the grave. Ray attempted a eulogy.

"Sammy was a good man in a hard life. Despite what he may have done to himself and to others, I think it's important today to remember that he was first a good man. I'd like to think we all start that way." He tossed the initial shovelful of dirt onto the casket.

The front desk clerk typed something into the keyboard. Ray looked around the lobby one last time for security cameras and again found none. Remembering an additional detail about the gun, he primed the flash pan and closed the lid. He pulled the striker back to half cock. The weapon was cold and heavy.

Holding papers, the night clerk yawned into the back of his hand. He rubbed his eyes and yawned again. Something in his fatigue reminded Ray of a painting he'd seen. He was in high school on one of the rare trips that his art teacher had been able to arrange to a Cincinnati museum. The painting had come through on loan as part of an exhibit: Labor in America. The show featured work by Bellows, Luks, Blythe, Kane, Lange, Neagle, Sloan, and Weir. Among the paintings was Thomas Anshutz's *The Ironworkers' Noontime*. He could still picture the worker in the foreground in his red sleeveless shirt. A first glance suggested that he was flexing his muscle. A closer look revealed that he was most likely rubbing away an ache. Ray had been so taken with the painting that he'd bought his father a print in the gift shop. "That ain't art," his father said, flipping the print into the air of the kitchen. "I see shit like that every day. Art's supposed to be beautiful."

Ray's teacher felt differently. "The painting," she explained, "celebrates America's growing industrial might, while still showing the dehumanizing effects of factory work." Its conflicted nature was what gave it its strength. "It gets after the truth," she said.

He looked through the glass at *Riverscape*. It got at nothing. It was idealized, banal, and gutless.

The clerk went into the backroom again. Ray jumped from a sound behind him in the parking lot. What would a hotel guest think about him lurking in the bushes? The source of the noise turned out to be a pop cup rolling across the asphalt in the breeze. He used the adrenaline that the scare had sent through him. Pushing open the lobby doors, he walked straight at the painting with the gun clenched at the end of his extended arm. Locking his elbow, he set the striker back to full cock, aimed for the freighter, and pulled the trigger. The explosion rang in his ears, and the kick sizzled in his hand. There was more smoke than he would have guessed. He'd blown a hole in the ship the size of a baseball, which he studied for a second before running out the door.

As he sprinted across the parking lot, he felt top-heavy, his torso seeming to try to get ahead of his legs. Twice he almost fell. He was running with the gun still in his hand. He stopped and shoved it into the backpack. He bolted again, steadying his run.

His mind filled with sounds—people shouting for him to stop, footsteps gaining behind him, sirens. When he did stop just inside the shadow of an alley, he heard nothing. He bent over, caught his hands on his knees, and worked to catch his breath. He didn't know how long it'd been since he'd run any kind of distance. Could it have been since he was a child? Strange to know his legs in this way again. His lungs burned with hyper-ventilated breathing.

Everything he'd just risked ran through his head. What if he were caught? Surely it couldn't mean prison. Jail? What about the college? He wasn't certain if tenure would protect him when it came to walk-by shootings.

He leaned against the wall. The sickly smells of the alley filled him—restaurant grease, dead pigeons, garbage. His breathing slowed. Whatever this was going to mean for him, it was done. He couldn't go back.

Then he heard them. Sirens.

He imagined the next day's headline. Local Hotel Suffers Art Attack. The story would report that an antiquated weapon had been used to ruin the painting of a local professor. Reporters would probably call to talk to him. If they wanted to meet him, he would suggest his office at school. He didn't want them

stumbling on his father's collection. He would have to tell Diane what he'd done. An overdue wife at home certainly gave him a good alibi. She'd be angry, furious, but she would have to cover for him. And, she'd soon forget it with the baby's arrival.

There'd been stranger stories in the paper. Hadn't a man run out of his house in the middle of the night with a samurai sword and severed the hands of a man who was passing by on the sidewalk? It was an incident of mistaken identity. The attacker was seeking revenge on those who had just beaten him in a street fight a half an hour before. The bizarre story only buzzed in the media for a few days and then was forgotten. The victim was supposed to have his hands reattached. If they had been, Ray had never read or heard anymore about it.

He walked the length of the alley, looking and then sprinting when he came to cross streets. He wiped at his running nose and smelled the black powder on his fingers. He laughed despite himself as he thought about what he'd done. *Riverscape* was destroyed, or at the very least had gone through an important revision if the hotel decided to keep it hanging. He stopped at the end of the alley and didn't recognize the street. The rooftops dripped around him. The early days of April had brought the first temperatures of spring. The town was thawing. He laughed in a way he hadn't in a long time. He felt drunk. Free.

Paintings began to flood his mind. He imagined Billy in one skateboarding in an empty swimming pool behind his parents' house. His left hand would be up for balance, a wedding ring glinting. Kari would be admiring him from a lawn chair. In the window behind them would be Billy's mother watching with her tired eyes, William fussing in her arms.

Other paintings came into his head. He could do one of Claude in a wheelchair. Welding mask over his face, arc coming off of the welding torch in his hand, he would be sculpting something beautiful out of a second wheelchair in front of him.

He walked—in what direction he wasn't sure. A vast stretch of pale blue building glowed dimly ahead of him behind nearly a half mile of cyclone fencing. Smoke rose in places from its roof. Its parking lot could be measured in acres. No more than thirty cars were freckled throughout the hundreds of spaces. Third

shifters. He looked up at the sign near the entrance. Powertrain. Something to do with cars. He tried to imagine the workers inside. What were they doing? How secure were their positions?

His thoughts went to Stevie...Stevie's wife and children. Their house for sale. Their cabin up north for sale, maybe sold. A family of reluctant nomads in the land of Nod.

Then, it came to him. There would have to be a painting of Sammy, the blue-collar worker. He would be in his hospital bed as Ray had seen him so many times. His helpless face, etched with his impending death, would stare out of the canvas, gawking into the uncertain future. No hospital gown, he would be in his factory clothes. Behind him, a window as black as Ray could paint it.

He walked leisurely, thinking of the paintings. He waited for them to show their flaws, their obviousness. Ten minutes later, they were still with him, rich in his mind. He could start that night, at least on one of them. He walked faster and his body shivered with his inspiration. He felt himself disappearing in anticipation of the work.

Home. Where was home? He looked at the houses and at the names of cross streets. He'd lived in the town for nearly two decades, but he was in a neighborhood that he didn't know, didn't even know existed. He stopped and looked around for something familiar in the darkness. His life had been a habit. He drove to the college. He drove home. He drove to the grocery. He drove home. The houses around him were small, and dark. Here and there a porch light. In front of him, despite the street lights, the road's vanishing point disappeared into blackness.

He guessed at a direction and started to walk. He calmed himself, not allowing the excitement about his paintings to turn into fear and melancholy. The town wasn't that big. Eventually he would have to recognize something. He would wait for the familiarity. Don't force it, and it would come.

His mind went back to the paintings he had envisioned. They were good. They would be good. Pumped up as he was he would have to start that night—at least some sketches— even if he didn't get home until three in the morning. A cold breeze started. He put his hands in his pockets, and in one he found the cell phone.

He checked its glowing screen. No missed calls. When would the baby finally come? He knew no more about it than what he'd learned from the ultrasound image. With something close to love, he pictured that tiny face again.

A new thought flooded into his mind. Ultrasound. Self-portrait. It hadn't been done before. And still, it was about more than just being the first. It would say something about who he was as an artist. More than just somebody about to be reborn— though that was good—it would combine the realism of the face with the black and white abstraction of everything surrounding it. Self portrait done as an ultrasound image. His adult face staring out of the screen. It was perfect. His heart beat as though responding to sex.

Sex. The thought of it surfaced in his mind as regret. Lately, he'd certainly been letting Diane down, even if she only really wanted him to help break her water. Still, whatever problem he'd had earlier that night wouldn't be a problem if he went home right then. His blood was freed. It was already tingling in his groin at the idea of Diane's naked, rounded body. He would go home and share sex with her. It might even help the baby come.

The baby. It's what she wanted more than anything. His paintings could wait. They were secure in his mind. They would stay. They were his, and he would soon be working again. Whatever blackness he'd been carrying for the last three months had left him. Every thought that came into his head shimmered. Even the idea of the baby excited him. He could still hear its insistent heartbeat. His own heart matched the frantic pace. Whatever it was going to mean for them, he was ready to bring this child into their lives. If he concentrated, he could still feel the way Billy's boy had felt in his hands. Heavy. Solid. It was a good weight—a weight that might keep one anchored, keep one from going adrift. The whole thing might give him roots. It was time to know. It was time for him to get all the way in.

He came to a cross street. Center Street. It was that easy. Turn right and he would be at their apartment. He would be with Diane, finally without the burden that had settled onto him since the fire.

The street was a mix of light and darkness. Porches, windows, street lamps—the head and taillights of passing cars. Where there wasn't light, there was the gray darkness of night, never a true black. Huge, ancient trees loomed over him, probably planted by the lumber barons. Ahead of him the roots of one tree held a slab of sidewalk at a forty-five degree angle. He quickened his pace, hurdled it, and kept running. Home. Home. Center was well lit. The squares of sidewalk blurred beneath him. His feet pounded against the cement, and his lungs burned with the cold air. He was running again, like he had so many years ago as a boy with Sammy. He wasn't going to slow down...wasn't going to stop. Somewhere, blocks ahead, Diane and the baby were waiting in limbo, and he would wake them and welcome them into this new vision of the world he hoped to keep.

 Jeff Vande Zande was born and raised in Michigan's Upper Peninsula. Rich in beauty, the Upper Peninsula is scarce in jobs, and in such an environment Vande Zande's sensibilities about work took shape. Vande Zande's father was a college professor, yet many of his cousins and uncles worked in the iron ore mines. Often the talk around Vande Zande's family table was of layoffs and strikes at the mines, and sometimes the threat of strikes at the university. As a young boy, Vande Zande was haunted by the palpable knowledge that having and fighting for a good job is an important thing. He came to understand this even more in his teenage years when he found and then lost his first job working at a small fast food restaurant, when the owner decided suddenly to close it. At sixteen, Vande Zande felt the rug of employment pulled out from under him and the experience of losing a job has stayed with him.

After graduating from college with a degree in English (without a teaching certificate), Vande Zande began the search for work again. He found it as a maintenance engineer in a hotel. Though he knew little about tools, a supervisor took him under his wing, and taught him how to fix things and to work hard and with pride. Vande Zande returned to lower Michigan with his wife, Jennifer, after grad school. After working part-time at a few colleges and universities, he became a full-time professor at Delta College. He has a son, Max, and a daughter, Emerson.

Vande Zande's life has been a mix of both working-class and academia, and this latest novel, *Landscape with Fragmented Figures*, is a study and tribute to both. His books include the novel *Into the Desperate Country* (March Street Press, 2006), *Emergency Stopping and Other Stories* (Bottom Dog Press, 2004) and the collection *Poems New, Used and Rebuilds* (March Street Press, 2007).

Bird Dog Publishing

Faces and Voices: Tales by Larry Smith
1-933964-04-9 136 pgs. $14

Second Story Woman: A Memoir of Second Chances
by Carole Calladine
978-1-933964-12-6 226 pgs. $15

256 Zones of Gray: Poems
by Rob Smith
978-1-933964-16-4 80 pgs. $14

Another Life: Collected Poems by Allen Frost
978-1-933964-10-2 176 pgs. $14

Winter Apples: Poems by Paul S. Piper
978-1-933964-08-9 88 pgs. $14

Lake Effect: Poems by Laura Treacy Bentley
1-933964-05-7 108 pgs. $14

Depression Days on an Appalachian Farm: Poems
by Robert L. Tener
1-933964-03-0 80 pgs. $14

120 Charles Street, The Village:
Journals & Other Writings 1949-1950 by Holly Beye
0-933087-99-3 240 pgs. $15

Bird Dog Publishing
A division of Bottom Dog Press, Inc.
Order Online at:
http://smithdocs.net/BirdDogy/BirdDogPage.html

RECENT BOOKS BY BOTTOM DOG PRESS

Bar Stories,
edited by Nan Byrne
978-1-933964-09-6 168 pgs. $14

An Unmistakable Shade of Red & The Obama Chronicles
by Mary E. Weems
978-1-933964-18-8 80 pgs. $15

Cleveland Poetry Scenes: A Panorama and Anthology
eds. Nina Gibans, Mary Weems, Larry Smith
978-1933964-17-1 304 pgs. $20

d.a.levy & the mimeograph revolution
eds. Ingrid Swanberg & Larry Smith
1-933964-07-3 276 pgs. & dvd $25

Our Way of Life: Poems
by Ray McNiece
978-1-933964-14-0 128 pgs. $14

Hunger Artist: Childhood in the Suburbs
by Joanne Jacobson
978-1-933964-11-9 132 pgs. $16

Come Together: Imagine Peace
eds. Ann Smith, Larry Smith, Philip Metres
978-1-933964-22-5 224 pgs. $18

Evensong: Contemporary American Poets on Spirituality
eds. Gerry LaFemina & Chad Prevost
ISBN 1-933964-01-4 276 pgs. $18

Order Online at:
http://smithdocs.net

LaVergne, TN USA
25 August 2010
194607LV00002B/28/P